FILM MAGIC

THE ART AND SCIENCE OF SPECIAL EFFECTS

DAVID HUTCHISON

FILM MAGIC

THE ART AND SCIENCE OF SPECIAL EFFECTS

PRENTICE HALL PRESS · NEW YORK

Published by Prentice Hall Press
A Division of Simon & Schuster, Inc.
Gulf + Western Building
One Gulf + Western Plaza
New York, NY 10023

PRENTICE HALL PRESS is a trademark of Simon & Schuster, Inc.

Library of Congress Cataloging in Publication Data

Hutchison, David, 1944–
 Film magic.

 Includes index.
 1. Cinematography—Special effects. I. Title.
TR858.H88 1987 791.43'024 86-43100
ISBN 0-13-314774-6

Designed by Publishing Synthesis, Ltd./Jack Meserole

Manufactured in the United States of America

10 9 8 7 6 5 4 3 2

Dedicated to My Parents

ACKNOWLEDGMENTS

THIS BOOK IS the result of many years spent prowling around special effects production houses as editor of *Cinemagic* magazine and as science and technical writer for *Starlog* magazine. I am deeply indebted to dozens of industry professionals who took the time to explain so much of the history and nature of their work. In particular I would like to thank Ray Harryhausen, Albert Whitlock, Douglas Trumbull, Richard Edlund, Dennis Muren, John Dykstra, Harrison Ellenshaw, Matt Yuricich, Thaine Morris, Scott Santoro, Bran Ferren, Neil Krepela, John Whitney, Jr., Phil Tippett, Bruce Nicholson, Mark Vargo, Gene Warren, and Garry Waller.

CONTENTS

INTRODUCTION

SPECIAL EFFECTS IS both an art and a science. Its artistic roots can be traced to the earliest days of the court magician, who created wondrous illusions to astound and entertain. Its scientific aspects often require the skills of engineers with a good understanding of practical physics.

For centuries the secrets of special effects were closely guarded and known only to a few. The success of grand stage illusions depended on this secrecy. Special effects was essentially a mechanical craft, requiring a knowledge of clever carpentry and cabinetmaking in order to make ladies vanish and rabbits leap from silk hats. But the invention of photography in the middle of the nineteenth century gave magicians a new tool with which to confound and entertain—trick photography. Now it was possible to see ghosts and angels hovering in the air, to be mystified by shots of tiny people living inside of wine bottles, or even to own a photograph of oneself surrounded by an extraordinary number of identical twins.

The first movie cameras were made in about 1889, during an era in which stage magic shows and grand illusions were enjoying unprecedented popularity. Among the well-known practitioners of stage magic and illusion, one man—Georges Méliès—has become known as the father of special effects in the cinema.

In December 1895, Méliès was among the elite invited to the Lumière brothers' first projection of a movie at the Grand Café in Paris (see Chapter 6). Although the early Lumière efforts, which did not involve special effects, depicted the most prosaic of everyday scenes—factory workers coming and going, street scenes, construction projects—they electrified and inspired Méliès. He immediately cobbled together movie equipment of his own and produced hundreds of short films, most of which have been lost to us.

Méliès' entire output of short films between 1896 and 1912 is estimated at more than 500 titles. While his first efforts were not much different from the early street scenes of the Lumière films, he soon broke the Lumière mold and began photographing the grand stage illusions that he and several others had been producing. His films include burlesques, stage illusions, political satires, science fiction, fairy stories, newsreels, adaptations of famous fantasy novels and other literary works, and costume dramas.

Méliès produced his first special effect in *The Vanishing Lady* (1896), which is essentially a film adaptation of a stage illusion. To create the effect, Méliès stopped the camera, allowed the lady to leave the stage, then restarted the camera. When the film is projected, the lady seems simply to disappear.

This technique, called the *arrêt* (French for "halt" or "stop"), is at the very heart of special effects filmmaking. Legend has it that Méliès discovered this method by accident while filming on the streets of Paris. His camera jammed for a moment and, when the film was projected, a cart was seen to turn into an omnibus as if by magic.

As a producer of stage illusions and theatrical spectacles, Méliès understood magic very well. He transferred those techniques to the motion picture and continued to adapt other still-photography techniques, such as double exposure, to the new medium. But the illusion created by the camera *arrêt* was something new and intrinsic to the motion-picture process.

Drawing on his photographic and theatrical background, he imbued his little "trick" films (most only a few minutes long) with an uncanny sense of the spectacular. His repertoire of illusions and tricks was truly astounding. Even today, few special effects cannot be traced back to the films of Georges Méliès.

Shooting a special effects sequence now involves specialized equipment and techniques far beyond the knowledge of most directors and producers. To create a special effects film requires specialists, people whose life work it is to produce and create special effects footage to be cut into films in postproduction. The director or producer of the film must rely on the special effects supervisor to determine what can or cannot be created on the screen.

Often a director is reluctant to relinquish any degree of artistic control to a special effects cinematographer. Yet few directors have the expertise to supervise a miniature shoot, for example;

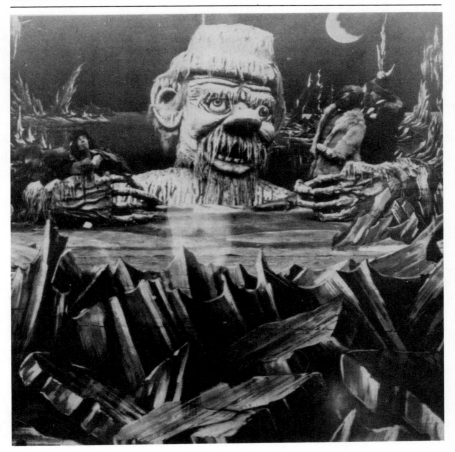

One of the last of Méliès' hundreds of films, *The Conquest of the Pole*
(1912), starred a gargantuan puppet called the Giant of the Snows.
Loosely based on Jules Verne's *The Sphinx of the Icefields* (1897), Méliès'
monster marionette required about a dozen operators. Méliès' trick
films were based on an amalgam of traditional stagecraft and in-
camera effects photography. Many of today's special effects artists
still prefer this approach. (*Museum of Modern Art/Film Stills Archive*)

moreover, they may fear the mysterious processes of postproduc-
tion effects, in which live actors are inserted optically into a min-
iature sequence. In order to maintain control over every foot of
film, a director may choose (if the budget permits or the director

has enough power) to shoot the sequence live, full-scale, with the actors. Such a decision is almost always very costly and can be extremely dangerous.

Accidents can happen even under the best of circumstances, but a director who ignores the advice of special effects experts and tries to "go it alone" is only asking for trouble. A good example is the 1929 Warner Brothers production *Noah's Ark*, directed by Michael Curtiz. For the climactic flooding sequence, an enormous set of the Temple of Moloch was built in a large studio tank. Hollywood is a desert town, so it was necessary to collect water for months and store it in reservoirs in the Hollywood Hills. It was producer Darryl F. Zanuck's first film, and he wanted it to be spectacular. The set was filled with hundreds of extras, few of whom knew what was in store for them when those tons of stored water were suddenly released. It has been reported that three extras drowned, one lost a leg, and numerous others suffered broken bones. No doubt both Zanuck and Curtiz learned that day that dramatic filmmaking is the art of finely crafted illusion and should have nothing in common with newsreel photography.

Ideally, the director should have the same confidence in the special effects director's work as in his or her own. Cecil B. DeMille had a reputation as one of Hollywood's toughest taskmasters, yet he usually gave his special effects director, Gordon Jennings, the freedom to do his own work. There are, however, alternatives to relinquishing complete control over a film's special effects.

Some directors have the know-how to direct their own effects sequences. Perhaps the most famous of these is producer-director Irwin Allen, whose *The Poseidon Adventure* (1972) and *The Towering Inferno* (1974) are filled with the thrills and chills of grand-scale special effects filmmaking. Allen is competent and at ease working on sets with actors amid fire, flood, and mud, and he is quite willing to let his effects specialists handle miniature and optical effects.

Directors who are less secure with postproduction optical effects rely on their effects specialists to come up with techniques that directly involve them and their own camera crews. These effects are incorporated into the film as it is being made, rather than being relegated to postproduction or assigned to a separate camera crew. Most of these techniques are what are called "in-camera" techniques. They include hanging miniatures, perspective shots, glass paintings, and a number of other techniques that

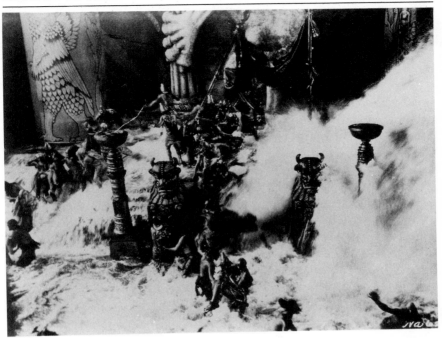

The desire for more and more amazing super-spectacles near the end of the silent film era sometimes resulted in tragedy on the set. During the filming of the deluge scene in *Noah's Ark* (1929), the opening of the studio's special effects dump tanks unleashed a flood of terrible force. Accidents can and do happen from time to time, but one of the purposes of special effects is the art of *suggesting* that something difficult or dangerous is happening. (*Museum of Modern Art/Film Stills Archive*)

date from the turn of the century and the magical in-camera effects of Georges Méliès.

Directors like in-camera effects because they can see what they are getting right through the lens of the camera. There are no surprises down the road, months later, when a special effects sequence comes back from the lab and the shot is not what the director had envisioned. But producers dislike in-camera effects because they usually involve extended setup times, which means they cost more.

Walt Disney's *Darby O'Gill and the Little People* (1959) made spectacular use of in-camera effects. Darby actually appeared to

be conversing, playing, and walking among live leprechauns—
little men only two feet high. There was no casting call for
"munchkins" to play the little men; instead, Disney relied on the
movie magic of his effects supervisor, Peter Ellenshaw.

It is a standard trick of perspective that two objects exactly the
same size can be made to appear smaller or larger in relation to
each other. For example, if you pick up two tennis balls, hold one
close to your face and the other at arm's length, and then look at
the two balls with one eye closed, the two balls will seem to be of
different sizes. The one closer to your face will appear much
larger than the other.

This principle was used to film the scenes with Darby and the
little people. The actor playing Darby worked very close to the
camera, while the actors playing the leprechauns worked much
farther away from it. Shot from the proper angle, the actors play-
ing the leprechauns appeared very small to the camera, while the
actor playing Darby appeared much larger. This old trick, which
dates back to the days of salon-hall magic and Georges Méliès, is
still in use today.

Perspective effects demand a great deal of time and expertise.
Special sets must be constructed to exacting specifications. Actors
are unable to see one another and sometimes cannot even
hear one another, because they are placed so far apart. Camera
position and lighting are critical. Such a shot requires a lot of
rehearsal and experimentation, but, since no camera trickery is
evident (there are no matte lines or grainy images), the results can
be very effective. The effect is produced inside the camera and is
of first-generation quality.

A more recent example of a perspective effect is the German
fantasy film *The Neverending Story* (1984), in which young Noah
Hathaway plays a scene with two gnomelike characters (played by
Sydney Bromley and Patricia Hayes). These two adult actors ap-
pear to be only about two or three feet tall next to youngster
Hathaway. Such camera-perspective tricks create an uncanny il-
lusion and are a delight to watch, since, unless you know the trick,
there is no way to tell how it was done. In fantasy films, these
flawless illusions add immeasurably to the audience's ability to
suspend disbelief and to be captivated by the spirit of fantasy and
fairy tale.

A special effect should always be a means to an end. A film tells
a story in a series of images; the job of special effects is to make

the visual storytelling effective and economical. Everything is planned very carefully in preproduction. After the script has reached the final-draft stage, the art director and staff prepare a series of drawings illustrating the key moments in the film. These visualizations are approved by the director, producer, and, in the case of special effects sequences, by the supervisor of special effects.

These planners evaluate and agree upon factors such as cost, technical feasibility, style, and visual impact. The next step involves the construction of a miniature, and the designing of special optical equipment—or, if the sequence is scrapped, the destruction of a drawing and a few pages of script. If the surgery has been radical, the script will have to be rewritten around the deleted scene.

One of the most important tasks for the special effects artists, designers, and engineers is to translate the words written on the pages of the script into visual terms. This process is especially critical when a literary work is being adapted to the screen; a literal translation into visual terms may not prove faithful to the literary concept. Thus, what appears on the screen may bear little or no similarity to what is described in literary terms; only the emotional impact will be the same.

The history of modern special effects films begins with Stanley Kubrick's *2001: A Space Odyssey* (1968), shot entirely in 65mm Super Panavision. Until the *Star Wars* era began in the late 1970s, *2001* was the best-known and largest-grossing science fiction film ever made. Interestingly, the success of the film had little to do with the story being told. It was the visual magnificence of the film—the purely visual experience—that attracted attention. The film's "star gate" finale used a technique called *slitscan*, pioneered by abstract filmmaker John Whitney and developed by Douglas Trumbull (see Chapter 5). Its visual novelty made *2001* a cult film for the drug trippers of the late 1960s and early 1970s. But the real achievement of *2001* was its use of special visual effects to create an experience in the theater.

Many films are conceived wholly in visual terms. This is particularly true of the disaster epics that were popular in the 1970s, such as *The Poseidon Adventure* (1972) and *Earthquake* (1974). The former created the illusion of a disaster at sea, while the latter illustrated what it might be like to live through an earthquake.

Viewers of *Earthquake* thrilled to the sight of massive, cataclys-

mic destruction. Although it all certainly *looked* real, it was, of course, an illusion. The skyscrapers that were being destroyed were only models, broad panoramas of a shattered Los Angeles were only matte paintings; and the unleashed fury of the crumbling Hollywood Dam was a back-lot miniature.

Special effects artists have the same problems as any stage magician. No trick, no matter how well performed, will stand up to repeated scrutiny. This is why a wise magician always turns down appeals to "do it again" and goes on to the next illusion. A good special effects film works the same way. In *Earthquake,* no attempt was made to build a tabletop model of Los Angeles and shake it apart while cameras rolled. In other words, the film was not built around a single special effect technique. Rather, a variety of effects were used in most sequences: Albert Whitlock's ingenious matte paintings, full-scale studio effects that included falling sets and stunt actors being "crushed" under tons of (Styrofoam) concrete, and Universal's jolting Sensurround audio system. Each technique played its part in reinforcing the verisimilitude of what the audience was seeing.

The make-believe devastation of Los Angeles by earthquake succeeds in the film due to a curious psychological contradiction. By design, the film establishes a set as "real" in the mind of the audience; usually this is done by filming live action at some well-known public building or park. For the destruction sequence, an extremely detailed and carefully constructed miniature is substituted before the cameras. The contradiction lies in the fact that everyone in the audience knows that the destruction isn't real, that it is an illusion, just like the stage illusion of sawing a lady in half. Of course, we know that there isn't real blood spattering out of the poor young lady, but we delight in the completeness and believability of the illusion.

Special effects in the movies have an advantage over those used in traditional magic shows. On stage a magician entertains the audience with a series of well-performed tricks. The show is no more emotionally involving than an ordinary exhibition of gymnastics, for example; nor is it supposed to be. In the movies, in contrast, the magic of special effects is called upon to help tell a story, which can simply entertain or stir our deepest emotions. Movie special effects are not an end in themselves, like stage magic. To subvert story to effects is to undercut the power of the film medium severely. Georges Méliès never realized this. He was con-

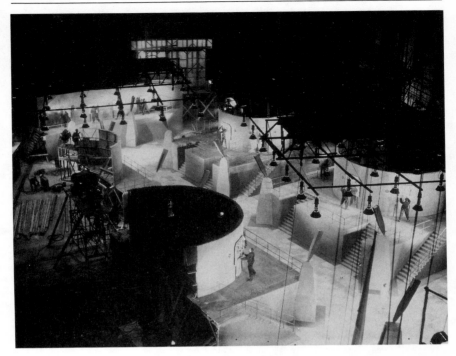

Fritz Lang's early science fiction classic *Metropolis* (1926) featured the effects work of Eugene Schufftan. Lang's expressionistic vision of the future successfully blended sprawling full-size sets and complicated miniatures. Schufftan later came to the United States (as did Lang) and earned an Academy Award for his vividly atmospheric photography in *The Hustler* (1961). Some of Schufftan's effects techniques are still in use, including one that bears his name, the *Schufftan shot* (see Glossary).

tent to continue making little trick films, relegating the art of filmmaking to the status of a toy. In a very short time, the cinema outgrew him.

Today, the motion picture is our most powerful and expressive storytelling medium. Much of its impact, of course, lies in the fact that it is a photographic medium. To many people, "seeing is believing." Special effects make it easier for people to believe.

In this book, I have not tried to write either a history of movie special effects or a how-to guide for the student. Instead, this book is dedicated to all inquisitive, gadget-minded people who are

Art director Michael Minor checks part of the surface detailing of a miniature in the 3-D film *Spacehunter* (1983). Most special effects sequences are completed in postproduction, long after the live-action sequences of a film have been shot. While the film is being assembled, production art can serve as a substitute for the finished shot. In addition, effects craftsmen constantly refer to the artwork while an effect is in production. A producer often expects the finished effect to look as good or better than the original art.

driven by the desire to understand the basic principles of how things work.

The first five chapters discuss each of the major areas of photographic effects in motion pictures. Chapter 6 takes a look at some of the various film formats in use for general filmmaking

and special effects. There follows a guide I have created to some of my favorite effects films with listings of the major effects screen credits and a few comments about what I thought was particularly noteworthy. The final section is a glossary, which explains in detail the terminology used in this book; I have relegated these discussions to the back of the book so that the topics being discussed in each chapter would not be bogged down with lengthy historical digressions.

1 Miniatures

THE MOVIES ARE filled with great moments. In Steven Spielberg's *E.T.* (1982), several youngsters on bicycles rise into the air over the heads of the police in the exciting escape that climaxes the film. In *War of the Worlds* (1953), a classic film from that great special effects master of the 1950s, George Pal, Martian war machines lay waste to city streets and buildings. In Pal's *When Worlds Collide* (1951), New York City's Herald Square is engulfed by a foaming tidal wave.

All these sequences involved special effects, simply because there was no other way to get the shots: bicycles don't really fly, Martians with war machines don't really exist, and Herald Square could not be turned into a boat yard. All these spectacular scenes relied upon the use of miniatures. A movie miniature is any carefully scaled model of an object, such as a ship or an airplane, or of an entire scene, such as a landscape or city, that is designed and photographed to substitute for the real thing.

It is easy to understand why miniatures must be used so often in fantasy and science fiction films. But sometimes miniatures are also used as cheap substitutes for places or objects that actually do exist. Too difficult and expensive to move cast and crew to the Taj Mahal? Can we even get permission to film there? Too bad there isn't enough time and money in the budget to build a full-size Taj Mahal on the back lot. All right, then, we'll build a miniature and put the actors into it with a little special effects hocus-pocus.

The technique was used for the PBS miniseries *Cosmos* (1980) with Carl Sagan. Special effects modelmakers constructed a miniature of the famed ancient library at Alexandria, Egypt. Special cameras made it seem as if Sagan were strolling through the halls, climbing the steps, visiting the rooms, and sitting for a moment in the ancient building's atrium. Few viewers realized that a cunningly contrived miniature was used for the entire sequence.

1

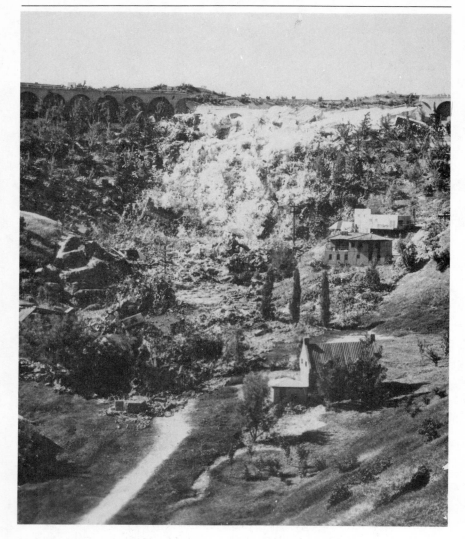

Water effects are the most difficult to create in miniature. This scene from *Earthquake* (1974) was filmed on Universal's back lot under the supervision of Clifford Stine. The Hollywood Dam set was built in 3/4-inch scale and filmed with nine cameras rolling simultaneously at speeds ranging from 96 to 120 frames per second. Since the model can be destroyed only once, the use of multiple cameras ensures a variety of angles for the editor to work with and a bit of insurance in case one of the high-speed cameras fails or one negative is damaged. (*Copyright © Universal Pictures, a Division of Universal City Studios, Inc. Courtesy of MCA Publishing Rights, a Division of MCA, Inc.*)

Well-crafted miniatures can fool almost anyone. These truck and car models were made by Brick Price Movie Miniatures, a company that specializes in constructing highly detailed models for commercials, feature films, and NASA. Such precise quality does not come cheap, however. The time and skills necessary to produce a model of this quality can raise the cost of models like these well above the cost of the actual vehicles. (*Courtesy Brick Price Movie Miniatures*)

Filming it this way was much cheaper than building a full-size set—and, of course, the real library was destroyed thousands of years ago.

A location may be very accessible, but perhaps the script requirements are such that the powers-that-be simply will not permit you to film there. New York's leaders, say, may object to parts of the city being scourged by a firestorm, split by an earthquake, and wiped out by a tidal wave. Even assuming that all these elemental forces could be summoned up on cue, imagine the cost of this "one-take" situation!

This is an extreme example, but it illustrates the point. Often it is necessary to obtain a permit to film in a city, and most permits require filmmakers to restore the premises to the state in which they found them. Moreover, if city officials dislike the script or think their town will be presented in an unfavorable light, they may deny permission to film there. No problem. Special effects miniatures of famous landmarks can be built and used in establishing shots. All the street-level shots can either be made in another city with a similar look or on a studio set. The audience will identify the special effects miniatures as the famous landmarks themselves and believe that the film was actually made on location.

Practical is the key word in choosing between special effects and the real thing. To a producer *practical* means: Do we need it? Can we afford it? Do we have the time and the means? The answers to these questions will determine whether a crew is sent out to a location or into a studio with a miniature.

In 1927 Buster Keaton chose to destroy two real locomotives in a head-on collision for the climax of his film *The General.* Producers debate whether or not the same effect could have been achieved through the artistry of special effects, but there is no denying the power of Keaton's shot.

The futuristic scenery of Everytown in Alexander Korda's production of H. G. Wells' *Things to Come* (1936) was created by the careful integration of miniatures and set pieces. Miniature craftsman Ross Jacklin worked with effects supervisor Ned Mann to create this vision of the world in the year 2036. Miniatures can add enormously to the look of a film at a comparatively modest cost. Such scenes, built full-size, would have been prohibitively expensive.

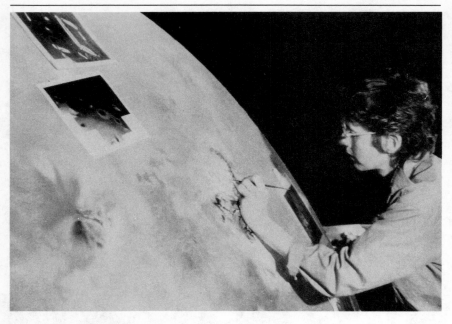

Artist Michelle Moen creates a miniature globe of Jupiter's moon Io for *2010*. Modern film effects require as much scientific accuracy as possible since most people have seen pictures of the real thing transmitted by NASA's space-exploration satellites. (*Photo by Virgil Mirano, courtesy Boss Film Co. Copyright © 1984 MGM/UA Entertainment Company*)

In contrast, Cecil B. DeMille, in his 1952 epic *The Greatest Show on Earth,* relied entirely on the skill of his special effects artists to produce the illusion of a spectacular train wreck with model trains and a miniature landscape.

The producer, art director, and director must constantly ask, What are the specific visual requirements for successful storytelling and for the success of this motion picture? What is the most economical way of producing these visual effects without sacrificing quality? How much "quality" can we afford?

Very often it is the special effects supervisor who supplies the answers to these questions. He will draw on his knowledge and experience to suggest various special effects alternatives to shooting a scene "for real." He will suggest the means to obtain the visualization designed by the art director and envisioned by the

director. What specific techniques are used, or whether special effects are to be used at all, depends on a number of factors.

First, there is image quality. For example, a crew could photograph a real hurricane in the Caribbean almost any autumn, and many newsreel photographers have done so. But the severity of the physical conditions tends to reduce the quality of the photography; everyone has seen the fuzzy footage of Florida hurricanes on the evening news. In contrast, the controlled conditions of a studio effects tank allow for better-looking photography and more predictable results with less risk to the cast and crew.

Viewed side by side, the live footage certainly looks real, while the effects footage looks fake. Why? Because the live footage draws such attention to itself. It is unsteady because of the high winds buffeting the camera, there are water drops on the lens, the image appears hazy. In the studio footage, there is no water or haze on the lens and the shot is steady; we can see what is happening without being distracted by the difficulties of getting the shot in the first place. To some, a certain "edge of reality" is lost, but in film there is such a thing as being *too* real. Photography under such "real-life" conditions often calls attention to itself; you find yourself sitting in the theater thinking, "How did they ever get *that* shot?" or "It's a wonder the actors and crew survived!" In this case you are certainly not thinking about the story and what the director and screenwriter wanted you to be thinking about—"Will the handsome hero rescue the beautiful heroine before she drowns?"

(This is not to say that studio situations are completely safe. There have been tragedies, such as the drowning of several stuntmen during the filming of special effects sequences for *Noah's Ark* [1929]. Since that time, safety standards have been made very strict, and accidents, though they still happen, are rare.)

There is another problem connected with shooting on location: The weather seldom cooperates. It ignores production schedules and doesn't read scripts. How long would a director, cast, and crew be willing to sit around on an island in the Caribbean waiting for just the right storm? And then, if a storm does happen by, it has to hang around long enough for the necessary sequences to be filmed—several days or weeks, at least. *The Wreck of the Mary Deare* (1959), starring Charlton Heston and Gary Cooper, begins with one of the most thrilling shipwreck sequences ever filmed; it was done using miniatures and a studio tank.

Usually a model or miniature is built when a variety of angles or shots are required and it is not possible or desirable to shoot full-scale. The three-dimensional nature of a model or miniature gives it greater flexibility than a two-dimensional painting. A model can be photographed from a variety of angles and be lit to suggest any number of different moods and times of day; even the seasons can be changed. A *glass shot,* which is a painting on glass that fills in part of a shot, can be used from only one angle, the angle that matches up with the live-action scene, and it can be lit only one way, to match the light of the live-action scene. Glass shots usually are used as "establishing" shots—single shots that give the audience an overview of an entire location. Miniatures are built when more than one shot is required. Miniatures can also incorporate some sort of movement—a flag waving or a drawbridge lowering. In order to get a painting to move, animation techniques must be used, which entails further postproduction work. Miniatures, in contrast, can be shot right along with the actors and the live action.

Ultimately, though, the final arbiter is money. The visual impact of any given effects sequence in a script is measured with a yardstick calibrated in dollars and days. Can a crew spend one year and half a million dollars to build a miniature set for a destruction sequence, or should they find an old skyscraper scheduled for demolition and dynamite it themselves with Panavision cameras rolling?

Sometimes there is no alternative. Either the sequence is created with the technical magic of special effects, or it is written out of the script.

David O. Selznick used no miniatures for the awe- and fear-inspiring burning of Atlanta in *Gone With the Wind* (1939). Combining master showmanship with a deep commitment to quality filmmaking, Selznick literally burned down the studio back lot for his memorable shot of Atlanta in flames. In fact, in a few shots you can make out the great wall and gates built for *King Kong* (1933) being consumed by the towering flames. The next morning studio crews cleared away the blackened wreckage to build the sets that were to be used in the rest of the picture. (It wasn't really necessary to burn the back lot for the sequence, but sometimes the publicity generated by such a sensational stunt justifies the action.)

Several years earlier, 20th Century–Fox had commandeered an old blimp hangar to build a miniature vision of New York City

in the year 1980 for its musical *Just Imagine* (1930). According to press reports at the time, the miniature covered an area 75 feet wide by 225 feet long and required the labor of 200 artists for more than five months. Built on a scale of ¼-inch to 1 foot, the tallest miniature skyscraper towered 40 feet, representing a scale height of nearly 2,000 feet. This sprawling miniature city landscape featured 250-story skyscrapers, airborne traffic cops, and a midtown canal for ocean liners. Effects director Ralph Hammeras spent $250,000 and took a full 14 months to create his vision of the future. Just imagine what that undertaking would cost today! (Though *Just Imagine* was a flop for Fox and is rarely seen today, footage of the future city appeared as stock footage in Buck Rogers and Flash Gordon serials during the 1930s, which still make fairly regular appearances on television's late-night movies.)

To modern eyes, the futuristic New York cityscape of *Just Imagine* looks like a model. Today's audiences have seen plenty of real cityscapes in films, and the model photography in Fox's futuristic musical doesn't compare to real photography. There are situations, however, in which audiences accept model photography because they do not have the real thing with which to compare it. This is true for the space sequences in the *Star Wars* films and other similarly accomplished films. We haven't reached the time when we can send a film crew into orbit to photograph ships and actors in space. And where could the Disney studio have rented a quarter-mile-long spaceship, which the script of *The Black Hole* (1979) called for, or the *Star Wars* (1977) crew an entire planet to vaporize?

Our notion of what looks real in space will change, as we begin to see more and more real movie footage from space. In fifty years the *Star Wars* models may end up looking just as quaint as Buck Rogers does to us today. Special effects artists thrive on fantasy and science fiction, as so much must be created wholly from the imagination. Such famous sequences as the landing of United Planets Cruiser C-57D on Altair IV in MGM's *Forbidden Planet* (1956); the destruction of Los Angeles by alien machines in *War of the Worlds*, George Pal's film of the famous H. G. Wells story; the destruction of the entire world in Pal's earlier film for Paramount, *When Worlds Collide* (from the novel by Edwin Balmer and Philip Wylie)—all have been given cinematic reality by skillful modelmakers and special effects crews.

Sometimes judicious intercutting of miniatures with full-scale

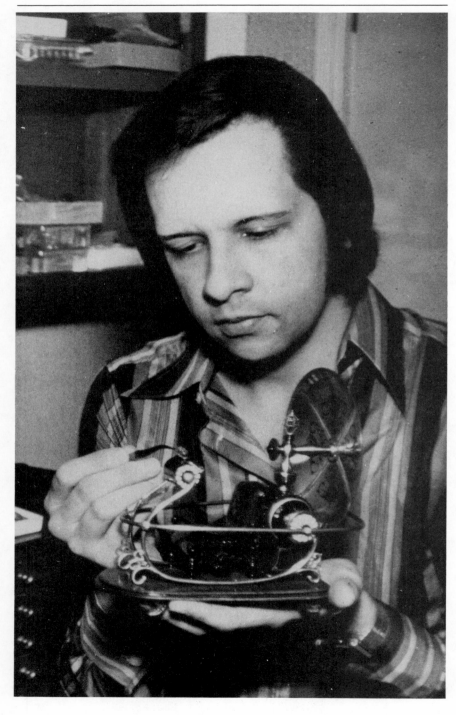

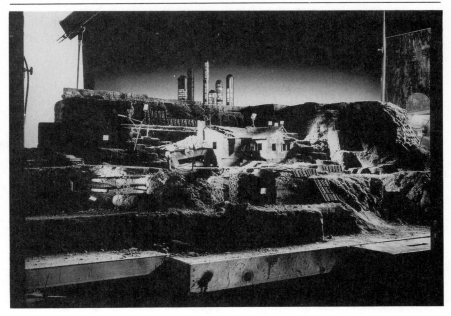

A miniature can be more than a single car or a spaceship. This model of an excavated village was designed and built by chief modelmaker. Grant McCune, in Apogee's model shop. Television commercials have reflected the trends in fantasy filmmaking and have made great demands on the skills of special effects artists. (*Photo by Michael Middleton. Courtesy of Apogee, Inc.*)

effects can increase the effectiveness of a scene. Such intercutting requires care, however, lest the full-size sequences expose the miniatures for what they are, instead of reinforcing the illusion they suggest. Miniatures are used sometimes as a cheap way to film a spectacular sequence, but they are among the most difficult of all special effects to photograph successfully. Miniatures are the ultimate refinement of the art of representational modelmaking; a successful miniature convinces viewers that they are seeing

Miniatures often come to be cherished as works of art in their own right. This reproduction of the miniature time machine from George Pal's Academy Award–winning film *The Time Machine* was created by model craftsman Harvey Mayo.

nothing but full-size reality on the screen. As miniatures must therefore be perfectly detailed, they are among the most expensive of special effects.

Precision-crafted miniatures exact so high a price in labor and talent that producers often settle for second best. The problem is that today's sophisticated audiences can spot a second-rate miniature in an instant. Audiences no longer can be fooled by cellophane laid on a studio floor, fluttering in the breeze of a fan to suggest water, or by the sponge rubber-trees and balsa wood houses featured in too many Japanese monster movies.

Modern film audiences have been intrigued by the superlative craftsmanship of Greg Jein, whose miniatures for Steven Spielberg's *Close Encounters of the Third Kind* (1977) and *1941* (1979) gained world fame. Beyond such miraculous models as the mother ship in *Close Encounters,* there were also the miniature houses created to dot a miniature Indiana landscape—houses that were less than an inch high, yet were detailed enough to show off doors, windows, and trim. But it was in *1941* that Jein was turned loose to re-create the Hollywood Boulevard of the early 1940s in miniatures that rose 20 feet in height. They were miniatures in name only—or at least only in relation to the actual buildings they represented.

Surprisingly, big miniatures are not all that unusual. True, most of us think in tabletop terms, perhaps envisioning the miniature train sets and towns that circle Christmas trees, but modelmakers will always specify that a model be built as large as is practical. Large miniatures are easier to build and easier to detail; they are also easier to light and photograph. And, as a result, they are more believable on screen.

There are some situations in which miniatures do not have to

Some models are miniatures in name only. The model buildings in this view of Hollywood Boulevard from Spielberg's *1941* are as much as 20 feet high. The effects technician in the middle of the shot gives a sense of the true scale. In general, a model is as big as the budget will allow and no smaller than is practical to work with. (*Copyright* © *Universal Pictures, a Division of Universal City Studios, Inc. Courtesy of MCA Publishing Rights, a Division of MCA, Inc.*)

be entirely believable to work. The war sequences in the Marx Brothers' *Duck Soup* (1933) use obvious miniatures and are very stagey. But this is a question of style, and the look of these effects adds to the comic impact of the film.

Outside the realms of science fiction and fantasy, disaster epics such as Universal's *Earthquake* (1974) have used some of the most sophisticated and expensive miniatures ever seen. For that film, teams of modelmakers created miniatures of existing Los Angeles buildings. Live-action photography with the principal actors on location established the reality of the landmark Los Angeles locations. Viewers could not doubt that they were seeing real actors on location in full-scale buildings. The miniature footage of the destruction sequences was cut seamlessly into the live-action footage.

Many of the models created for today's films are so handsomely crafted and so beautifully constructed that directors have actually saved them from being destroyed. Greg Jein's re-creation of the Pacific Coast Amusement Park in *1941* so captivated director Spielberg that he gave orders that certain pieces be saved from destruction during the film's climactic scene. In the film, the park is shelled by a Japanese submarine (also a miniature) and devastated by an out-of-control army tank (another miniature), but a miniature carousel with handpainted horses and miniature lights won Spielberg's heart, and it was saved from destruction.

The models from *Earthquake,* however, all met their scripted doom. (After all, the full-size buildings still exist in reality.) A particularly thrilling and effective example of the duplicate-and-destroy approach involved the Ahmanson Theater in the Los Angeles Music Center. An exact-scale replica of the theater was crafted by the studio's team of highly gifted modelmakers. First the sequence was filmed on location at the real theater, with three hundred extras running from the theater at the start of the earthquake. The camera's position in relation to the real structure was carefully noted. Its position was then duplicated in scale with the model of the theater, and the sequence of the theater model being shaken apart was filmed. On the theater screen the audience sees the three hundred extras streaming from the Ahmanson Theater. At an appropriate point a cut is made, and the model footage is substituted for the real theater as it is destroyed. Printed with the live extras, this destruction sequence appears very real on the screen.

Good model work belongs not only to the current generation

of supercolossal spectacles. Although modern fine-grain stock and better duplication techniques have raised the quality of the miniatures seen on the screen today, intricate and sophisticated models have always been built whenever the necessary time, patience, skill, and money have come together.

Such a fortuitous conjunction was apparent in the spectacular miniature effects that added so much to John Ford's *Hurricane* (1937), starring Jon Hall and Dorothy Lamour. This Academy Award winner used models for its climactic storm sequence, a sequence impossible to achieve under actual hurricane conditions. Lee Zavitz, who would later travel in outer space in George Pal's *Destination Moon* (1950), was called in to film the obliteration of the idyllic Manikoora by a hurricane. Even today this studio-created storm retains all its power and effectiveness. The effects sequences are among the finest that have ever been produced. To be sure, a few shots appear to modern audiences as obvious models; but this is chiefly the result of the impossibility of "miniaturizing" water.

The art of miniaturizing landscapes and buildings has been with us for a long time, but whenever water is introduced into a sequence, difficulties arise. The principal problem is the necessity of overcoming the surface tension of water. Droplets, spray, waves, and foam refuse to reduce their physical scale in relation to the model being photographed. Chemical agents, added to the water to lessen the effect of surface tension, have a slight miniaturizing effect on water droplets and spray, but the usefulness of such additives is limited. A miniature water sequence usually can be spotted immediately for what it is.

For a sequence involving water, there are two approaches that can minimize the scale problems: film the sequence at night (shooting day for night) to minimize the amount of visible detail, or build as large a model as possible.

Earthquake used both of these techniques for the dam-break sequence. The sequence was shot darker than normal so that the night effect would obscure some of the problems created by the physical properties of water. The model was built 56 feet across. The scale selected by special effects cinematographer Clifford Stine was 3/4-inch to 1 foot.

To some extent, the scale of the model governs the speed of the camera. Motion pictures are normally shot at a rate of 24 frames per second. The standard projection speed in American theaters is also 24 frames per second. Thus, what you see on the

screen is exactly what you would see if you were standing next to the camera when the shot was made.

But what happens if the camera operates at a speed other than 24 frames per second? Suppose the camera operates at twice its normal speed and records a scene at 48 frames per second. In the theater, the projector is still operating at the standard 24 frames per second — exactly half as fast as the scene was photographed. The scene will appear in slow motion, objects will seem to fall more slowly than they should, and people and vehicles will appear to be moving through molasses. Time has been expanded.

From our real-life experience, we associate speed with object size. For example, a 2-inch wave traveling at its normal speed but photographed at four times its normal speed will appear to be approximately four times larger. The 56-foot miniature of the Hollywood Dam in *Earthquake* was one-sixteenth of the dam's actual size, necessitating a camera speed of at least 96 frames per second instead of the usual 24. The rule of thumb: camera speed equals the square root of the scale. The square root of 16 is 4, and so the one-sixteenth-size Hollywood Dam required a camera speed four times faster than normal. This is not a firm rule, but is a starting point for the special effects cinematographer. What looks "right" on the screen may not necessarily be mathematically correct.

In the case of the Hollywood Dam sequence, nine cameras were used to record this "one-take" situation, rolling at speeds of from 96 to 120 frames per second. Effects veteran Clifford Stine was coaxed out of retirement and credited as Miniature Cinematographer. It was Stine who determined such critical factors as camera placement, speed, and angle. He positioned three cameras up close to the dam itself, where the action of the water was traveling cross-screen; these cameras were turning at five times their normal speed. Halfway down he had another camera shooting three-quarters into the ravine and turning at four times the normal speed because the water was moving straight toward the camera. (Whenever an object is coming toward you or away from you, it has a feeling of speed different from the speed of an object going cross-screen.) The variety of camera angles and speeds under Stine's direction produced quite satisfactory results on the screen.

To overcome the difficulty of shooting water in miniature, Stine directed that the miniatures be constructed on the largest

scale practical. Nevertheless, although one-sixteenth is considered to be the smallest practical scale, the immense size of the Hollywood Dam sequence forced construction at that scale in order to hold down costs.

The appropriate scale cannot be determined by absolute formulas. There are no hard-and-fast rules in the special effects business—only guidelines based on years of experience.

The problems involved in getting water to behave appropriately at various scales have led some ingenious filmmakers to use substitutes. In *Raise the Titanic!* (1980) salt was used to suggest foaming, churning water around the miniature of the *Titanic*. In *Ghostbusters* (1984) a miniature fire hydrant spewed fine sand instead of water, but the effect on the screen is much more realistic than if real water had been used.

Scaling miniatures sometimes involves more than working with factors of relative speed and size. It may also be important to scale the *weight* of the object.

Automobiles and trains involve a relationship of weight to size. A large car, say, 18 feet in length, weighs at least 3,200 pounds. Scaling this down to one-sixteenth normal size gives the miniature a required weight of 200 pounds and a length of 13½ inches. But there is obviously no material available that can be shaped into the form of a model car measuring 13½ inches long and weighing 200 pounds. Therefore, to honor the laws of physics, a larger scale must be used. Building a model one-quarter of full size is practical. The reason so much importance is placed on the laws of physics is that if the car is too light when it crashes into a wall, it will bounce back in a very unrealistic manner. The quarter-size miniature will still have a big discrepancy in the weight-to-size ratio, but the fact that the camera will be *overcranking* (see Glossary) will cover enough of the fault to make the action believable.

Large miniatures add more to the cost of a film. They take up studio space and take longer to build. Still, a model will usually be built as large as can be logistically and economically managed. If the model's size and the amount of detailing are kept within manageable limits, costs will be manageable as well.

The space freighter *Valley Forge* in Douglas Trumbull's *Silent Running* (1971) is a good example of a highly detailed model. Inspired by the Expo '70 tower in Osaka, it was constructed of steel, Plexiglass, and plywood, and thirty technicians worked for eight months before the delicate detail met Trumbull's exacting

specifications. The 26-foot structure ended in a cluster of greenhouse domes 2 feet across, made of blow-molded acrylic plastic. The domes were drilled in a geodesic pattern and rigged with three layers of copper wire to simulate the tubular steel framework of a full-size geodesic dome. External details, glued on piece by piece, were scavenged from 850 plastic model kits of a German army tank. The miniature detailing of hatches, doorways, and equipment enabled Trumbull's cameras to work very close to the model without losing the feeling of authenticity: Stretching 26 feet across the studio floor, the *Valley Forge* looks half a mile long on screen. This same detailing technique was used again by Trumbull's shop for the creation of the mother ship in Spielberg's *Close Encounters of the Third Kind* (1977).

In contrast, too much detail can detract from the feeling of authenticity, particularly in the case of landscape miniatures, in which the human eye is accustomed to seeing diminishing detail toward the horizon. This is due to the eye's inability to resolve fine detail at great distances and to the effects of atmospheric haze.

A model landscape in a studio will photograph razor-sharp from foreground to background unless special precautions are taken. One of the methods used to simulate this loss of detail at receding distances is the use of diffusion filters over the lens of the camera. These impart an effect of atmospheric haze by decreasing contrast and softening edges. Unfortunately, they impart the same degree of softening to everything in the frame, so they must be used selectively.

Alternatively, special machines can be used to lay down a layer of fog over portions of the set. Under certain conditions such fogging can appear quite realistic. The difficulty lies in controlling the artificial vapors, since any movement of air can blow the fog into the wrong areas of the studio or completely off the set. Further, the density of the vapor fog must be kept consistent over a long period of time.

In other cases, particularly with large studio landscape miniatures, large sheets of scrim (a very sheer fabric used mostly in the theater for stage effects) can be stretched across the portions of the set that represent more distant vistas. Any material that acts as a mild diffuser can be used as scrim—wire mesh, spun glass, fine silk, or sheer cotton fabric. If the miniature set is large enough, or if it encompasses a very remote vista, a number of layers of scrim can be used on successively distant portions of the set to soften

edges and flatten out contrast. If a number of successive scrims are used, they must be stretched and lit very carefully, and the air movement in the studio must be controlled to prevent them from fluttering. Movement of scrim material produces a series of moire patterns (wavy ripples, as in watered silk) in the background of a shot, detracting from the reality of the scene and creating an undesirable "pop art" look. The time-consuming scrim technique requires great care in lighting as well.

Doug Trumbull has been a pioneer in achieving scaled atmospheric effects by carefully fogging an entire miniature stage. His theory is that if you are working on a one-sixteenth scale, the atmosphere should be sixteen times "dirtier" than normal. This technique was made famous in Spielberg's *Close Encounters of the Third Kind* and used again in *Blade Runner* (1982) to create the thick atmospheric effects of a futuristic Los Angeles. Director-cinematographer Peter Hyams (*2010, The Star Chamber, Outland*) likes the atmospheric effects of smoke so much that he even uses a very thin veil of smoke on his live-action sets. Combined with backlighting and diffusion filters, this technique gives Hyam's movies his trademark atmosphere.

For model photography, special smoke studios are constructed. The smoke generator must have very precise controls so that the amount of smoke in the air can be monitored and regulated. Smoke photography also requires the use of robot cameras, since human technicians would do their lungs no good by working in a studio with an atmosphere sixteen times dirtier than usual.

A smoke studio has even been used to simulate the murkiness of the ocean floor. For *Jaws 3-D* (1983) the underwater models were shot "dry" by working in a heavily smoked studio. Fish and bubbles were added later by matting processes.

A technique that dates from the very earliest days of filmmaking and is still used from time to time in Britain, or on low-budget underwater fantasies to avoid postproduction matting of fish and bubbles, is to shoot the scene through a narrow fish tank placed between the miniature underwater set and the camera. Through the camera lens the dry miniature set appears wet and inhabited by fish. This technique gives itself away when the tank is too close to the camera, in which case the fish are always out of focus, and the set looks as if it were inhabited by giant guppies.

Sometimes it is desirable to use more than one scale on the same set. This is most often true with landscape miniatures, but it

has its application for full-size sets as well. Miniature sets can be built entirely on a single scale or they can be of mixed scales. A single-scale set has its own natural perspective and can be photographed from a variety of different angles and points of view. Since every object is built to the same scale, the perspective will be correct from whatever position the camera takes.

Sometimes it is necessary to *force* the perspective of a miniature, so that there will be a greater illusion of depth than would normally be permitted by the scale of the model within the confines of the studio space. Clifford Stine used this forced-perspective technique in *Earthquake*. In the foreground of several shots, the famous Capitol Records Building is visible. This was a model built on a scale of 3/4 inch to 1 foot. Very-small-scale miniatures were placed approximately 50 feet beyond the Capitol Records model to produce an apparent depth of about a quarter of a mile. Beyond that the actual skyline of the valley was visible, tying models and reality together in a single shot.

Such mixed-scale or forced-perspective sets can be photographed only from a very limited number of camera positions. In fact, the greater the mixture of scales used to force the perspective, the closer we get to having only one usable camera position.

Forced perspective is used from time to time on full-scale sets as well. In Paramount's *Star Trek* motion picture series, the engine room of the *Enterprise* was made to appear twice as long by using forced perspective. In this case short actors were called upon to man the rear of the set in order to give the illusion of being farther away from the camera than they actually were.

Sometimes these forced-perspective tricks involve studio situations. In *Arsenic and Old Lace* (1944), mixed-scale miniatures were used to create a city background, complete with trains and skyscrapers, in a very small space.

Sometimes a model ship is built in two or three sizes. The submarine *Nautilus* in Disney's classic *20,000 Leagues Under the Sea* (1954) existed as a full-scale mockup 200 feet long and 26 feet wide as well as in a half-dozen scale models ranging from 18 inches to 22 feet long. These were used in a variety of situations, such as the destruction of the frigate *Abraham Lincoln* (also a model) by the *Nautilus* and the *Nautilus* traversing its underwater cave.

Harper Goff, the production designer of the *Nautilus*, said that a very special forced-perspective model of the submarine had to be built for some of the underwater model sequences. Appar-

ently, close-up photography with the early CinemaScope lenses was a problem (*20,000 Leagues* was only the second CinemaScope feature to go into production), so a special "squeezed" version of the submarine was constructed. This special model could be filmed with normal lenses. In the theater the CinemaScope projection lens "unsqueezed" the model so that it matched its properly proportioned counterparts.

Most forced-perspective work involves placing smaller-scale models in the background to extend the illusion of depth. A variation of this technique places the miniature in front of the full-size set. In this method, known as *hanging miniatures,* a miniature is suspended between the camera and the full-size set; the miniature thus extends the full-size set. Usually this is done to add a second, third, or fourth story to a set in a studio that has room for only one story. The miniature must be placed so that its lines of perspective match the lines of perspective of the full-size set that it is supposed to complete. The technique was very popular in the 1930s, and fine examples of it can be seen in H. G. Wells' *Things to Come* (1936). More recent examples include *Beastmaster* (1982) and *Conan the Destroyer* (1984), in which exotic locales are created in miniature and photographed on location with the live action. This can be a very successful in-camera technique, since there are no telltale matte lines or poor matte paintings to spoil the illusion.

The hanging miniatures technique saves money on set-construction costs (it is much cheaper to build the upper story of a building in miniature than in full size), but setting it up in the studio is very time-consuming. As a result, the technique has largely been supplanted by even more economical optical compositing methods. It is still used from time to time, mostly by effects artists who are infatuated by its magic.

2 Frame by Frame: Model Animation

LET'S SET THE dials of our "way-back-when" machine to the year 1922, when the world was a much larger and more mysterious place. Even by the fastest means, it took three days to travel across the United States. Africa was a land of mystery, a vast blank on the map marked "Unexplored." And magic was still alive.

The fad of spiritualism was indicative of the times. One of its leading proponents was Sir Arthur Conan Doyle, who had dedicated his life (apart from writing Sherlock Holmes mysteries) to establishing "the reality of the spiritual world."

Sir Arthur's archenemy in this respect was the master magician Harry Houdini, who had dedicated *his* life (apart from performing feats of magic) to unmasking mediums and exposing séances—which were then all the rage—as frauds.

This rivalry is perhaps one of the strangest examples of role reversal in history. Sir Arthur's most famous literary creation was Sherlock Holmes, that steadfast bulwark of reason and intellect. Harry Houdini, the peerless master of all forms of legerdemain, made his living by hoodwinking the public in a grand and glorious manner. Yet here was the mysterious magician dedicated to exposing phony mediums and the master of reason waging a crusade for spiritualism. World-famous in their respective professions and hobbies, the two were constantly at loggerheads.

In June 1922 Houdini invited Sir Arthur to a meeting of the Society of American Magicians. Sir Arthur, who had been ridiculed for his belief in psychic phenomena, saw a chance to pay back his adversaries. Some time earlier he had sold the film rights to his novel *The Lost World*. A relatively unknown special effects artist named Willis O'Brien had completed a test reel for *The Lost World*—several sequences of dinosaurs fighting in a lush prehistoric setting. So Sir Arthur set off for the meeting with the test reel under his arm, confident that he would be able to pull off a

little magic of his own before an assembly of the world's greatest magicians.

Instead of the little stir Sir Arthur planned to create among his critics that night, pandemonium ensued. The following morning a front-page story in the *New York Times* proclaimed:

DINOSAURS CAVORT IN FILM FOR DOYLE
Spiritist Mystifies World-Famed Magician
With Pictures of Prehistoric Beasts.

KEEPS ORIGIN A SECRET
Monsters of Other Ages Shown, Some Fighting,
Some at Play, in Their Native Jungles.

Aside from some early pioneering efforts by the legendary Georges Méliès and a few others, model animation as a cinematic technique was virtually unknown in the early 1920s. *The Lost World* made its debut in 1925 and is generally credited as the first feature-length film to depend on model animation. *King Kong* in 1933, the classic tour de force of the process, established Willis O'Brien as the reigning king of the technique that he popularized.

Model animation is still in use today. It is common in children's puppet fantasies, TV commercials, and even a few feature films. What exactly *is* model animation, this technique that brings miniature dinosaurs, clay figures, and puppets to life?

Ray Harryhausen, O'Brien's assistant in his later years and acknowledged current master of the process, explains model animation as basically three-dimensional, stop-motion photography—single-frame work. *Stop-motion* animation involves the creation of apparent motion by taking a series of still photographs of lifelike miniatures, changing their positions minutely for each photograph, and then projecting the photographs as a motion picture.

In this context, "three-dimensional" refers to the models being photographed, not to a 3-D photographic process. Whereas cel or cartoon animation involves two-dimensional drawings, model animation uses three-dimensional models. This is what makes the process seem so lifelike, and it is the reason Houdini and others were baffled by O'Brien's dinosaur reel in 1922.

Model animation begins with the design and construction of the model to be animated. It can be built to resemble either an existing creature or, more often, creatures of the scriptwriter's

Hand puppets or rod puppets can sometimes be substituted for stop-motion animation. This groundhog puppet is being filmed by Doug Smith of Apogee for *Caddyshack* (1980). (*Copyright © Apogee, Inc.*)

imagination. Existing creatures are rarely subjects for model animation, because they can usually be filmed more effectively and more cheaply in live-action sequences.

The scriptwriter determines the physical description of the model and the extent of its physical activity in the story. After a script is approved, the production designer produces a *storyboard,* a series of detailed sketches illustrating the key scenes in the film. These sketches portray the model or creature at the key moments of mood or action called for in the script.

After the sketches are approved by the producer, the general "look" and visual mood of the film are decided upon. The production team will refer to the sketches time and time again during the next stage of production so that they will not deviate from the visual concept the sketches portray. (Such sketches are as visually stunning and dramatic as possible, since the producer also uses them to raise money for the project.)

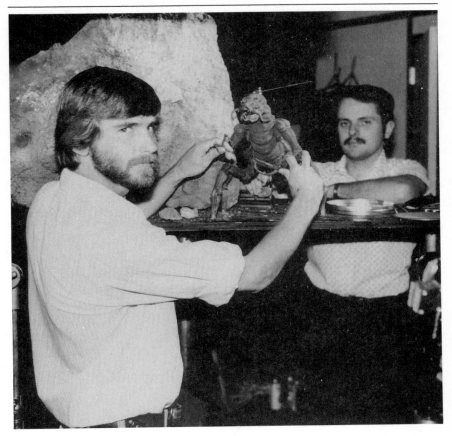

Animators Stephen Czerkas and James Aupperle animate an alien creature frame by frame for the live-action television series *Jason of Star Command,* produced by Filmation. (*By permission of Filmation Associates*)

From this pre-production artwork, the art director produces a series of continuity drawings, and the model animator produces a series of model sheets or a "sketch" in clay. Sometimes these tasks are handled by the same person (Ray Harryhausen does both), but often they are executed by different individuals in different departments of the production company.

A model sheet consists of a series of drawings depicting the animated character in a variety of poses and moods. These de-

tailed illustrations determine how the model will move as a character—how it will express itself physically and what its range of movements will be. The model sheet is similar in principle to the model sheets used for cel animation in a cartoon.

Continuity sketches are a series of drawings made for each scene in the film and very often for each camera shot of a difficult sequence. Continuity, or storyboard, sketches show what action is to be filmed; which parts of the shot will be live-action and which will be model animation; which parts of the shot will be full-size and which will be miniature; what processes (traveling matte, perspective shot, glass shot, rear-screen projection) will be used to achieve the shot.

The importance of complete continuity sketches to the success of a production that involves extensive special effects work cannot be overemphasized. Weeks, months, and sometimes years will separate the filming of the live action from the special effects that must be created. Continuity sketches tell the actors and the director what is expected of them in any given scene, since the giant crab, raging dinosaur, or tiny princess isn't actually there for the actors to work with when the scene is shot. In addition, such sketches enable the production manager and producers to construct an accurate budget, draw up a production schedule, and know in advance what equipment will be necessary for each shot.

Once the continuity sketches and model sheets have been completed, the first rough three-dimensional model is sculpted in clay. After approval (perhaps after a single try, although sometimes after many have been submitted), a skeletal structure is designed and constructed, usually of ball-joint sockets and rod-and-bar stock in machined steel and aluminum alloy. Some of Harryhausen's boyhood models were constructed of wooden-jointed armatures, with swatches of his mother's fur coat to finish the exterior.

Nowadays armatures are almost always constructed of metal for strength, and they have ball-and-socket joints that can approximate the movement of the ball-and-socket joints of actual bone skeletons. Some parts of the armature may simply have a wire core that can be bent into any required position. Wire-armature work is used for lips, finger tips, and similar areas for which machined ball-and-socket joints would be too difficult or expensive to build. But there are no rules about this. The degree of sophistication and the amount of engineering time spent on the

skeletal structure are largely a function of the demands of the continuity sketches. You don't build more than you have to.

The hero of *Mighty Joe Young* (1949) had an extremely dextrous skeletal structure (four models were produced for the film, each about 12 inches high), machined by Harry Cunningham. In the interest of realism, care was taken to duplicate the actual skeletal joints of an ape. Even the joints in the fingers were fully articulated.

This care pays off in many sequences, often with comical, though wholly appropriate, results. Near the end of the film, just before the famous burning-orphanage rescue sequence, Joe is being hurried away from police by his rescuers. The police have a court order to destroy the "beast." After finally eluding his pursuers, Joe is seen seated on the tailgate of the escaping truck, watching the pursuing police cars slowly disappear into the night as the truck speeds Joe to freedom. We see Joe smile and nonchalantly look around, enjoying the passing scenery, while *drumming his fingers on his knees.* Stop-motion animator Pete Peterson is credited with this sequence.

Drumming ones fingers may be a simple action for a human actor or a man in a monkey suit, but it is extremely demanding

Inside every puppet is an armature, usually with ball-and-socket joints. This armature is for a small dinosaur on the television series *Land of the Lost*. Animation by Gene Warren's studio. (*Courtesy Gene Warren*)

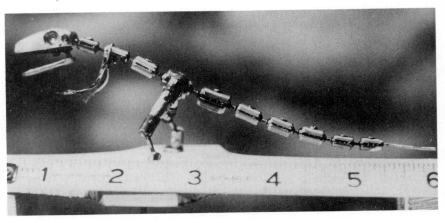

work for a special effects model animator. Oddly human, completely convincing, and utterly delightful, that single shot never fails to elicit an immediate response from the audience. That single moment of Joe's cool triumph probably took O'Brien and his staff all day to film—one frame at a time.

Such convincing action depends not only on a finely crafted skeleton but also on the "muscle and tissue" construction of the creature as well. Marcel Delgado built Joe Young muscle by muscle with such elementary materials as cotton, liquid latex, and dental wax in an attempt to create the illusion of physiological reality—muscles that would flex and stretch on the precision armature.

A less time-consuming (and therefore money-saving) method is to use the clay model to create a mold, from which a latex model can be cast to fit over the armature. Such foamed-latex castings, while infinitely cheaper, have a considerably different look than models produced by the cotton and liquid latex method. Sometimes modelmakers apply sheet foam rubber directly to the armature, building up the body with carved and cut pieces of foam rubber rather than casting it in foamed latex. The choice of methods is dictated by the demands of the script and the budget.

All the time, money, and effort in the world can be poured into the production of a lifelike flexible model, but unless the model is photographed properly and animated believably in a realistic setting, the effort will have been for naught. Not only must the model be believable, but so must the model creature's setting. This is particularly important in films that mix full-scale live-action photography with model animation. Exotic, out-of-the-way, but very authentic-looking locations (such as the ancient city of Petra in *Sinbad and the Eye of the Tiger* [1977]) are a hallmark of Harryhausen's work, while Gene Warren's tabletop sets for the old television series *Land of the Lost* are remarkable for their breathtaking beauty and demonstrate his expert use of studio lighting to simulate an outdoor environment. *King Kong* (1933) made use of tabletop miniature landscapes interspersed with scenery painted on glass to achieve an exotic yet realistic effect.

Such a process is extremely expensive in an inflation-ridden industry. The "golden-age" of the big studios occurred during the depths of the Depression, when the vast studio facility with its extravagant teams of matte artists and special effects technicians came more cheaply. Today it is a thing of the past, the stuff of

stories about "the good old days." *King Kong*'s luxuriant jungles, towering cliffs, and plunging gorges were the careful work of Mario Larrinaga and Byron Crabbe, who produced both the preliminary sketches and the final glass paintings. Sometimes as many as three layers of glass paintings, sandwiching miniature settings with a painted backdrop, were used to convey the prehistoric lushness of Skull Island.

Miniature settings, which are usually built on three-foot-high platforms and can cover thousands of square feet, must be photographed from a carefully selected angle if they are to have a chance of appearing realistic. The camera lens is usually only an inch or two (sometimes less) above the surface of the table. The camera must be positioned low enough to achieve the proper scale and perspective, yet high enough so as not to pick up the edge of the table. Willis O'Brien relied on glass paintings to disguise the table edge, and some designers have built tables with sloping surfaces. When the model landscape has been built on the studio floor, camera operators have often resorted to photographing a *reflection* of the set from a mirror placed on the floor of the set, so that the camera works like a periscope. Generally, though, it's less awkward to get things off the floor if at all possible.

Certainly there is more than one solution to any animation problem. O'Brien was among the first to state that there are no set rules or methods to his art. Each situation requires a fresh approach, and experience is the only teacher.

Gene Warren, a stop-motion artist who worked on such fantasy films as *Kronos* (1957), *The Time Machine* (1960), and *The Wonderful World of the Brothers Grimm* (1962), as well as TV's *Land of the Lost,* produced some of the most detailed and realistic settings for his models ever seen. He was able to use materials not available in O'Brien's day, such as real-looking plastic shrubbery and foliage.

Imagine for a moment that you are Willis O'Brien, working in your studio on an animation sequence. Let's be extravagant. You've got a tabletop miniature with a painted backdrop and glass paintings in the front to mask the table edge. The lights are bright and hot (since miniature photography demands an enormous amount of light), and the air is still (since a breeze from a fan would move your foliage from one frame to the next and spoil the sequence). If all goes well today, you will get about 8 feet of film exposed (one frame at a time), which is about 128 frames or about 5½ *seconds* of screen time in the theater.

A glance at the timing sheet tells you that fierce tyrannosaurus *A* must take a bite out of dying triceratops *B*. The models have been secured in the positions in which you left them yesterday. You have made careful notes marking the direction in which each creature was moving before you stopped work for the day.

Your camera is securely mounted on a tripod that is bolted to the floor so that it will be in the correct position and will not creep around the studio floor powered by stray vibrations or careless kicks. Racking the camera over to the viewfinder, you line up the next shot. Your notes from the previous day confirm that dinosaur A had been slowly moving in for the kill on dinosaur B and that dinosaur A's left foot was just about to take a step.

Stepping around to the side of the table, you reach behind the glass foreground and open dinosaur A's mouth a little wider, move the head the tiniest fraction of a millimeter closer to the exposed body of the defenseless dying dinosaur B, and make a tiny upward movement of dinosaur A's left hind foot.

The electrician turns on the lights as you prepare your first shot. (The bulbs are changed daily, before or just after a session, to avoid a burnout in the middle of a sequence that might go unnoticed and to prevent the shift in color that occurs as lamps slowly "age.") It will take about 4 or 5 hours to expose the day's 128 frames. During this time, a color shift in the lamps would not be noticeable to the human observer in the studio. On the screen, however, any shift in color would be *very* noticeable, because of the fact that 128 frames go by in about 5 seconds.

After your models are positioned for the next exposure, you double-check the lens setting, making sure it has not been disturbed, and then hit the foot pedal, which opens the shutter to expose your first frame of film for the day. After the exposure, you make a mark on the timing sheet beside you and step around the set to adjust the model dinosaurs for the second frame.

Routine . . . so far.

As the work proceeds smoothly, you feel satisfied that the shot will be in the can and will look pretty good. But somewhere on the background of your stunningly realistic set, a live miniature primrose begins to bloom! The primrose goes unnoticed as it slowly opens.

The damage is done. The sequence comes back from the lab the next day, and as you sit in the screening room proudly watching the extra-dramatic way you have gotten the mouth of dino-

A closeup view of the animator's work. Little Dopey, of *Land of the Lost,* has gotten stuck in a tar pit. The animator is animating not only the dinosaur but a wire-loop rope, which is being used as a lasso to rescue the cute little fellow. (*Courtesy Gene Warren*)

saur A to open and sink its teeth into dinosaur B, someone shouts, "Hey! Look at the magic flower." And sure enough, there, through the magic of time-lapse photography, you watch a now not-so-tiny primrose burst into full bloom. All your fierce tyrannosaurus action has been upstaged by a plant. The sequence must be scrapped and completely redone. Farfetched? No. This actually happened to Willis O'Brien long ago, in that "golden age" of moviemaking.

Today, live foliage is almost never used for special effects, since realistic foliage is readily available in plastic and cloth. The

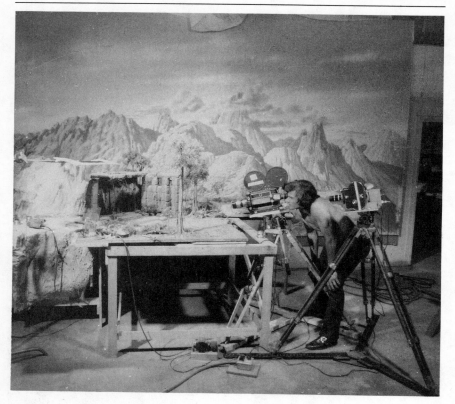

This is Dopey's world: the tabletop miniature upon which Dopey and the other dinosaurs in TV's *Land of the Lost* series are animated. Animator Gene Warren, Jr., is at work. (*Courtesy Gene Warren*)

fake foliage is impervious to temperature and humidity, it doesn't fade, and it doesn't grow.

Also, much less lamp-changing is done today, now that the old incandescents have been replaced by modern quartz halogen lamps. These modern lamps last much longer and do not cause color shifts as the bulbs age.

When live action must be combined with model animation, as in a scene calling for a fight between a dinosaur and a live actor, two general approaches must be considered. Either the live action is filmed first and the model animated creature is inserted later, or vice versa.

Ray Harryhausen, whose name has become synonymous with fantasy and model animation, usually films the live action first, with giant cardboard cutouts standing in for the fantasy creatures on the live-action set, giving the actors something to work with on the set. Gene Warren, for *Land of the Lost*, shot the model sequences first on a tabletop set and inserted the live action later with video's chroma-key process.

In the early days of *King Kong*, a common solution to the live-action-with-model problem was to project the model animation from behind a screen that served as a backdrop for a live-

The hand of the animator reaches down into the miniature tabletop world in order to make a minute change in the position of the puppet. The illusion of motion (and life) is created by changing the puppet's position very slightly from frame to frame so that, when the film is projected, the puppet seems to move just as a living creature would. (*Courtesy Gene Warren*)

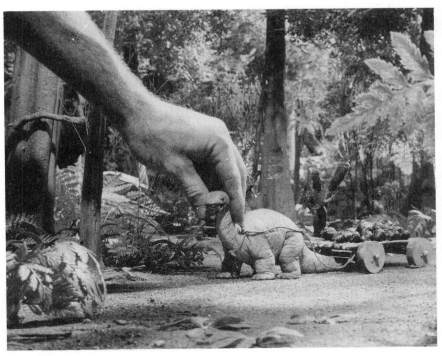

action full-scale set. The rear-screen projector and the live-action camera were electronically linked so that the projector shutter and camera shutter were both open at the same time. The live action was staged in front of the screen, and the two sequences were photographed as one.

Alternatively, when glass paintings were used in miniature settings, an area of the glass could be painted black so that live-action footage could be superimposed in the black area after the model sequence was completed. This was one early method of achieving a large-scale dinosaur fight to the death, with live actors double-exposed into the blacked-out portion of the miniature set.

A technique more commonly used today for combining live action and model animation involves a process known as miniature *rear-screen projection.* Here the live action is photographed first, with the actors and director referring to continuity sketches so that they can more easily perform in a given scene. Harryhausen's cardboard cutouts of his fantasy beasts help maintain the scale of the creature and give the actors something to look at. The actor needs a physical guide to match eyelines between the live-action footage and the miniature shots to be inserted later.

After the live action is satisfactorily photographed, the footage is projected one frame at a time onto a miniature screen that forms the backdrop to the miniature set. The live action is then rephotographed with the miniature as it is animated frame by frame, and thus is created the illusion of interaction between the model and the live actors.

Harryhausen has considerably refined this technique so as to make his animated models appear to be within a live-action scene. The live action is rear-projected as before on a miniature screen behind the model. The model is photographed full-length, and no attempt is made to hide the edge of the tabletop. That portion of the rear-projected plate that was blocked by the table edge is optically superimposed over the table edge. This, in effect, causes the animated model to be *sandwiched* between a rear-projected plate and an optically matted foreground lifted from the rear-projected plate.

The process is slow and requires many tests for density matching, illumination, matte registrations, and color balance, but new methods and streamlining techniques are being developed every day to deal with new problems.

Sometimes the opposite of rear projection—*front projection*—is

W.H. O'BRIEN
MEANS FOR PRODUCING MOTION PICTURES
Filed April 16, 1928

Fig.1

Feb. 14, 1933

1,897,673

Willis O'Brien's patent illustration for his miniature rear-projection system. Live action is projected, one frame at a time, from the projector at left onto the process screen in the center. The action is rephotographed along with miniature foreground figures and glass paintings by the camera at right.

used to insert model creatures into a live-action scene. In this case the rear-projection screen on the tabletop miniature is replaced by a highly reflective silver screen. The projector is moved from the rear of the set to the front. The projector lens is aligned to the same optical axis as the camera by means of a beam splitter. One of the advantages of front projection is that it enables technicians to photograph a sharper image. The translucent rear-projection screen has its own characteristics that are photographed along with the image; these undesirable features are eliminated in front projection.

Harryhausen remains the dean of model-animation artists in the United States and England, and perhaps the rest of the world as well. With more than forty years in the practice of this meticulous art, and more than fourteen feature films and several short subjects filled with fantasy stop-motion effects to his credit, it is amazing that he has yet to be honored with at least an honorary Oscar. Many an animator and special effects artist today refer to the moment of wonder they experienced on seeing a Harryhausen fantasy for the first time.

One scene in *Sinbad and the Eye of the Tiger* (1977) especially shows off Harryhausen's unique mix of dramatic animation and brilliant technique. The sequence takes place in Sinbad's tent. A treacherous witch, Zenobia, causes a demonic ghoul to rise slowly from the campfire in Sinbad's tent. The ghoul grasps a burning branch and attacks Sinbad, who must battle for his life.

To film the sequence, Sinbad's fight moves were very carefully choreographed. The cameras rolled with Sinbad going through the motions of the fight, as if the ghoul were there. Next the set was draped totally in black velvet. A stuntman, dressed all in black, played the role of the ghoul by following a complementary choreography. Since both set and stuntman were dressed in black, only the flame of his torch moving in the air appeared on film.

Months later, Harryhausen animated his miniature ghoul by matching, frame by frame, the position of the live action torch flame with his stop-motion animated ghoul. A pretty neat trick!

It was *King Kong* that awakened Harryhausen's own fascination with model animation. In 1933, when he was only thirteen, his aunt took him to see the film, which was playing at the fabulous Grauman's Chinese Theater in Hollywood and was being advertised as "the Eighth Wonder of the World." The plaza in front of the theater was decorated with a full-size moving bust of Kong himself set among live pink flamingos in a jungle setting. *King Kong* was the first feature sound film to use model animation and the first for Willis H. O'Brien, the film's technical effects wizard and animator.

All the mystery, magic, and spectacle of that afternoon worked together to establish the direction of Harryhausen's life. With a borrowed 16mm camera, he began experimenting with stop-motion animation. His model was a "cave bear" with fur snipped from his mother's fur coat. The results of his first experiments only whetted his appetite for more. Looking for a way to develop

H.M. DAWLEY
ARTICULATED EFFIGY
APPLICATION FILED FEB. 26, 1920

Fig.1

INVENTOR
Herbert M. Dawley,
BY
Frautzel & Richards,
ATTORNEYS

Patented July 27, 1920 1,347,993

Animator Willis O'Brien's first film after leaving the Edison studios was *The Ghost of Slumber Mountain* (1918). Created in only three months on a budget of $3,000, the film grossed a very respectable $100,000. The producer of the film, Herbert M. Dawley, patented the articulated armature that was built for the model dinosaurs used in the film.

a hobby into a career, he went to night school at the University of Southern California to study filmmaking and, in particular, special effects photography. He also took classes in sculpture, ceramics, and drawing from life.

His first studio was a corner of the family's back porch, but his father later built him a studio in the garage. By 1940 he had begun work on his first feature-length film, *Evolution,* which he hoped would find use in schools as a documentary of some sort. The project grew in scope and became too ambitious for a first feature. But today Harryhausen does not regret placing his goal so far beyond his youthful reach; he knows that you learn far more by striving for the impossible than by placing your goal too low.

Disney's *Fantasia* (1940), released at about that time, discouraged Harryhausen from continuing with the project, which he felt had been pre-empted by the Stravinsky "Rite of Spring" passage in *Fantasia.* The uncompleted footage from *Evolution* became a first "portfolio" piece, however. George Pal, who was making his Puppetoon shorts at the time, saw the footage, thought the work brilliant, and hired Harryhausen. World War II ended Harryhausen's employment with Pal in 1942; he found himself assigned to a film unit and spent the war making animated sequences for orientation films.

After the war Harryhausen had the opportunity to work for two years with his boyhood hero, Willis O'Brien, on *Mighty Joe Young.* O'Brien became so taken up with production problems that Harryhausen recalls animating 85 percent of the film himself.

Following a few lean years making fairytale shorts, Harryhausen was asked to handle the animation effects for *The Beast from 20,000 Fathoms* (1953), based on a Ray Bradbury short story. The film was produced for a mere $200,000 (which, at $10 a fathom, would make it a low-budget film even by early 1950s standards). This film was followed immediately by *It Came from Beneath the Sea* (1955), his first film with producer Charles Schneer. This "happy association," as he describes it, has lasted until the present day and has yielded *Earth vs. the Flying Saucers* (1956), *20,000,000 Miles to Earth* (1957), *The Seventh Voyage of Sinbad* (1958), *The Three Worlds of Gulliver* (1960), *Mysterious Island* (1961), *Jason and the Argonauts* (1963), *First Men in the Moon* (1964), *One Million Years B.C.* (1966), and others, right up to the MGM production *Clash of the Titans* (1981).

In all those years and thousands of feet of film, Harryhausen has animated nearly every great mythological creature from the Medusa to the Hydra, enough dinosaurs to populate a museum of natural history, and wondrous magical creatures from ghouls to skeletons. Small wonder that many young filmmakers today feel they owe a debt of gratitude to Ray Harryhausen for inspiring them in their own careers.

Moviegoers have been delighted by special moments of animation in recent films such as the tiny chessmen in that box office giant *Star Wars* (1977) and the fabulous Tauntaun in the George Lucas sequel, *The Empire Strikes Back* (1980). These films were created by a new breed of filmmakers who are building on the

films and techniques they encountered as children. In fact, Lucas has created a facility in northern California, Industrial Light & Magic, devoted solely to the production of special effects and to the development of new techniques for creating those effects.

Recent years have seen the application of computer technology to filmmaking, lessening the tedium of the mechanical business of equipment operation by turning it over to machines. Machines can be "effortlessly" precise, freeing animators to concentrate their energy on the "art" while leaving the mechanics to machines.

Dennis Muren, one of the effects cameramen at Industrial Light & Magic during the first decade of its existence, wondered how this technology could be put to use in a Hal Barwood project, *Dragonslayer* (1981). Producer Barwood knew from the start that the dragon had to be believable if the film was to work at all. "That's the key to fantasy—to make it real, to go beyond symbolism and allegory to actuality," Barwood believes.

Stop-motion photography was the first choice of Barwood and director Robbins to obtain those shots in which the dragon could appear as a miniature. Full-size effects with fire, smoke, and water required a large dragon head, a section of tail, a leg, and a wing. These were constructed under the supervision of Danny Lee at Walt Disney Productions in Burbank. The 16-foot head-and-neck assembly was designed with fully articulated eyes and jaws; Brian Johnson, supervisor of special mechanical effects, rigged the beast to shoot a 30-foot jet of flame from its mouth. It was unreliable, but when it worked, the effect was not only absolutely terrifying but truly magical—a storybook come to life.

The full-size dragon weighed more than 2 tons and had to be suspended from a 70-foot industrial crane. It was extremely effective for the master shots and at middle distance, but it would not do for small, incremental movements. Johnson and Barwood decided to turn over the production of these movements to the effects staff at Industrial Light & Magic. More than 160 composite dragon shots had to be created, which would account for only 15 minutes of screen time but on which would depend the real success of the dragon as a character—and *Dragonslayer* as a film.

Imagine Hal Barwood's surprise when the ILM team informed him that classical stop-motion work might not be good enough. It had been good enough for *King Kong,* but after *The Empire Strikes Back* was released, Dennis Muren and others at ILM began to

have doubts about using traditional stop-motion effects for modern audiences. The Tauntaun in *Empire* was ILM's first attempt at going beyond classical stop-motion animation. When live-action running or other rapid movement is filmed with a regular camera, there is a slight blurring of the image on each frame. Miniature motors in the Tauntaun model were designed to duplicate this blurring on a frame-by-frame basis; the body of the Tauntaun was blurred going forward and going up and down when it was running. The legs, however, were still animated with traditional stop-motion techniques.

Though the ILM team was generally pleased with the Tauntaun sequences when they were completed, the moviegoing public did not respond so positively; many in the audience thought the Tauntaun looked "fake." Since the Tauntaun was used in only a few early sequences, the overall look of *Empire* was not affected by this problem. But if the dragon in *Dragonslayer* looked "fake," the film would be in big trouble. At about this time Dennis Muren began to examine his perception of the stop-motion process. Many of the animators at ILM had grown up loving the classics of Ray Harryhausen and Willis O'Brien, and they were clearly biased toward the stop-motion technique. Moviegoers, however, had no reason to share that prejudice, and to many of them the stop-motion technique was not entirely believable. As *Dragonslayer* began to be more fully developed, Muren thought that perhaps Phil Tippett, one of ILM's stop-motion animators, should consider animating the dragon as a rod puppet, a technique that had been used a few years earlier in the low-budget Amicus films *The Land that Time Forgot* (1975) and its sequel, *The People that Time Forgot* (1977). Muren was not entirely happy with this idea, since for the most part the results looked terrible. But some of those cuts from the Amicus films contained moments that *did* look real.

Muren believed that rod puppets had the potential to look more realistic than models animated via classical stop-motion techniques. With puppets, the animator could achieve the same degree of control that stop-motion would provide and could more closely match the live-action photography. The setup for filming the rod puppets would be very difficult to work with, however. It would require four or five puppeteers under the table to operate the rods and intense arc lights to get full depth of field, since the camera operator would be shooting at normal speed or faster.

An alternative was discussed—putting small motors inside a puppet. But small-enough precision motors were not available and probably would not be for years to come. Even though motorizing the puppets was out of the question, however, motorizing the rods from underneath was not. At first Muren rejected the idea of motorizing the rods because too many movements were involved. Each of the dragon's four legs had to move up, down, forward, backward, left, and right. Then there were the body motions to worry about. It all added up to at least fifteen motions and ILM didn't have motion-control equipment that could handle fifteen motions. But it was a daring idea.

After the dragon had been designed, it was discovered that the wings of the puppet were so large that they blocked the legs; it would be practically impossible to move the legs of the puppet by conventional stop-motion methods without the wings being in the way. Someone would have to be under the table to move the puppet. So, Muren reasoned, as long as there has to be someone beneath the table, then maybe a system of rods should be considered after all.

Phil Tippett and Jon Berg were intrigued by the idea of a motorized rod puppet, but there was the question of getting the equipment designed, built, and working in time. Gary Leo, one of ILM's electronics people, made some modifications to an off-the-shelf Apple computer to supply sixteen channels of motion-control memory capability, enough to make the dragon look acceptably real. Jerry Jeffress, ILM's electronics chief, built special power supplies to drive each motor.

Once the motion-control system was built, the motorized rig for the puppet had to be constructed. The team decided to build a carriage with flexibility, one that could be used for any puppet. The carriage would be modular, with the motorized units assembled beneath the puppet, underneath the leg or limb to be moved. Stuart Ziff designed a carriage about 2½ feet wide and about 4 feet long. The entire assembly moved along underneath the puppet, which was about 10 inches wide and about 3 feet long. The miniature set was built around the puppet and the motorized carriage.

ILM decided to go with this untried and unproven motorized system because so much of the dragon footage would be taking place in the dark; the legs of the dragon would show, but the feet

would not. The rods of the puppet would never have to be dis-
connected; they could remain fastened to the dragon's feet at all
times.

Programming the movement of the dragon puppet with its
motorized rods is almost exactly the reverse of traditional stop-
motion. Classical stop-motion, as we have seen, requires the ani-
mator to move the model slightly, click off a frame of film, make
another tiny move, click off another frame of film, and so on until
the end of the shot. When the film is projected, the illusion of
continuous movement results. The degree of life, character, and
personality that the model or puppet achieves depends on the
skill of the animator.

With the motorized rod puppet, the illusion of movement
works in the opposite manner: rather than being moved between
frames, the puppet moves while the frame is being exposed, and
it is programmed in continuous time, although slower than it will
appear to move on the screen. The motion of the walking dragon
was programmed by Phil Tippett one step at a time with a joystick
control.

Let's say Tippett started with the left front leg. The leg had to
be programmed to move forward; then he ran that motion back
and programmed the left front leg moving left or right; then he
ran those two motions back and added the left front leg moving
up or down. He then had all the left front leg's motion done—
then had to go on to the other legs.

Tippett might have been able to use the same program for the
other legs by flopping it or running 90 degrees out of sync to
simulate a walking cycle. He had not done any motion program-
ming before, and it took him quite a while to learn the process.
Just learning to think in terms of a continuous-speed approach
took time.

In this technique one thing remains constant, and it is critical
in any kind of animation work: the image in the animator's mind.
The animator must have the talent to visualize a concept. Without
that image in mind, it doesn't matter what animation technique
you apply. You must be able to *see* it first, in your mind. For
example, Tippett studied film of lizards to get some ideas about
how the dragon should move. That's the kind of basic research
every animator must do.

This technique of motorized movement was dubbed "go-

motion," because the puppet moves during the exposure instead of between exposures. The frame rate for go-motion depends on what sort of supplementary animation is necessary. Not everything is motorized, for example. There will be times when you can shoot 8, 10, or 12 frames at a time and other times when every frame requires supplementary hand animation. The exposure per frame is about one second at f/22. Not much light is necessary because of the long exposure time per frame; something like 100 foot-candles might be enough. But that's only if you want something to be *normally* exposed, and most shots in *Dragonslayer* are anything but normal. Every shot has a special drama to it—brighter, dark, silhouetted, or employing some other effect.

At first, the *Dragonslayer* team animated only the legs and body of the dragon in go-motion. The head and neck had to be animated in traditional stop-motion, because no one could figure out how to get a rod to them that would be invisible. The first results in dailies were very disappointing to the animators. In some ways combining the two techniques looked worse than if the puppet had been fully stop-motion animated. Muren thought that the problem lay in mixing techniques. It should be one technique or the other; either an audience will accept an artificial look as part of the style and love the story, or they have to see it as real and be overwhelmed by it.

The shot that caused so much difficulty is the one in which the dragon kneels down to look at its baby; it cuts to a shot of a hand puppet (built by Chris Walas), and the hand puppet actually nudges the baby. Tippett had to do the animation shot three or four times, each time trying to cut down as much as possible on the motion of the head in order to eliminate jerkiness. The moves were very subtle, but even so, that approach was ultimately abandoned. It didn't look right and was not worth the time spent building the set and getting the scrims up in such a tight area. So the animators decided to use go-motion, with the dragon in front of a blue screen. This approach would allow them to grab the neck of the dragon with one of the motion-control rods.

In the film all those scenes where we see the head, neck, and part of the body of the dragon thrashing around were shot in front of a blue screen. The closeup shots were mostly of a hand puppet; a couple were usable footage of the full-size dragon. The scene in which the dragon walks into the cave and the camera tilts

up to Galen walking out is a full miniature shot. The head of the dragon is down toward the ground so that the rod can attach from underneath and remain invisible. Mike McAlister was the master who built the rigs for ILM and devised ways of mounting them.

Blue-screen photography presents problems of its own. Bruce Nicholson and his optical department at ILM had to create mattes that would preserve the soft-edged blurring effect of the go-motion. The optical compositing had to be handled in such a way that the dragon didn't look like a cutout pasted onto the scene. The composites also had to match the smoky atmosphere of the live-action and full-miniature-set photography.

The low-key smoky look that Derek Van Lint was using for the live-action filming in England was hard to duplicate on the miniature sets at ILM. Originally, Muren planned to use scrims on the miniature sets, as had been done on *Empire,* to suggest the atmosphere of a smoky cave. He thought he could match what was being done on the live-action set with a piece of glass in front of the camera to reflect some smoke effects back into the camera. But when Muren switched to the blue-screen process, the atmosphere problem was transferred to Bruce Nicholson's optical department.

Ultimately, the background elements were shot without smoke. For the purposes of photography, smoke is nothing more than illuminated atmosphere. To achieve this effect, the optical department "flashed" the background elements for a smoke effect. The flash was a special piece of film shot on the stage; it was a clean white field that was brighter on one side of the frame so that a directional light source could be suggested in the smoke effect.

Nicholson took those background elements and the blue screen dragon animation shots and combined them in the optical printer. That is, he took the background element with the male matte of the dragon, printed that, rewound the film, and printed a flash exposure over it. Next, the dragon was printed in, and a smoke effect was added over the dragon. The dailies were intercut with the live-action footage so that the animators could see how the smoke effect matched.

It takes a lot of discipline to maintain quality in work like this, but the results are worth it. Certainly the Academy of Motion Picture Arts and Sciences thinks so. In 1982 Dennis Muren and his *Dragonslayer* team at ILM were voted Academy Awards for scientific and technical achievement.

The development of the go-motion technique is indicative of the kind of dedication and inventiveness that is the stock in trade of a good special effects artist. Go-motion and stop-motion continue to be invaluable basic methods for the creators of motion picture illusions.

3 Matte Paintings: In-Camera Effects

THE "OLD MASTERS" had it easy. Their imaginary fairytale castles and romantic locations built to mythological proportions were just paint on canvas. The invention of the motion picture camera breathed life into the visions of nineteenth-century Romantic painters. But early film producers, eager to satisfy the public clamor for spectacle, found that they had to build from wood, plaster, and metal the objects that artists had created with paint on canvas. Whether it was Camelot or a Greek temple or the splendor of ancient Egypt, it all had to be built.

The fantasies created by motion pictures had an immediacy and impact far greater than painted depictions of similar scenes. Motion pictures were *photography* rather than paint on canvas, and were therefore more "real." With this superior sense of reality as its dominant characteristic, film reigned until it was rivaled by an even more immediate and "real" medium—television. But for at least fifty years, film spectacles were unmatched in grandeur and visual impact.

There are quite a number of landmarks in the history of the art of spectacle making in films. One of the last was 20th Century–Fox's epic *Cleopatra* (1961), which re-created the Egyptian city of Alexandria with a set that covered more than 60 acres. Samuel Bronston's production of *The Fall of the Roman Empire* (1964) called for the reconstruction of ancient Rome's Forum. The mere re-creation of history wasn't good enough for Bronston: The set was built on a scale more than twice the size of the original Forum. It covered an area of 1,312 feet by 754 feet and required 1,100 workers and more than seven months to complete.

Even filmmaker Steven Spielberg has entered the record books with his set for the UFO landing site at the climax of *Close Encounters of the Third Kind.* This set, some 90 feet high, 450 feet long, and 250 feet wide, was six times the capacity of the largest

sound stage in Hollywood. For this super-colossal vision, Spielberg found an old 10-million-cubic-foot dirigible hangar in Mobile, Alabama.

But such spectacular sets are not solely the property of big-time filmmakers; they go back to the days of the film industry's birth and to the man reputed to have invented the term "super-colossal." This was D. W. Griffith, whose towering set for ancient Babylon, featured in *Intolerance* (1916), rose 90 feet above Holly-wood. A little farther across town, in Pasadena, the medieval cas-tle designed by Wilfred Buckland for Douglas Fairbanks' version of *Robin Hood* in 1922 was 450 feet long and 90 feet high, equaling the dimensions of the *Close Encounters* set made more than fifty years later.

Not all filmmakers have such resources, however; in fact, only a very few have the box-office power to command the dollars necessary for such spectacles. To compensate, resourceful pro-ducers long ago developed the ability to suggest more than is actually there. Perhaps only a few establishing shots of a large medieval town are necessary to set the story properly; all of the other scenes can be played out on small sets. For these establishing shots, a producer turns to a matte artist. Many years ago the situation might have gone something like this.

"It's a great shot!" rumbled the rotund producer as he moved a well-chewed cigar from one side of his mouth to the other. "Too bad we can't afford it."

A young draftsman in shirtsleeves looked up from his pile of neatly arrayed storyboards for the film *The Golden Princess,* which was about to go before the cameras.

"What do you mean, we can't afford it?" asked the draftsman. "We *have* to afford it. The script clearly states in the first scene that the imprisoned princess is seen waving for help from the tower of the golden castle where she is being held prisoner by the evil sorceress."

"I mean we can't afford to build a golden castle. Do you know what sets cost these days?"

The young storyboard artists looked longingly at his fancifully detailed rendering of the wicked witch's magic golden castle. "But we can't just use some old run-down ruin. Besides, we don't need to build an entire castle—just one wall of it."

"Do you know what it costs to build location sets?"

"Well, how about a model?"

"A model? I can't afford to hire a crew of modelmakers. Who do you think I am?" thundered the producer, clutching at a chest racked by imaginary pains. "Irving Thalberg, I'm not." The producer let silence hang heavy for a few moments before deciding that his artist needed cheering up. "Nice artwork, though. Too bad we can't just use your skill . . . I'm already paying you," said the producer in an effort to shore up his artist's flagging spirits. "Of course, if we did, you'd have to paint every frame of film by hand," joked the producer.

"Paint the film?" the artist pushed a shock of red hair out of his eyes as he looked up at his boss. "I can't paint the film, but we *can* film the painting," he said breathlessly.

"Huh?" The cigar bounced in the producer's clenched teeth.

"Sure. We'll get the photo lab to make a big color print of this . . . maybe 3 feet square. Then I'll cut out the castle and paste it to a large sheet of glass. If we take the glass with the painted castle on it outside and put it in front of a camera and film it, who'll

Artist Matthew Yuricich nears completion of a full painting for the climax of *2010*. (*Photo by Virgil Mirano. Copyright © 1984 MGM/UA Entertainment Company*)

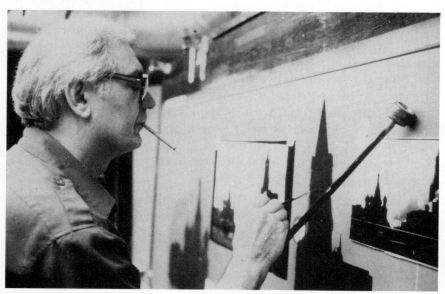

know? We can line up the glass and the camera so the castle looks like it's sitting on top of a hill. We won't have to build a thing."

The story has a happy ending, of course, The artist got his shot of the castle on the hill, and the producer stayed within his budget. This technique is called an *in-camera effect* because the entire special effect is recorded without any tinkering with the image after the film comes out of the camera. The effect is complete when the film is developed; no special laboratory process is needed. And since the image is complete on the original film, the image is of the highest quality. All work on the image "out of camera" involves duplicating the shot in order to combine it with other images—such as our castle on the hill.

Think of the difference in clarity between a typed letter and a photocopy of it. If another copy is made from the photocopy, the image quality deteriorates a bit further. If you keep making copies of copies, each generation is more difficult to read. Parts begin to vanish altogether. The page becomes speckled. What started out as a pristine letter now looks dingy and fuzzy. Somewhere along the line, somebody is going to have to retype that letter and start the duplication process over again, because eventually it is going to be unreadable.

Filmmakers have the same problem. Unless they can get the entire image in-camera on the first go-round, they will have to employ a series of copying procedures so that separate images can be combined later. Each step means a loss of quality. And, ultimately, the audience will see a very fuzzy, grainy shot on the screen and realize that some very complicated special effect is going on that couldn't be done in-camera.

Nobody really knows who did the first *glass shot*, the method used to obtain our castle-on-the-hill shot. Records from the early years of this century, around 1907 or so, describe workers holding up large sheets of painted glass before the old hand-cranked movie cameras. To get the castle-on-the-hill shot, the camera operator lines up the painting with a distant hill while looking through the camera's viewfinder. The one-eyed camera can't tell that the castle is a small painting close to the lens and that the hill is some distance away. To the camera it looks as if the castle is actually on the hill.

The technique may be very old, but it is still in use, and over the years filmmakers have added variations to the trick. Do we want a beautiful princess to be seen waving from one of the castle

Matte painter Rocco Gioffre, of Dream Quest in Los Angeles, adds a detail to the towers of Notre Dame in a matte painting. The clear glass area at the lower half of the painting is where the live action will appear.

windows to her knight in shining armor on the road below the castle? Simple. Just perch our beautiful princess on a ladder positioned on that distant hill in such a way that she can be seen waving from the painted castle's tower window. Our artist must make a window by scraping paint from the glass in the right place. The camera sees the princess through the window in the painting.

As you might imagine, it takes a good deal of time to prepare this kind of shot. The glass panel must be set up and the camera mounted in front of it in just the right positions. Then our artist spends some time painting the castle. While he is painting his castle, the sun is marching across the sky and moving the shadows cast by trees and other buildings across the landscape. So when the artist finishes his painting, the camera operator must wait until the sun causes the shadows cast by the trees, buildings, or other objects in the shot to match the shadows in the painting. This usually means waiting until the second day, assuming that the artist needs only one day to do his painting. Even then the sun will be in the right position for only about an hour before the difference in the shadows becomes too great.

If, on that second day, the weather starts to cloud up at just the hour scheduled for shooting, then the crew will have to wait for a third day to get their shot. With the sun behind a cloud, the landscape shows no shadows, but the artist's painting does. Waiting for the right moment can be very time-consuming, and in the movie business time is money, often literally thousands of dollars per minute.

Necessity being the mother of invention, it wasn't long before artists discovered a way to solve this problem of waiting for the right moment with an entire crew of well-paid technicians twiddling their thumbs. Instead of painting the castle and waiting for the right moment to get the shot, they paint a *matte* instead. A matte can be simply a piece a black cardboard or black paint on glass that is placed between the camera and the subject. The matte blocks out a portion of the scene being filmed so that part of the frame remains unexposed. This unexposed area is left black for the special effects artists to work their magic on.

In our castle-on-the-hill example, suppose our artist wants to save the producer the time and money involved in waiting for the painting to be completed and for the sun to be in the correct position. Instead of taking many hours to paint a castle, our artist merely paints the black silhouette of a castle on his glass. If the

crew can concentrate on getting the live-action portion of the scene, then the producer will be able to send the crew on to other work while the artist finishes the painting. Whereas before we had been doing the painting first and matching the live action to it, now we propose to shoot the live action first and put in the painting later.

With the expensive crew out of the way, our single artist can work at a much more leisurely pace. Alone, working in peace and quiet, he gets out his palette and paints in all the gray rocks, green ivy, and blue towers of the castle, working right over the black silhouette. When the painting is finished, the camera operator rewinds all the footage of the live-action portion of the scene and prepares to expose the film again, but this time to record only the castle.

To protect the already exposed portion of the film and expose the rest just for the painted castle, the artist takes a large black cloth and drops it over the back of the sheet of glass with the now-completed castle painting. When the camera operator looks through the viewfinder, he sees the painted castle against a solid black background. This is the complement of what the camera operator saw during the live-action film of the shot.

All is ready, and the film is run through the camera again. Now it is recording the image of the painted castle in the area that had been previously unexposed. The twice-exposed film is taken to the lab, developed, and printed. *Voilà!* We see a brave knight on a country road with a beautiful storybook castle in the background. This basic principle, called a *latent-image shot* or *held take,* is still used today. A *take,* of course, is a single continuous shot of a scene. "Held take" means that the shot has been held back by the camera operator so that it can be run through the camera again for the special effects artist, instead of being sent off immediately for processing.

Held takes are still the choice of artists whenever work of highest image quality is demanded. Since the artist is working on the original piece of film, there is no visible difference in quality between the special effects shot and the rest of the film. The success of the shot rests entirely with the artist.

And what an artist he or she must be if the painting is to look as true to life as photography! What sort of special talent is demanded here? Obviously, a good matte artist must have mastery over the laws of perspective, color, and form. The eye of the

viewer should be able to move from the painting to the filmed image without detecting a difference.

In the early days of the cinema, a glass shot was most often used to improve locations or to finish off sets. For example, the director might have found exactly the location he was looking for—an old Spanish mission, say. But the script calls for a tall belltower, and his existing mission has none. A good matte artist can supply the tower with a painting on glass. After all, the only time the tower is going to be seen is in the opening shot, which shows the entire mission in the valley. A large sheet of glass is placed before the camera, and the artist paints in his belltower above the ruins of the old mission so that to the camera's eye it appears to be one creation—the painting and the old building blending together with no visible seam. This fulfills the require-

A very early full painting used as an establishing shot in Fritz Lang's *Metropolis* (1926). A matte painting can either fill in a small portion of the frame or function as a complete shot. When the painting is photographed, small animation effects, such as moving clouds or flashing lights, can be added to give life to the painting.

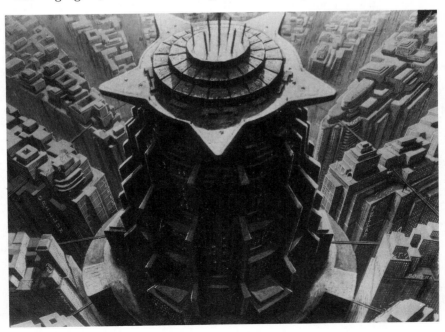

ments of the script, and the producer will not have to pay for the construction of a full-size belltower.

Sometimes a matte painting can be used to resurrect a ruined actual site. Director Norman Dawn lent his name to one of the earliest uses of the glass shot, in 1907, with his film *Missions of California*. His artist painted tiled roofs and graceful arches on a large sheet of glass placed before the camera. Glass painting and camera were aligned precisely with the real scenery, which at the time consisted of a few rows of column bases. In these early days the shot became known as the "Dawn process," and Norman Dawn is generally given credit for the first use of this technique, at least in the United States.

More typically, glass shots are used to add roofs and second stories to back-lot sets. A producer needs London in 1650. But instead of making streets of two-, three-, and four-story buildings, the crew constructs only the first-floor level of his London street. The first floor is needed for the actors to work in. The upper stories will be seen only in occasional panorama shots. For these shots the artist can paint the upper stories and roofs on glass and save the producer much money on set construction.

Sometimes these paintings can be spectacular in their own right. In the second version of the classic *Hunchback of Notre Dame* (1939), there are shots that show the entire height of the famous cathedral. Shooting in the latter days of the Depression the producer did not go to the expense of building a full-size cathedral on the back lot, or of transporting the entire company off to some European locale and persuading the local inhabitants to let him use their cathedral. Instead, he used a matte painting.

In order for these shots to be successful, matte painters must possess virtuosity and precision. One matte artist of the 1930s, Chesley Bonestell, studied architecture at Columbia University and soon mastered the intricacies of rendering perspective. For his final exam he was required to draw a mirror tipped 10 degrees out from the wall, a chair tipped 10 degrees from the mirror, and the reflection of the chair in the mirror. Bonestell later became so renowned in the film industry that his skill was in great demand; he worked for RKO, Warner Bros., Columbia, Fox, and Paramount. You've seen his paintings in such classics as *Mr. Deeds Goes to Town* (1936), *Citizen Kane* (1941), and *The Hunchback of Notre Dame* (1939), among many others.

Matte paintings are usually created on large panels of glass. The glass provides an absolutely flat, stable surface, but there is always danger of breakage or cracking from the heat of studio lights. Matte painter Rocco Gioffre of Dream Quest says he has never cracked a painting.

Such architectural precision is not always necessary, however; nor are microscopic brushwork and detail. Very often an artist can use just a few strategic blobs of paint to suggest details and textures that are not really there. Artist Matthew Yuricich has painted mattes for many major productions. His credits range from *Ben Hur* (1959) to *Brainstorm* (1983). He has mastered the art of *suggesting* detail.

Some years ago Yuricich was called upon to paint a matte for a pirate epic. The producer had money for only one ship, and that was the one on which all of the principal action was staged. But a few shots required a number of ships to be seen at anchor with cannons visible through gun ports.

As it happened, the director walked by as Yuricich was working on his painting. The director insisted that Yuricich paint very detailed cannons. "I want to be able to see the guns and right down into the muzzles. There are twenty-four guns on each ship. It will probably take you some time to get the detail correct," announced the director.

Yuricich calmly replied that such detail wasn't necessary and that achieving the desired effect would be very easy. He strode over to the painting and with a small brush flicked a single stroke where each cannon should be.

"That's all that is necessary."

The director turned purple with rage. "This is not some schlock production. I want to see holes in the ends of those guns and I want to see the shape of the barrel." And with that he stomped out of the studio.

A week later the completed painting was shot and screened for the director with the rest of the live-action dailies. That afternoon a smiling director came in to congratulate Yuricich on his fine job.

"I'm glad you took the time to do the job right," he said.

"But, no. The painting was just as you saw me do it—just a flick of the brush."

"But I swear each of those guns had real muzzles and barrels."

"No, you just thought you saw them. I paint just enough detail to fool the mind into seeing the rest."

One of the great names among today's matte artists is Albert Whitlock, who headed the effects department for Universal Studios in Los Angeles before his retirement. He is a master of the held-take technique, which few people today have the nerve to try.

Why does it take nerve? you ask. Because you can't afford to make a mistake. Remember, with the held take the artist is working with the original negative—the latent undeveloped image of the live-action scene. Normally, the film from a day's shoot of live-action footage is immediately sent to a lab. Then everyone waits nervously until the lab calls a few hours later to say that the film has come out all right.

But with a held take, the film is not developed right away. Instead the matte artist takes that film, with tens of thousands of dollars worth of live action exposed onto it, and puts it in a freezer until the painting is ready. The artist has asked the camera operator to expose an extra few hundred feet of film to use as test footage. As the painting progresses, the artist takes out a few feet of test film, exposes it with the painting in the matted-out area, develops it, and sees how closely the painting blends in with the live action. When the artist is satisfied with the result, the actual takes are used.

Now it is the artist's turn to pace the floor until the lab calls to say that the take is all right. Sometimes accidents happen in the lab. The film may get scratched or an error in processing may be made. Such accidents are rare, but with millions of feet of film passing through Hollywood's labs, they *do* happen. Reshooting at this stage can be very expensive, especially if the live-action unit has completed its shooting by the time the matte artist has finished the painting, and all the actors have gone home, the sets have been torn down. . . .

Albert Whitlock did quite a lot of floor pacing for a single shot in Mick Nichols' *Catch-22* (1970), which would have cost about $350,000 to restage.

A matte artist does not always have to rely on paintings, though. In some situations the artist can work with large photographic blowups pasted onto the glass. For the film *The Hindenburg* (1975), a very detailed model was constructed, which Whitlock photographed from every angle. These photos were enlarged and became the basis for many of the matte shots in the film; it would have been far too tedious to do all those paintings of the *Hindenburg*'s structure from scratch. Whitlock apparently did a very good job with the mattes, since the film won an Academy Award for special effects that year.

So far, we have been talking about matte artistry in terms of the glass shot or matte painting that adds detail to an existing

location or finishes out a partially constructed set. Quite often the artist is required to create a full painting—that is, to make a painting of the entire scene.

Such scenes have a tendency to look rather static, so the artist will instruct the camera operator to pan across the painting to add a little movement to the shot. Sometimes animation effects, such as moving clouds or smoke and fire, can be added. Good matte artists have a variety of tricks and gimmicks on which they can call in order to keep full paintings from going dead on the screen.

If the painting is of a fanciful forest, perhaps a prehistoric scene that couldn't be shot on location, the artist is faced with the problem of "frozen" vegetation. People are accustomed to seeing leaves and branches swaying in a breeze, but of course a painting doesn't move. This unnatural stillness of leaves and trees is an instant giveaway to today's sophisticated audiences that the shot isn't "real."

To overcome this handicap, matte artists have developed a repertoire of techniques to add life and movement to a painting. When the painting of the forest scene is photographed, perhaps a small branch of a live tree will be placed in front of the painting and moved slightly during the film exposure. The audience sees a moving branch in the shot and accepts the rest of the painting much more readily.

During the final duel between Mel Ferrer and Stewart Granger in *Scaramouche* (1952), crowds of onlookers are seen in tiers of boxes in the theater where the action is taking place. A slight stirring in the background crowd is the work of a clever matte artist. For not only are all those people in the upper tiers of box seats just a painting, but the motion too is an illusion. Before the glass painting was filmed, the artist scraped away tiny pinpricks of paint. A little movement behind those pinprick slots was all that was necessary to suggest the waving of fans or the stirring of bodies.

Much more elaborate was an entire whirling dust storm created in a matte painting by Albert Whitlock in *Bound for Glory* (1976). Whitlock is a master at adding movement and life to otherwise static matte paintings. Many of the long shots in *Earthquake* (1974) revealing the massive destruction of Los Angeles are made convincing by the addition of moving smoke and flames to his paintings.

In the George Lucas classic *Star Wars* (1977), Alec Guinness and Mark Hamill stand on a cliff looking down at a settlement in a desert valley—the Mos Eisley spaceport. Matte artist Harrison Ellenshaw created this full painting by working with a large photograph of a rocky desert valley. In one portion of the photo, he painted in the hazy lines of habitation—a few indistinct streets and buildings far off in the distance. Since most of the shot is a photograph of a real location, the artist did not have to worry about improving on nature. He could just concentrate on making the city look as if it really belonged in the distant valley.

Held takes and the use of photographs are only two methods used by matte artists to create illusions. As we shall see, there are other, more flexible and much more commonly used methods to combine live action and matte paintings, and there are many more ways to animate paintings so that they match live-action photography more closely.

4 Traveling Mattes

IN THE PRECEDING chapters we have seen how miniatures and matte paintings are used to complete a set for a film scene. In such situations the actor is working on a set in one part of the frame, and the special effects background takes up the rest of the frame. At no time do these two elements interact—that is, the actor cannot cross in front of the painted castle or walk across the painting of the rooftop. That's because these elements are miniatures; if the actor crossed into the painted area the illusion would be destroyed.

There are many situations in which it would be more convenient to photograph the actor and the background separately and then somehow combine the two images photographically. Usually, this situation arises when for various reasons the producer does not want to film on location, yet the background must appear to be moving, to be alive with people going about their business or with scenery passing by. This effect cannot be achieved with a simple matte painting.

Let's consider two classic situations that occurred quite often in the early days of film. The first scene takes place at night on an ocean liner somewhere in the middle of the Atlantic. A man and a woman are carrying on a conversation at the ship's rail, and in the background the moon is breaking through the clouds and illuminating the rolling waves as the ship steams along. It's a typical romantic situation that has appeared in dozens of movies. Yet it is a situation that—for the camera—cannot exist. It is simply impossible to photograph a moonlit sea and two lovers at the ship's rail who happen to be standing in a pool of light from the ship's own sources of light.

The second situation has occurred in several Hitchcock films. Two people are having breakfast in the dining car of a train as miles and miles of mountain scenery speed past the windows. We

know that it would be exceedingly difficult, though not impossible, to get a crew, lights, and camera into the cramped area of a real dining car to shoot this scene. Yet we can see that the camera is shooting squarely between the couple at their table and is looking squarely through the window.

Both the shipboard shot and the train shot are obtained with special effects. The background scenery and the foreground action are photographed separately and then combined—but how?

One of the earliest techniques for combining separately photographed foregrounds and backgrounds is *rear-screen projection*. In its most basic form, rear projection involves arranging actors and props in front of a large, translucent projection screen. A film of the appropriate moving background is projected onto this screen from behind while the scene is being shot. The camera records the studio action and the rear-projected background at the same time. No further special laboratory work is required. This standard studio technique can be used to create instant settings, which appear to be taking place in any part of the world at any time and under any weather conditions. For the match to blend, it is necessary only to match the lighting on the foreground actors and set pieces with the lighting of the background photography.

One of the most popular uses of this technique involves automobile sequences. Suppose the action is taking place in the back seat of a taxicab. The camera's point of view is from the front seat looking into the rear of the cab upon two actors who are having a conversation. Behind them, in the rear window, we see receding buildings, shops, and sidewalks. In reality, the camera, cast, and crew are working indoors, in a studio. The cab is a studio prop with its front half cut away and a large rear-projection screen set up behind it. Off to the side, some studio technicians may be standing in front of a bank of lights which they occasionally block off briefly to suggest that a passing building has momentarily blocked out the sun as the cab travels through the streets.

Rear projection is a great time- and money-saving technique. Only a small crew is needed to go to the specified locale to shoot the background film. This can easily be done with a camera mounted on the rear of a flatbed truck at a height that suggests the view from an automobile's rear window. Once the film is processed, printed, and threaded into the studio's rear-process projector, take after take of the actors can be shot in the comfort and

convenience of the studio. In the early 1930s this procedure was crucial, since studio conditions were necessary in order to record the soundtrack. The technique saves not only the major expense of shooting on location with a full cast and crew but also the paperwork and logistics involved in handling traffic through repeated takes.

(Despite these advantages, many of today's directors shun the controlled environment of the studios, preferring the more raw and realistic quality of the streets. They use lightweight, compact cameras fastened onto the hood of a real car, which is driven through the streets. Radio microphones pick up the actors' dialogue. Such *cinéma vérité* techniques are possible only with the most modern equipment.)

The same process works for the train and shipboard sequences mentioned earlier. A small crew is sent out to shoot some background footage, which is later rear-projected during the live-action filming with the actors. Often it is unnecessary even to go to that trouble and expense, because over the years the studios have built quite a library of stock footage for such backgrounds. This is particularly true for scenic situations, such as the countryside that might be seen from the window of a train or the expanse of sea and sky that would be visible from the rail of a ship. In city situations, however, the director must be conscious of objects that "date" the backgrounds either ahead of or behind the time in which the story takes place. If a film is set in 1965 but the background film was shot in 1970, the shot will probably include quite a few cars that hadn't yet been built. It is possible to get away with the reverse situation—although viewers are likely to wonder why they see nothing but old cars on the streets.

Footage shot for the rear-projection screen is called the *plate*. The term dates back to the days when large-format photographic cameras, using film or plate sizes up to 8 by 10 inches, were used for background photography. Today the term refers to motion picture as well as still-format process backgrounds.

It's always risky to assign "firsts" in the motion picture industry, because the early days of film in general, and of special effects in particular, are so poorly documented. But one of the earliest recorded uses of rear projection was in Norman Dawn's 1913 film *The Drifter*. He used a rear-projected still plate in two scenes but was not satisfied with the look of the process and did not use it again.

Nevertheless, by the 1930s first-rate results were obtainable, and the process became very popular in sound films. The advent of sound led to the development of very precise rear-projection equipment.

Rear projection has the advantage of allowing the camera operator actually to see what he is getting as the scene is being shot. Moreover, the camera can be moved quite freely within the limits of the rear-projection screen, dollying, panning, and trucking exactly as if the shooting were taking place on location. The actors, too, can see the background scene and react to it.

The rear-projection process is used to best advantage when the background image is not a major element of the scene. The focus of the action should be on the actors, with only glimpses of the rear-projected plate visible in the background. In situations where the background plate becomes the most important element of the scene, then the best choice for combining foreground and background images is the traveling-matte process.

A *traveling matte* is one that changes shape or position from frame to frame. In Chapter 3 we described a matte that remains stationary throughout the scene. Its purpose is to finish out architectural details of a set or to add certain scenic elements that are either missing from a given location or too expensive to build. The matte in this instance does not change.

Traveling mattes offer a great deal more flexibility than rear projection. In this process it is not necessary to film the background plate first, since the entire process of combining the foreground and background images is carried out in postproduction. This has the added advantage of lowering production costs, since expensive studio personnel and special equipment do not have to be rounded up for a shot. Also, since the background image is not being rephotographed from a background screen, the image quality will be higher than in rear projection. This is particularly important in color photography, in which it is much more difficult to achieve a convincing rear-projection effect. The traveling-matte process also lends itself to a wide range of image-manipulation techniques, which are useful in special effects work.

The making of a traveling matte is a fairly complicated procedure, but the principle is not difficult to understand if we can first grasp what the process is meant to accomplish.

Suppose we have two still photographs—ordinary snapshots, for example. One is a scenic view of Niagara Falls and the other

is a shot of your friend Alice standing in her backyard. Wouldn't it be interesting if we could combine the two pictures so that Alice appeared to be standing in that view of Niagara Falls, as if you had taken her picture actually standing in front of this famous geological landmark?

All we need to combine the two images is a pair of scissors, paste, a sharp eye, and steady hands. First we cut out the picture of Alice, paper-doll fashion, making sure that we have not trimmed off any fingers or wisps of hair. Then, by applying a little paste to the back of the cutout, we can fasten Alice's image onto the snapshot of Niagara Falls. Perhaps we can place Alice at some appropriate spot on the walkway where the tourists in the Niagara Falls photo are taking in the view. If we've been very neat, we can make the finished composite look just like thousands of other tourist snapshots taken every day here, so that we see Alice smiling happily into the camera with the falls in the background.

Of course, someone examining our handiwork will be able to spot the trick right away, because they will see an extra layer of film paper pasted on top of the photo. We can disguise our trickery, though, by taking a picture of the pasteup. When this composite picture comes back from the lab, our work will look more genuine, since the new photograph hides the evidence of our careful pasteup work.

Or does it? Our sharp-eyed friends may still be able to tell that the composite photo is not genuine. What are some of the possible clues?

One of the most noticeable telltale signs is the lighting. Perhaps the picture of Alice was taken with her facing into the sun; she may even be squinting. In the photo of the falls, however, everyone in the background, and for that matter everything in the picture—lampposts, fence rails, and trees—is lit from the side and casts shadows to the other side. In our composite the sun seems to be coming from two directions at the same time—head on for Alice and aslant for the background.

Another thing that might give our game away is image quality. Perhaps the two photos were taken with two different cameras. Let's say the shot at Niagara Falls was taken with one of those Kodak Disc cameras that fit so neatly into your pocket and are thus ideal for carrying on trips. But the shot of Alice was taken with our professional 35mm camera, which cost several hundred

dollars and is capable of very clear, very sharp photography. Of course, the two photos will differ to a greater or lesser degree in terms of image quality. One picture will be a little sharper and a little more detailed than the other. Once again our gimlet-eyed friends are not fooled. "How come," they ask, "Alice is sharp and clear but everything else in the picture is a little fuzzy?"

We can avoid this awkward question by shooting the two pictures with the same or equivalent cameras and by using the same type of film. If the two shots are black-and-white, so much the better; otherwise we would have to worry that the lab might not print our two color pictures to the same color balance and density. (Is the light on Alice's face slightly orange, while the light on the background is slightly blue?) But who shoots black-and-white these days?

Let's say we've been very clever. We always use the same camera and the same type of color film, and our lab is very consistent. But now our friends look very closely indeed at our shot of Alice at Niagara and see a faint outline around the figure of Alice. In rephotographing the pasteup, we were not able to hide the faint edge of the paper itself, so Alice appears to have a very thin line all around her. Foiled again. So we proceed, with surgeon's tools and surgeon's skill, to make an extremely careful cut around Alice with the sharpest of blades so that no tiny paper burrs remain. Then we file down the edges so that the cutout photo of Alice blends very subtly with the surface of the background photo.

It's difficult, but with great skill and painstaking effort we stand a good chance of fooling our friends with "Alice at Niagara."

All the problems that we have encountered with our composite still photograph are similar to those faced by special effects filmmakers who want you to believe that Mary Poppins and Bert are dancing with penguins or that the *Millennium Falcon* of *Star Wars* fame is zooming over the jungles of the planet Yavin (actually the Mexican jungle). But they have two additional problems that we didn't have in making our Alice composite.

First, they are making a movie, which means they are dealing not with just one but hundreds of still photographs that must be viewed at the rate of 24 per second to make the image appear to move. Remember, a movie is a series of still photographs taken and viewed in rapid succession.

Second, filmmakers are working with reel film—tiny, transpar-

ent frames of film similar to the 35mm slides you take with your own camera—not with large, paper-based prints like those we used to make our Alice composite.

Why is this a problem? On film we can no longer just cut out Alice's image and paste it onto the Niagara Falls background. On film our Niagara background and our picture of Alice are transparent, like 35mm slides. If we cut out Alice and paste her over the background, we will be able to see the background *through* the image of Alice (assuming that our paste is perfectly transparent; if the paste is opaque, then no light will be transmitted through the image of Alice and we will see a black silhouette on a background of Niagara). What to do?

Filmmakers have a solution for this problem—or, rather, several solutions. The basic answer is the traveling matte. If shooting "Alice at Niagara," for example, a filmmaker must make two mattes. One matte is made by taking the backyard shot of Alice and blocking out all the background. The other matte is made by taking the background picture of Niagara and matting out just that area in which Alice will appear. The result is a picture of Niagara Falls with a black silhouette in the middle of it—a silhouette that corresponds exactly to the picture of Alice that is to be matted in. These two images are combined in a special laboratory process.

Moviegoers would not be satisfied with a still shot of Alice at Niagara, however. She would have to be seen walking or performing some other activity. For this, of course, each frame requires a slightly different silhouette matte of Alice and a correspondingly different matte for the background—a "traveling matte."

Any number of methods of creating traveling mattes have been developed over the years. One of the earliest, which is still in use today, involves laboriously drawing the mattes by hand one frame of film at a time.

To illustrate this method, let us suppose that we have filmed a short sequence of Alice surveying her backyard with a pair of binoculars. Also let us suppose that we have shot several hundred feet of movie film at a particularly picturesque spot at Niagara Falls, one that hundreds of tourists regularly use to observe the falls. We want to make a composite that will look as if Alice is looking at the falls with her binoculars. To accomplish this, we must create a pair of mattes. One series of mattes will block out Alice's backyard, leaving the image of Alice against a solid black

background; a complementary series will create a black silhouette in Alice's shape standing in our Niagara Falls scene.

In order to draw the mattes, we will need a large easel to hold the matte paper and a special projector to project the film, one frame at a time, onto our easel. The projector is threaded with a positive print of Alice in her backyard. As the first frame of the scene is projected onto the matte paper, an artist draws a black silhouette around Alice. After the background is completely filled in, the sheet of matte paper is removed, the film is advanced to the next frame, and a silhouette is drawn on a new sheet of matte paper to match *that* frame. The artist continues drawing silhouettes and painting in a black background, frame after frame, until the entire scene has been run through the projector.

This process can add up to quite a lot of drawings. Suppose our shot of Alice is to last just 30 seconds on the screen at a running speed of 24 frames per second. This means that the artist must paint 24 times 30 mattes, or 720 hand-drawn mattes.

When all the drawings are complete, the film of Alice is taken out of the projector. At this point the special effects artist converts his projector into a special camera. This piece of equipment, often called a *Rotoscope,* which can change from a projector to a camera and back again, is one of the basic tools of the special effects photographer.

With the projector converted to a camera, the black silhouettes, numbered 1 through 720 for reference, are photographed one at a time. On each matte there is a blacked-out background with an open area representing the image of Alice. The camera is loaded with black-and-white negative film, and each hand-drawn matte is photographed in numerical order on successive frames of film.

When the film is developed, what you will see is a strip of film with 720 successive exposures of the hand-drawn matte. The film, of course, is a negative, so the image will be the reverse of what we have drawn. We filled in a black background around the image of Alice; on the film we have a *black* image of Alice on a *clear* background. This matte will be combined with our background plate, which has an unexposed area in the middle that is exactly the same shape as the figure of Alice.

Now we have to work with our foreground image of Alice. We can take the same matte we made for the background—the piece of film with the 720 successive black silhouettes of Alice on a clear

background. If we send this matte to the laboratory to have a print made, we will get back another piece of film that is the reverse of our matte. This new matte, or countermatte, will have a *black* background with a *clear* area in the center representing the image of Aice. This strip of film is combined with our foreground picture of Alice so that we see Alice on a black background.

Finally, we take our background plate (with the black area in the center in the shape of Alice) and our foreground film (with the image of Alice on a black background) and combine the two in a laboratory process that results in a single, 30-second film sequence of "Alice at Niagara."

This use of mattes, and successive stages of duplication is basic to the traveling matte process. The above description is vastly oversimplified, but it does describe the basic principle involved. In practice, there are dozens of ways of combining negatives and positives, some with just a few steps, some with dozens of steps requiring absolute precision to make a good traveling-matte shot.

Obviously, drawing mattes by hand is a time-consuming, tedious process. Over the years quite a number of methods have been devised to simplify the making of traveling mattes. In the early 1920s a technique was developed called the black-backing process. The foreground action was shot against a large black drape. The mattes were produced through several processes of high-contrast duplication and intensification by the laboratory. Usually the results were not very satisfactory, since by the time enough processing had been done to achieve usable mattes, the mattes no longer fit together properly. What appeared on the screen in those early black-and-white days was a heavy white outline around the object being matted. You might see a shot of a car that had been matted into the background, but the background did not quite fit around the shape of the car; there would be a gap between the foreground and background images.

A much more successful, although certainly not ideal, process was developed in the 1920s by C. Dodge Dunning and became known as the *Dunning process*. This was one of the first processes that relied upon the use of colored filters to achieve a matte. It was also a self-matting process—the mattes were produced in the camera as part of the process. No special laboratory work was needed to produce the mattes, and no long hours had to be spent drawing them by hand.

The Dunning process depends on a basic principle of optics. It

involves contrast manipulation with the use of colored light and filters. For example, suppose you have two pieces of colored construction paper, one bright yellow and one bright blue. Place them side by side in front of you on a larger white piece of paper. If you view the two pieces of colored paper through a yellow filter, the yellow paper will look as white as the background paper, but the blue will appear to be very dark—almost black. Conversely, if you view the same two colored papers with a blue filter, the blue paper will look very light, but the yellow paper will appear to be very dark—almost black. The Dunning process depends on this method of contrast control through colored filters.

As with standard rear projection, which we discussed at the beginning of this chapter, it is necessary to film the background plate first. But instead of rear-projecting the background plate and rephotographing it from the front with the actors, the film of the background plate is bleached to remove all the silver and then dyed a yellow-orange. What results is a strange-looking piece of film: Instead of a normal black-and-white image, we have an orange-and-white image. This special piece of film is used when the scene is filmed.

The *bi-pack matting* technique is used to film the scene. A special camera, known as a bi-pack camera, is needed. It must be capable of handling two pieces of film at the same time, one right on top of the other. First the yellow-orange-dyed positive of the background plate is threaded into the camera. Then, right behind the yellow-orange positive, we run unexposed black-and-white negative film. This is the film that will record the full image.

On the shooting stage the foreground is set up with the actors and whatever foreground scenery is necessary. Instead of a rear-projection screen, however, a large blue screen is set up and brightly illuminated.

Perhaps you have already guessed how the process works. Remember how the yellow filter made yellow objects light and blue objects dark and the blue filter made blue objects light and yellow objects dark? That's exactly what happens here. The actor and foreground images are illuminated with yellow light, and the background is illuminated with blue light. As the camera begins to film the scene, the yellow-orange-dyed background film is in contact with and in front of the fresh black-and-white film that is recording the scene. The black-and-white film records the foreground action normally. That is, the yellow light on the actors

passes through the camera's lens and through the yellow-orange-dyed background plate to be recorded on the regular black-and-white film. The yellow filter of the dyed plate has no effect on the yellow light illuminating the actors.

The blue light coming from the background screen *is* affected by the yellow-orange-dyed plate, however. Just as the blue filter causes yellow to appear dark, the blue light from the background screen makes the yellow-orange image of the plate appear dark to the camera film. The result is that the image on the plate is printed through to the camera film as the scene is being filmed.

Unfortunately, the Dunning process works better in principle than it does in practice. The density of the background plate and the lighting on the foreground actors and background blue screen are all critical. And there are any number of special situations in which the process simply does not work well. Although it was improved by Roy J. Pomeroy in the 1930s, the process soon fell into disuse after equipment for rear-screen projection was perfected. Years later, when modern color emulsions became available, a variation on the process was revived. The result was still a black-and-white picture, but the use of color film made the process much more reliable.

By the end of the 1930s, *Technicolor* had come into its own. Various systems of color photography had been experimented with since the turn of the century, but the Technicolor process became the first genuinely successful commercial system. For traveling-matte work, however, entirely new approaches had to be devised.

Today's blue-screen traveling matte is an extremely complicated laboratory process involving many complex steps carried out in a highly controlled environment. In principle, the process still involves the creation of foreground and background mattes. But now these mattes are created by using colored filters to separate foreground and background elements in the original color negative. The most modern blue-screen traveling-matte process is the *color-difference process,* patented by Petro Vlahos in 1964. It has been steadily improved on over the years and is capable of producing extremely high-quality mattes, even in difficult situations involving transparent and translucent objects such as smoke, glass, and water.

Although modern blue-screen traveling-matte processes require lengthy and complicated laboratory procedures, the origi-

nal color photography from which the mattes are taken can be handled by the average low-budget producer without great expenditure for sophisticated and costly equipment. All the complicated work is handled by a laboratory during the more leisurely postproduction process.

In addition to the blue-screen traveling-matte system, a few other systems are in occasional use today. These are multifilm systems that produce high-quality mattes in the camera at the same time that the foreground photography is being shot.

These systems require a special camera capable of running two films at the same time. Some old Technicolor cameras, which ran three films simultaneously, have been adapted for this purpose.

Apogee's camera and systems design engineer Don Trumbull and director of R&D Jonathan Erland run some tests on the Blue Max front-projection system. The most common form of traveling matte system in use today requires a blue screen to be used behind the foreground action. Apogee's technique transforms standard front-projection screens into blue-screen backings. This technique makes the use of very large blue screens more economical. The Apogee-designed system won an Academy Award for Scientific Achievement. (*Photo by Michael Middleton. Copyright © Apogee, Inc.*)

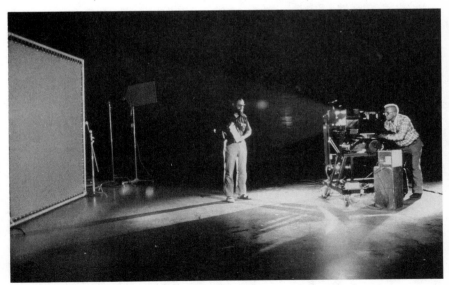

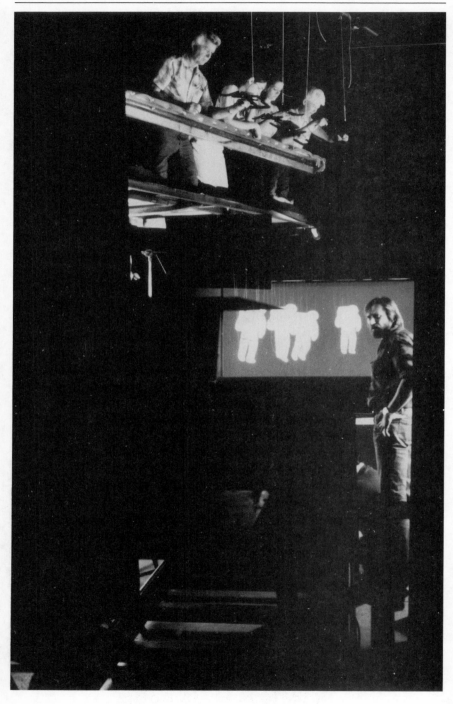

Just behind the lens on these cameras is a small prism that splits the light into two paths aimed at the two different films in the camera. One of the films is a color negative film, on which the foreground action is recorded; the other is a black-and-white negative film, on which the matte is recorded.

In all these systems the foreground action is played against a special background screen. This screen is illuminated with a color of light that is recorded only on the black-and-white film, while the foreground image is recorded in color on the color negative film. The color negative and the black-and-white negative are developed normally. What we see is a color negative with a clear background, and a black-and-white negative with a black background and a clear area representing the foreground. These two pieces of film form the basic units necessary to proceed with the matting process exactly as described at the beginning of this chapter.

There are a number of different systems involving the use of various kinds of light to illuminate the background screen. The processes are named by the type of light that is used—the infrared process (illuminated with infrared light), the ultraviolet process (illuminated with ultraviolet light), and the *sodium vapor process* (illuminated with light from sodium vapor lamps; you've probably seen these intense, bright yellow lamps used for highway lighting). In each case the light that illuminates the rear screen is recorded only on the black-and-white film, which has been sensitized to record this light.

Perhaps the most famous use of the sodium vapor process was in Walt Disney's *Mary Poppins* (1964), in which Julie Andrews and Dick Van Dyke were matted into fantasy worlds created by artists and animators. The system is useful for high-quality work but cannot be used for wide-screen (anamorphic) films, because the

In the long shots in *Lifeforce* (1985), spacewalking astronauts were doubled by small marionettes. Special visual effects director John Dykstra directs puppeteer John Brunner and associates as they manipulate the diminutive stand-ins in front of a transmission blue screen. Miniatures are often filmed in front of a blue screen so that they can be matted into a separately filmed background. (*Copyright © Cannon Films, Inc./Apogee, Inc. Reprinted by permission.*)

special camera required for these films cannot be fitted with anamorphic lenses.

There is one other major use of traveling mattes that all moviegoers have seen from time to time. This is the "wipe," a type of transition from one scene to the other in which one shot appears to slide out of view as it is replaced by another shot. This technique became popular during the silent era but was relegated to serials and B movies during the 1930s and 1940s. Because the technique draws attention to itself, it is best used in fantasy situations rather than in realistic drama. Wipes are achieved with a set of traveling mattes available in a variety of patterns.

Sometimes these mattes are used for purposes other than scene transitions. One is the highly specialized effect known as *split screen*. This method is used when an actor is playing two roles in one film and the script requires the actor to appear in both roles at the same time in the same scene.

In the simplest form of the split-screen technique, the actor as character A is filmed playing his role on the left side of the set with a stand-in playing character B on the right side. After this part of the scene is filmed to the director's satisfaction, the actor changes costume and makeup to appear as character B. He takes his place on the right side of the set and plays the scene again, this time with a stand-in reading the lines of character A.

The laboratory takes the two separate pieces of film, mattes out the stand-in in both shots, and pieces together the film so that the actor is seen in both roles simultaneously. The split is placed at some convenient point between the actors and can move or travel as the scene dictates. Danny Kaye in *Wonder Man* (1945) and Bette Davis in *Dead Ringer* (1964) played dual roles involving split-screen shots.

The split-screen traveling-matte process has applications beyond letting an actor play dual roles. It is sometimes used to protect actors from danger. For example, a scene might call for a lion to be following a few steps behind an actress as she walks through a jungle setting. The difficulty of training a lion to follow

The heart of every effects house is the optical printer. Frank Van der Veer makes sure that all the elements are lined up within a tolerance of .001 inch. (*Courtesy Van der Veer Photo Effects*)

obediently behind an actress or of finding an actress who does not mind being followed by a lion can be put aside when split-screen traveling mattes are used.

The lion and the actress are filmed separately. First, we get a shot of the actress quietly strolling through the setting. Then we can get the shot of the lion walking through the same setting— either being called from the other side of the set by his trainer or following a few steps behind the trainer.

In the laboratory, a split is made just behind the actress on the first piece of film. And another split is made just ahead of the lion on the other piece of film. When the scene is printed, the split travels just behind the girl and ahead of the lion, so that the lion appears to be following our fearless actress. If well made, such splits are invisible on the screen.

A split-screen traveling matte was used in just such a sequence in MGM's science fiction thriller *Forbidden Planet* (1956). Anne Francis appears to be strolling along with a tiger, but actually Francis and the tiger were filmed separately and matted together with the split-screen traveling-matte process.

The process can also be seen in the screwball comedy *Bringing Up Baby* (1938). More than a few shots have Cary Grant and Katharine Hepburn on one side of a split screen and a leopard on the other. Another fine example occurs in Disney's *Song of the South* (1946), in which a bull chases young Bobby Driscoll across a field. A split-screen traveling matte joined separate shots of the bull and Driscoll. More recently, in *Krull* (1983), a split-screen effect allows a tiger to stroll behind a small boy in the corridors of a great fortress.

At issue here is more than the question of safety. Most animals used in film work are very gentle and well-behaved, but they are exceedingly unreliable actors. Endless takes and rehearsals are often necessary to get an animal to perform as the script requires. Most producers would rather not let their expensive stars and crew stand around waiting for an animal and a trainer to get down to business. The split-screen process allows the human actors to act their parts and go on to something else while another unit tries to get the animals to perform.

All the processes described in this chapter are photographic processes. They are expensive and time-consuming, and they require many tests before satisfactory results can be obtained. Today, however, electronics and computer science are changing the

Modern special effects houses rely on a variety of optical printers in order to handle large volumes of work. The printer consists essentially of a camera and a projector. It rephotographs separately filmed elements and combines them into a single scene.

movie industry. Old photographic and optical techniques are gradually being replaced with modern electronic processes. We have moved into a new era of special effects filmmaking, one that has opened up a world of unimagined wonders, as we'll see in the next chapter.

5 The Digital Brush

FOR A LITTLE over a quarter of a century now, that mysterious and awesome machine, the computer, has been having an ever-increasing impact on our lives. The dawn of the modern computer age in the mid-1950swas marked by a flood of small rectangular cards, punched full of holes and imprinted with the warning: "Do not fold, spindle, or mutilate." These IBM punch cards were the average person's introduction to computers and data processing. Until quite recently, however, most people thought of computers as vast machines owned and used by giant corporations to get the bills out on time or used by ivory-tower professors in their search for prime numbers.

In recent years, however, computers have undergone a technological revolution of their own. First the transistor, then advances in microchip circuitry forever changed not only the size of computers but their accessibility as well. A computer that once filled a good-size room with tens of thousands of electron tubes requiring enough electricity to power a high-rise apartment building was the prized possession of government and research organizations. Today the same—or better—equipment has shrunk to the size of a portable typewriter, is powered by flashlight batteries, and can be purchased by anyone who can get to a Radio Shack.

Computers, both in their large industrial size and in small home-convenience models, are rapidly becoming indispensable factors in every part of our lives, doing everything from guiding our astronauts into space to teaching toddlers how to "speak and spell." Certainly, it was only a matter of time before computers found their way into the film business as well.

The first practical application of computers in the film business was in the *business* itself—the record-keeping and paper-shuffling sides of filmmaking. But as valuable as the computer is

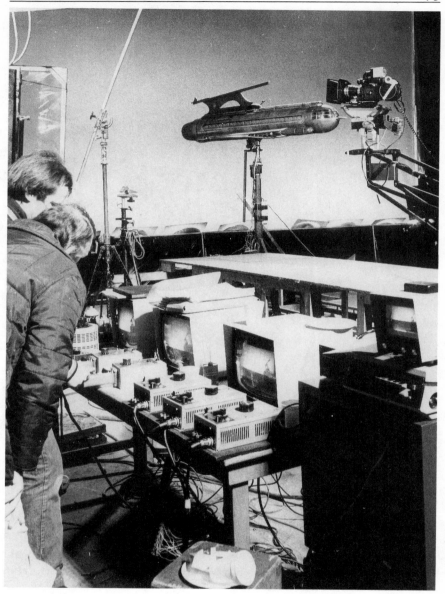

Modern special effects equipment appears to be almost alien in its complexity, but it has made life much easier for the effects artist. This nest of controls and video monitors is being used to shoot a blue-screen sequence for Dina de Laurentiis' production of *Flash Gordon* (1980). (*Courtesy Famous Films B.V.*)

Systems engineer Don Trumbull displays Apogee's custom-designed
motion-control camera. (*Photo courtesy Apogee, Inc.*)

in handling the data and details of the film business, the real
revolution is now taking place on another battlefield—the cre-
ation of the film image itself.

There are two ways computers assist filmmakers with image
making: by controlling the operation of the actual moviemaking
equipment (everything from cameras to projectors) and by actu-
ally creating the images that appear on the screen.

It is the role of the computer as image maker that concerns us
in this chapter. The two computer applications to image mak-

ing—and to special effects, in particular—are computer-controlled cameras and computer scene simulation.

A *computer-controlled camera* is one whose movement is monitored and instructed by computers. It can repeat a series of movements with only minor changes from frame to frame, creating an animated streak effect. Alternatively, the camera repeats the same movement many times, allowing each object in the scene to be shot individually and later composited into a complete shot. This technique of controlled multiple-pass photography predates the computer; it was done laboriously by hand in the early days of Edison filmmaking at the turn of the century. Used in this manner, the computer is a labor-saving device. It tirelessly repeats a series of moves in robot fashion, over and over again with absolute precision. The space ships in George Lucas' *Star Wars* saga and in Spielberg's *Close Encounters of the Third Kind* (1977) were filmed with computer-controlled cameras.

In *computer scene simulation* an image is created entirely within the "mind" of the computer; no camera is involved. In this application the photographic aspect of filmmaking is dispensed with. There are no studios, sets, models, matte paintings, or miniatures. Everything is produced by computer simulation. Some of the images in Disney's *TRON* (1982) were produced in this fashion. Other good examples are the computer image of Peter Fonda's head in *Futureworld* (1976), Susan Dey's computer-realized head in *Looker* (1981), and the "Genesis" sequence in *Star Trek II* (1982).

Star Wars (1977) was the film that dramatically showcased the potential of computer-controlled cameras, or what is termed "motion control." The entire business of movie special effects was changed forever by that razzle-dazzle opening sequence. The camera slowly tilts down through a star field past a small moon until finally the curved edge (or "limb," in NASA terminology) of a large planet comes into view. In the upper right-hand corner of the frame a small spaceship speeds into the scene, rocket exhausts glowing, pursued by an enormous battle cruiser that seems to pass directly over the camera and the heads of the audience. Green laser bolts fly with deadly accuracy at the fleeing ship as the big cruiser closes the gap. A quick cut to a reverse angle puts the big ship in the background as the scene of capture is played out. Needless to say, that scene and, for that matter, the rest of the picture caused a sensation.

It would be wrong to say that special effects alone accounted

for the success of *Star Wars*. But there is no denying the fact that here was something new. For the first time the special effects camera tilted, panned, and zoomed with the action, just the way normal live-action photography would. This sense of camera freedom and motion contributed significantly to the feeling of adventure that *Star Wars* evoked and added immeasurably to the excitement and believability of the picture. There are instances of carefully plotted and brilliantly executed effects camera moves that date back to Edison, but *Star Wars* was the first picture to make them routine.

To create this extraordinary opening shot and the rest of the effects shots in *Star Wars,* a special camera system was built. The camera was mounted on a crane that dollied on a dozen or so yards of track. The boom arm of the crane rotated and moved up and down, and the camera itself could tilt and pan. All these movements were controlled by electric motors, which in turn were controlled by a simple computer system.

Using a joystick control to operate the motors, the effects camera operator steered the camera in whatever direction the storyboards called for. The computer system recorded the motions of the camera, which could then be repeated very precisely. In this way the camera could individually photograph every element of a shot—star field, moon, and space ships—and its corresponding matte. All these individually photographed elements were then assembled by the optical printer.

In 1977 the Academy of Motion Picture Arts and Sciences recognized John Dykstra, Alvah Miller, and Jerry Jeffress for their technical achievement in the creation of a camera with electronic motion control. But theirs was not the first attempt to build or use a robot camera for special effects, nor was *Star Wars* the first film to incorporate movement into special effects.

One of the earliest recorded moving-camera special effects shots was for an apparition effect in *The Flight of the Duchess* (1914). This film, made for Thanhauser, used the traditional *double-exposure* technique to create the ghosts, which involves shooting the live-action scene normally, rewinding the film, and shooting the ghosts against a set draped with black velvet. The finished result looks very spooky indeed, with the double-exposed ghosts seemingly transparent against the very solid set. It is a standard technique of still photography and was easily adapted for the movies. The only difficulty is that the camera cannot move

at all during either the first or the second exposure; if it does, the separately photographed elements either will not line up properly or will jitter senselessly through the scene, making the shot look like a mistake.

The camera *can* move, however, provided the movement it makes in the first exposure is precisely duplicated in the second exposure. Knowing this, the camera operator for *The Flight of the Duchess,* Otto Brautigam, designed a means to duplicate precisely his camera movement for both the live-action shot and the double-exposed ghost shot. The scene starts with a long shot of a picture gallery, as ghosts appear to step out of the pictures and move along the corridor. The camera moves to a closeup of the central character surrounded by the ghosts of his ancestors. By means of counts, careful timing, a calibrated winch, and several takes, Brautigam was able to create by hand one of the first moving-camera effects shots. Other cinematographers in succeeding years occasionally took the time to work out systems of recording camera moves by hand, if the shot seemed to warrant the extra effort.

During the 1950s mechanical means were developed to record automatically camera moves for special effects shots. Gordon Jennings and G. L. Stancliffe, Jr., of Paramount Pictures built a camera-motion-repeater system that was used for the climax of Cecil B. DeMille's *Samson and Delilah* (1950). Only the lower third of the temple set, which Samson destroys by pushing apart two massive pillars, was built to full size. The upper two-thirds was a miniature some 37 feet high. The camera pans and tilts across the action as the temple, with its miniature columns and towers, comes crashing down on the actors. For this shot the camera move was plotted out first and recorded on film. The new motion-repeater system moved the camera through identical pans and tilts for both the live action and the miniature.

MGM, too, had its own motion-control system, which it used principally for matte paintings. A special system recorded camera moves on phonograph records. Designed by Olin Dupy, the system made possible a number of sweeping panoramas in *An American in Paris* (1951). Both systems soon fell into disuse, however, because for most directors they were too cumbersome to be worth the trouble.

Effects technicians went back to working things out by hand when time and budget allowed. But for the most part, effects

shots were static, without any camera movement at all. But every now and then a moving effects shot turned up, and not necessarily in the most expensive features. David S. Horsley in the low-budget *Abbott and Costello Go to Mars* (1953) took pains to rotate precisely a camera pan across the skyline of New York so that the camera would appear to be following a matted-in spaceship sputtering across the rooftops.

Not until the 1960s were the first primitive computers applied to motion-control systems. Stanley Kubrick's landmark *2001: A Space Odyssey* (1968) is generally credited as the first film to make commercial use of large-scale computer-motion graphics. The famous "star gate" sequence at the end of the film, with its corridors of light streaks and smears that seem to stretch into infinity, was produced with a motorized camera operating robot-fashion according to a program, a specific set of instructions.

This technique was based on ideas and methods invented by abstract filmmaker John Whitney, who began experimenting in the 1940s. In the late 1950s Whitney assembled a mechanical analog computer from parts of surplus anti-aircraft gun directors; he used this computer to explore the potential of nonobjective film. By 1961 he had created an abstract film, *Catalog 1961,* which was the result of many years of experimentation using his computer camera to "paint" symmetrical patterns of light. These techniques were further developed by Douglas Trumbull and Con Pederson for various effects in *2001*—most notably the "star gate" sequence—and became known as *slitscan*. Motion-control graphics have since become part of the standard repertory of visual effects. They are used for TV commercials, titles, and logos and continue to find applications in movie special effects. Two examples of interesting computer-motion graphics sequences are the zooming opening titles of *Superman* (1978) and the worm-hole effect in *Star Trek* (1979). Both of these effects, and others, can be traced directly back to the abstract artistry of John Whitney, whose work was the link between motion-control graphics and computer imaging.

John Whitney, Jr., has pushed his father's artistry to its next logical step—from the creation of abstract patterns of light to the simulation of real objects. The Whitney company's computer simulations have appeared in *TRON, Westworld* (1973), *Futureworld, Looker,* and *The Last Starfighter* (1984), as well as in numerous TV commercials and logos.

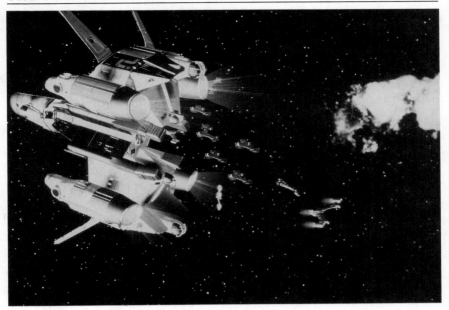

Digital Scene Simulation™ by Digital Productions created the space-
ships in this scene from *The Last Starfighter* (*1984*). The explosion at
right is a conventionally filmed miniature. (*Copyright © Universal
Pictures, a Division of Universal City Studios, Inc. Courtesy of MCA Pub-
lishing Rights, a Division of MCA, Inc.*)

Disney's *TRON* incorporated about 15 minutes of pure
computer-generated imagery involving such scenes as the
thrilling "light cycle" sequence, the creation of the MCP, and the
Solar Sailer gliding over the Sea of Simulation. The younger
Whitney's talented staff and three other companies—MAGI,
Robert Abel & Associates, and Digital Effects—supplied com-
puter graphics for the film. Most of the rest of the imagery was
created with bottom-lit mattes on an animation stand.

 Although every computer animation company has its own pro-
prietary methods for creating images, there are similarities among
them. No models or miniatures are actually built, but detailed
plans and drawings of the objects to be created with the computer
are produced.

 For both *TRON* and *The Last Starfighter,* John Whitney's crew
worked at large graphics tablets using blueprints and drawings of

the spacecraft to digitize or transfer the shape of the model into the computer. A cursor was positioned over the beginning and end of every line in the blueprint, and its dimensions were read into the computer. In this way a full three-dimensional "wire cage," or vector-line model of the spaceship, was constructed as a data base. This data-base spaceship could be rotated and moved in any fashion at will and with much greater freedom than if a real model had been built and photographed.

A traditional model builder would have to worry about the laws of physics: How is the model going to be supported and moved? How close can I get with the camera before the seams show or the camera bumps into the model? And so on.

After the model is entered into the computer in the form of a data base, the data can be manipulated in any way. Each shot is set up in accordance with the production storyboards, and the director can be called in to check each scene. If the director wants something to move slower or faster, smaller or bigger or at a different angle or in a different part of the frame, the change can be made on the spot. With traditional motion control, the scene would have to be reshot and then recomposited in an optical printer, which would involve a delay of at least several days, if not weeks. But today all this happens almost instantly as the objects in the computer are manipulated on a monitor in real time. The universal emphasis is to make the entire computer-graphics imaging process as "user friendly" as possible.

When everything has been approved, the wire-cage model is colored, shaded, and detailed by the computer. Each frame is transferred, one frame at a time, to 35mm negative film. Each frame is exposed three times through individual red, green, and blue filters to build up a full color image. The film is developed and printed normally.

MAGI, also one of the major suppliers of computer images for *TRON*, does not digitize plans and blueprints to create wire-cage models. They build their images out of solid geometry instead. They create objects, such as the light cycles, by combining sets of geometric shapes—spheres, cones, cylinders, toruses—which they assemble into whatever form is desired. Not only can they add geometric solids, they can *subtract* solids as well. As a very simple example, if they want a wheel, they may start with a sphere and chop off parts of it until they get it down to the shape they need.

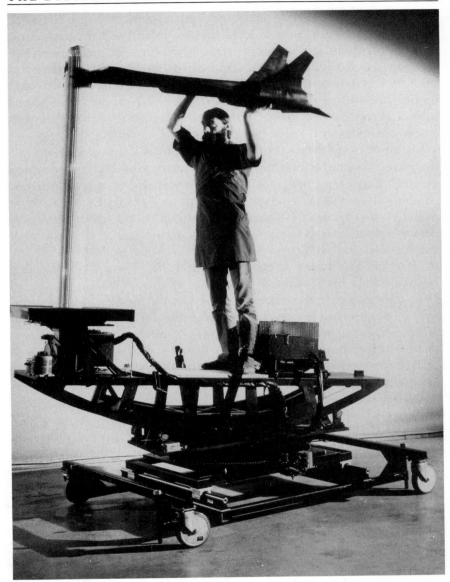

Apogee constructed a special motion-controlled support for very large models. With computer controls such supports can control the motions of a model very precisely—a necessity for modern traveling-matte techniques. Modelmaker David Beasley is adjusting the model of the *Firefox* (1982) supersonic jet. (*Photo by Michael Middleton. Copyright © Apogee, Inc.*)

For *TRON,* MAGI constructed light cycles, tanks, and recognizers by assembling sets of solid shapes. John Whitney's system is completely different. It uses a vector graphic method. Instead of creating a solid object out of solid geometric shapes, an object is built by constructing a shell out of polygons. Whitney's artists and technicians define the points of a surface and connect those points into a series of polygons. They have computer programs that smooth, shade, and color the surface.

Whitney's methods require an enormous amount of computing power, but the method is much more suitable for complex organic shapes because it isn't really necessary to rely on the existence of regular geometry. Points can be defined in any fashion and any sort of shape can be created out of polygons. It is this power that allows Whitney's staff to create human faces or very organic-looking shapes such as the *Solar Sailer* in *TRON.*

For his computer scene simulations in *The Last Starfighter,* Whitney and his company used one of the world's largest and most expensive supercomputers, the CRAY X-MP. This $15 million number cruncher, standing about 6½ feet high and 5 feet in diameter, is packed with about 250,000 integrated-circuit microchips interconnected with 67 miles of wire. The computer weighs 15,000 pounds and requires about 100,000 watts of power. The image resolution produced for *TRON* and *The Last Starfighter* is 4,000 by 6,000 pixels, which at least equals the resolution of 35mm motion picture film.

Other companies, too, are contributing computer-generated special effects to motion pictures. In *Star Trek II* all the space flight shots are traditional computer-controlled camera shots. But there is a short sequence of full computer imagery in the sequence, produced by George Lucas' computer research team, that depicts the "Genesis Effect." A projectile is fired at a barren moon, a raging firestorm envelops the planet, and as the surface cools, lush forests, mountain peaks, deserts, and seas appear. This sequence is briefly reprised in *Star Trek III* (1984).

Two moments in the "Genesis" sequence are particularly exciting for fans of computer scene simulation: the raging firestorm generated by Bill Reeves's fire-rendering program and the growing mountain landscape, which was created by Loren Carpenter working with a branch of mathematics called fractals. Both effects are created strictly by means of mathematical algorithms, without

any visual reference at all. The effects are startlingly realistic and represent some of the very latest work in both mathematics and computers.

The "Genesis" sequence reflects George Lucas' commitment to the future of computer imaging. His company is devoted to the practical development not only of digital imagery but also of digital scene matting and computerized editing and post-production processes. The Lucasfilm organization is determined to bring a nineteenth-century invention into the twenty-first century.

The goal of computer scene simulation is to create computer graphics that are indistinguishable from a photograph of the real thing. Though this goal may seem decades away to many film-makers, even it may be too limiting. It reflects the early days of computer-game manufacturing, when the industry was obsessed with creating computer simulations of everything from baseball to bridge. The real power of the computer to create games that could be played *only* on a computer was realized only recently.

Likewise, computer scene simulation is much more than merely synthesizing reality. It can also be used to create physically impossible pictures. The computer will become a sort of digital brush for the artists of tomorrow. It has the power to create and manipulate images far beyond the dreams of most Hollywood scriptwriters, whose imagining is limited by the technology of the past. Some special effects are actually easier for a computer to do. Transforming a table into a pig or a vase of flowers into a hideous monster is very easy for a computer, but very difficult, if not impossible, for a modelmaker or animator.

Another goal for the application of computers in filmmaking is the construction of a digital printer. Filmmakers have long envied the ease with which television special effects are created and combined. Merely by pushing a few buttons, the video engineer can create split-screen effects, insert other images via video's blue screen (the chroma-key), and generally manipulate the image in dozens of ways, changing colors and shapes at will, all instantaneously.

In film, however, all these effects are still created by means of many laborious hours, days, and even weeks spent working with an optical printer. When a digital printer becomes available, film-makers will have nearly the same speed and flexibility as in video but will retain all the high-quality resolution of film. A number of prototypes have been built, and it will not be long before tedious

optical techniques are supplanted by modern digital computer technology.

The door into the twenty-first century for filmmakers is steadily being pushed farther open by the enormous power of the computer. Not only will artists be able to create scenes not yet imagined but it is hoped that the computer will bring down the ever-escalating cost of high-quality film production—enabling more work to be produced for less money and with even greater production value.

The computer cannot replace the artist. Only the artist can bring an image into being, and the computer is the tool of the artist of tomorrow. Like any other tool, the imagination of the human mind is required to operate it. As one computer graphics designer put it, "Computers create the motion, we create the emotion."

6 The Shape of the Image

PERHAPS YOU'VE WONDERED what it meant, when you've read on the poster outside the movie theater: "presented in 70mm and six-track Dolby sound," or "presented in Technirama 70," or "Ultra Panavision" or even the old familiar "CinemaScope." What do these names mean? And why do many special effects studios rely on these special formats to shoot special effects sequences? George Lucas' *Star Wars* films, for example, have effects shot in VistaVision. Other films like *Ghostbusters* and *2010* have effects shot in Super Panavision. What difference does it make?

Before we get into a discussion of the difference between Superscope and Techniscope, let's take a look at standard movie film, the 35mm stock that has been with us since Thomas Edison started operating his penny-reel peep shows before the turn of the century. Legend has it that Edison asked George Eastman to manufacture some rolls of film for his kinetographic camera, which was then in the early stages of development at Edison's West Orange, New Jersey, laboratory.

"How wide?" queried Eastman, so the story goes.

"Oh, about this wide," replied Edison, holding up a thumb and forefinger.

Eastman reportedly measured the distance between the famous inventor's digits with a pair of precision calipers. It turned out to be 35mm, which is what Eastman produced and shipped to the Edison laboratories. Other people have noted that the 35mm film was exactly half the width of the 2³/₄-inch-wide celluloid film that Eastman had just started marketing, which suggests that Eastman simply slit his current stock to half-width for Edison.

In any case, by 1892 a young Scottish electrical engineer named William K. L. Dickson, who was responsible for most of the motion picture work at the Edison lab, completed his work on the

kinetograph, which used 35mm perforated film moving at about 40 frames per second.

In America, the first movies were designed to be shown as peep shows running a continuous 50-foot loop of film. In the spring of 1894 the Edison peep shows were causing a sensation not only in this country but abroad as well. European inventors, notably in France and England, had been working along similar lines, but with a different size film (a 60mm width was not unusual) and with the goal of projecting the image on a wall or screen.

The Lumière brothers in France have been credited with developing the first commercial camera *and* projection apparatus. The Lumière apparatus operated at the slower speed of 16 frames per second, which became the approximate industry standard— approximate, because cameras were not motor operated. The operator turned a hand crank, keeping as constant a tempo as possible to run about 1 foot of film per second through the camera. The Lumières projected their first motion picture show in the basement of the Grand Café in Paris in December 1895. British inventors projected movies with equipment of their own design just a few weeks later in London. Other inventors in other countries rapidly followed suit. Thus, the motion picture camera was the result of forty years of experimentation conducted simultaneously in many countries.

It has been suggested that Edison was opposed to film projection. He believed that he could maintain greater control over the product, and therefore make more money, if the films were exhibited as peep shows and shown to one customer at a time. (Perhaps if Edison had envisioned his product being projected rather than viewed as a peep show, he would not have selected a square image.) Nonetheless, the Edison company switched over to film projection as the technique gained in popularity over the next few years, but it retained the 35mm film stock and the square format. The American marketing pressure for the new industry was so strong that many other countries and companies adopted the 35mm format, too. In 1907 it was officially recognized by international agreement as the standard gauge.

Little else was standard, however. The sprocket holes, or perforations, were usually carefully and precisely hand made by the camera operator. Each camera type used its own style of perforations, and laboratories usually printed the negative film onto

stock that was perforated to match. Not until 1904 did Eastman Kodak offer the option of factory-perforated film, and the company continued to sell unperforated stock until 1949.

Although the 35mm Edison-Lumière gauge became dominant very rapidly, other film gauges were in use in both the commercial and for the "home," or amateur, market in the early years of the motion picture camera. Before the turn of the century, films had been produced using a variety of different film widths including 17.5mm, 50mm, 51mm, 60mm, 62mm, 63mm, 70mm, and 73mm. Most of these formats were not wide-screen in the modern sense because the image on the film was usually a square. Early filmmakers were influenced both by the standard square or only slightly rectangular format of still photographers and by the square peep show format that Edison favored. The image in one frame of Edison film was about 1 inch wide and 3/4-inch high. This can be expressed as the ratio 4:3, or what is commonly referred to today as the 1.33 *aspect ratio.*

The earliest experiments in wide-screen aspect ratios and wide film gauges date back to 1895. Over the years, filmmakers have enjoyed playing around with many different frame formats and aspect ratios. In some cases the oddball shapes and nonstandard screen sizes were nothing more than presentational gimmicks.

At least one process actually varied the aspect ratio during the film to conform to the composition of a shot. That is, some scenes were projected high and narrow, some square, and still others low and wide. Very few films have been made in variable-width processes; perhaps the most notable is Britain's *The Door in the Wall* (1955), based on a story by H. G. Wells. The film was shot in standard 35mm anamorphic, but in the printing stages each scene was cropped so as to select the best aspect ratio for each scene. Most viewers found the constantly changing shape of the image very distracting. Quite recently another film was made in variable aspect ratio, Douglas Trumbull's *Brainstorm* (1983). This film alternated sequences shot in 65mm Super Panavision at 2.2:1 with sequences shot on standard 35mm film at an aspect ratio of 1.66:1. The projection print was made on 70mm film, with the wide-screen images taking up the full width of the projection aperture and the 1.66 images printed with black masking on both sides. In this case, the use of two aspect ratios was integral to the story and not simply a gimmick.

Big-screen impact was the goal of Paramount's Magnascope,

introduced in 1924 and first used for the finale of *Old Ironsides*
(1926). Although Magnascope films used standard 35mm film, a
special projection lens in the theater enlarged the picture up to
400 percent for certain key scenes. At a cue from the projection-
ist, curtains were pulled up and away to reveal a larger screen for
big spectacle shots. The suddenly expanding image had a certain
dramatic impact. Magnascope was used sporadically for nearly
thirty years, in such films as *The Last Waltz* (1927), *Stagecoach* (1939),
Portrait of Jenny (1948), and *Niagara* (1953).

Today, the motion picture industry uses primarily two film
widths or gauges: 35mm and 70mm. The old Edison width of
35mm is the universal standard. Wide-screen 70mm is usually
advertised as being something new, but this is not the case. Hol-
lywood filmmakers first showed significant interest in wide-screen
70mm-movie-making near the end of the Silent Era, the late 1920s.
Movie exhibition had grown from small, back-room operations
that accommodated a few dozen people for each show into great
movie palaces that sat thousands. As the theaters grew larger, so
did the screen. The 35mm Edison frame was hard pressed to fill
the new giant screens without the image becoming noticeably
grainy and washed out.

The problem was solved by moving up to a bigger film format
that was twice as wide as the old Edison standard. At that time
many filmmakers had just invested heavily in the expensive con-
version to sound. The stock market crash of 1929 and the Great
Depression of the 1930s discouraged the movie industry from
investing in an even more expensive technology, wide-screen
70mm. Warner Brothers shot two features, *Kismet* (1930) and *The
Lash* (1931), in wide-screen 65mm, and Fox unveiled its 70mm
Grandeur process for *Happy Days* (1929) and *Fox Movietone Follies
of 1929* (1929), but without lasting success. There were other pro-
ductions in various wide-screen formats from United Artists,
MGM, and RKO, and they, too, rapidly faded from view as the
economic situation worsened. Wide-screen did not win full accep-
tance until the 1950s when the movies were forced to compete
with television and the movie industry made a point of selling
films as a big-screen experience.

Modern filmgoers should note that there really is no differ-
ence in terms of picture area between the designations 65mm and
70mm. In all cases, the camera-negative stock is 65mm wide. The
70mm positive print has an extra 2½ millimeters on either edge

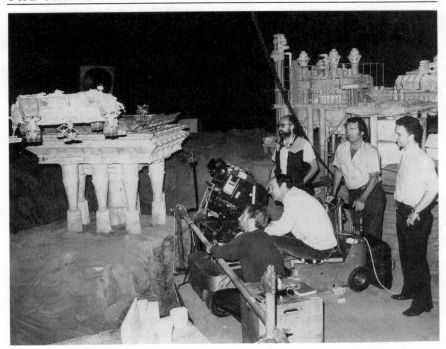

Film formats larger than the standard 35mm are commonly used for special effects photography. The most popular is the VistaVision format, which is more than twice the size of the standard Academy aperture. Miniatures constructed by Britishers Martin Bower and Bill Pearson are being filmed with a large-format camera, which uses the VistaVision, or "lazy-8," format. The latter term is derived from the fact that the film runs through the camera horizontally rather than vertically and uses an aperture that is eight perforations (rather than four) wide.

of the film outside the perforations. This added width is used for the magnetic sound tracks and doesn't affect the picture size.

Several other means of achieving wide-screen effects in the early days are worth mentioning, since they are the ancestors of processes still in use today. Henri Chrétien's anamorphic lens, which he first proposed in a 1927 paper, demonstrated practically in 1931, and ultimately tested for Paramount in 1935, was the direct predecessor of CinemaScope (Fox purchased the rights

from Chrétien). Polyvision, a triple-screen process developed by Abel Gance for *J'accuse* (filmed in 1918) and *Napoleon* (1927), was the ancestor of the Cinerama process, which was introduced in September 1952, and was ultimately responsible for kicking off the modern era of wide-screen films.

Cinerama, one of the most spectacular wide-screen processes ever devised, signaled the rebirth of wide-screen processes and super formats for the major studios. Both the economic turmoil of the 1930s and, later, World War II severely restricted the technological development of the film industry for nearly 20 years. The Great Depression made it impossible to accumulate the large pools of capital necessary to install new film processes. Later in the decade when capital did become available, the war siphoned off materials necessary to build new equipment.

CinemaScope achieves its widescreen effect (about 2½ times as wide as it is high) using standard 35mm motion picture film and a special lens to squeeze more picture into the standard frame. The most famous name for this technique is CinemaScope, which was adopted only months after the sensational premiere of *This Is Cinerama* (September 1952). Fox executives screened test footage with the Henri Chrétien anamorphic lens and immediately took an option on the process, enthusiastically announcing that henceforth all their pictures would be shot in this wide-screen process and with stereophonic sound as well. Motion picture producers and exhibitors at this time were in a panic: Movie attendance was dropping alarmingly (by 1953 attendance was only half that of 1948). Perhaps, they thought, by pushing motion picture technology into the modern world of high fidelity sight and sound, they could recapture the audience that was being lost to television. *The Robe* (1953) was the first of many Fox CinemaScope films. In short order, Universal, Walt Disney, MGM, United Artists, Columbia, and Allied Artists announced productions in the new process, which was billed as "the modern miracle you see without special glasses" (a slogan designed to compete with the 3-D films being made in the early 1950s).

The Chrétien anamorphic lens effectively doubles the aspect ratio, so that the old 35mm Edison square 1.33 frame became a super wide 2.66 image. The addition of magnetic stripping on the release print for the sound track reduced this to 2.55. Eventually the camera aperture was adjusted, so that the current CinemaScope wide-screen ratio is 2.35:1. This smaller ratio is

much easier to work with in comparison to the 2.55 original. Films such as *The Robe* and *How to Marry a Millionaire* (1953) were too wide for most critics, who compared the process to watching a film through a mail slot or venetian blinds. CinemaScope lasted until 1962 when it was abandoned by Fox in favor of Panavision lenses.

The story of modern 65mm processes began in 1953, when Michael Todd, one of the original backers of Cinerama, broke with the company and announced the formation of his own company. He teamed with Dr. Brian O'Brien of the American Optical Company and brought the 65mm process to rebirth as Todd-AO.

The Todd-AO system is basically a large-screen, wide-angle process using 65mm film at a camera speed of 30 frames per second. The image area is five perforations high (standard 35mm is four perforations high) and covers an area approximately 3½ times that of a full 35mm frame.

Todd-AO is an entire system including camera, printer, and projector. The camera included a complement of four high-quality lenses, which were rated by their angle of coverage—the widest being a bug-eyed giant that covered an angle of 128 degrees and was designed to compete with the coverage of the Cinerama process. The projector was designed to handle all formats in 35mm and 70mm at 24 and 30 frames per second and included the special 6-track magnetic sound capability, as well as standard optical sound tracks and Perspecta Sound stereo. The Todd printer built by Acme not only printed the Todd-AO image, but could convert the Todd-AO negative to other formats including Cinerama, VistaVision, and Technirama.

Michael Todd's first feature in the process was the musical stage classic *Oklahoma!* (1955). Rogers and Hammerstein had consistently turned down all offers for film rights to their musical property until Todd demonstrated his wide-screen system. The Todd-AO image is known for its remarkably clear, well-saturated colors, but perhaps it was the system's superior sound capabilities that convinced the famous composer/lyricist team. Michael Todd was the first to use 35mm magnetic tape for recording the six sound tracks instead of the ½-inch tape that was being used by most of the rest of the industry. Interestingly, *Oklahoma!* was shot also with 35mm cameras because Todd's backers were concerned about the availability of Todd-AO projection equipment for this first feature. It has been reported that there are minor differences in the 35mm and Todd-AO prints of the film.

Jules Verne's fantasy classic *Around the World in 80 Days* (1956) was the next Todd-AO release, followed by *South Pacific* (1958). Sadly, Todd was killed in a plane crash just before the release of *South Pacific,* and with him went the plans for a Todd-AO production of *Don Quixote.* But the process lives on with dozens of Todd-AO productions including *Porgy and Bess* (1959), *Cleopatra* (1963), and *The Sound of Music* (1965).

The marriage of 65mm original negative and 70mm release positive is very rarely seen in this decade. Much more common is the technique of blowing up a 35mm negative to 70mm for release. This is done to take advantage of the superior sound capabilities of 70mm with its six tracks of magnetic sound. Features shot in 35mm and blown up to 70mm include *The Cardinal* (1963), *Becket* (1964), *Dr. Zhivago* (1965), all of the *Star Wars* films, *E.T.* (1982), *Ghostbusters* (1984), *Out of Africa* (1985), and *Top Gun* (1986).

Paramount's VistaVision process was a large-format widescreen process that had its roots in the early days of filmmaking. In 1918, a unique wide-screen system using 35mm film was described in an issue of *Scientific American.* The process required a special camera in which the film moved horizontally rather than vertically. Each image was twice as large as the standard Edison 1.33 frame (1 by 1½ inches instead of ¾ by 1 inch). The system used standard 35mm film but used two Edison size frames for each image. The idea was to use the new format with its bigger and clearer image to more closely duplicate the effect of a stage performance in the theater. But this double-frame format did not come into use for feature films until Paramount developed it in competition with Fox's CinemaScope process. Paramount unveiled VistaVision with the premiere of *White Christmas* in 1954.

The full VistaVision negative has an aspect ratio of 1.5:1, but release prints were often run slightly cropped to a ratio of 2:1, the magnetic sound track slightly cropping the top and bottom of the frame. Notable VistaVision films include *The Far Horizons* (1955), *The Court Jester* (1956), *The Ten Commandments* (1956), *The Matchmaker* (1958), and *North by Northwest* (1959). The last feature shot in VistaVision was *One-Eyed Jacks* (1961).

In the mid 1950s, MGM created the Cadillac of wide-screen formats, Camera 65. This process combined the large 65mm negative with anamorphic compression lenses. A new anamorphic lens system developed by Robert E. Gottschalk gave a slight squeeze to the 65mm image, yielding a negative that could be

Apogee's front-projection rig uses 35mm eight-perf plates in the VistaVision format. A standard Panavision camera has been mounted on top of the rig. (*Photo by Michael Middleton. Copyright © Apogee, Inc.*)

contact-printed to 70mm and projected with a special lens; or, with an additional squeeze, printed down to 35mm, resulting in a standard 35mm anamorphic print. The first MGM spectaculars to receive the Camera 65 treatment were *Raintree County* (1957), which though filmed in 65mm was released in wide-screen 35mm, and *Ben Hur* (1959), which was actually released in full 70mm.

Gottschalk's Panavision company preserves this process today under the name Ultra-Panavision 70. This process can match Cinerama's extreme aspect ratio; in fact, the Ultra-Panavision 70 cameras were used to shoot difficult sequences for the three-panel version of *How the West Was Won* (1963), and later replaced the three-camera system altogether. Notable Ultra-Panavision 70 films include *Battle of the Bulge* (1965), *The Fall of the Roman Empire* (1964), and *Mutiny on the Bounty* (1962).

An interesting hybrid development in the mid-1950s came from Technicolor with the invention of its Technirama process. Technirama combines the convenience of 35mm film with the quality of a large double-frame negative similar to VistaVision and the wide-screen capabilities of anamorphic lenses. In other words, this 35mm system utilizes the same horizontal movement and negative area as VistaVision but adds an anamorphic squeeze. The Technirama negative can be printed either to standard 35mm full squeezed image, four perforations high, or to an unsqueezed 70mm release print, which is called Technirama 70. The Walt Disney Studios are particularly fond of this process for special wide-screen animated features. They have produced both *Sleeping Beauty* (1959) and *The Black Cauldron* (1985) in Technirama. Other notable Technirama films include *The Big Country* (1958) and *Auntie Mame* (1958).

All of these super-format processes were designed to produce a bigger, brighter, clearer image in the theater. This is by no means an exhaustive accounting of the film formats and screen processes that have come and gone over the years. It isn't even a complete list of the ones still in current use. What does this panoply of film sizes and lenses mean for the special effects artist? Many of these nearly obsolete super-format processes have made possible the high-quality special effects we see on the screen today. *Star Wars* is the classic example. The live action portion of the film was shot with standard Panavision 35mm cameras and anamorphic lenses. Each image was squeezed by the anamorphic lens into a frame four perforations high, not very much different from the frame size used in Edison's day.

The special effects, on the other hand, were shot in VistaVision format. Recall that in this process the film runs through the camera horizontally with each image taking up a distance of eight perforations. Why use it for special effects? Because, as you have discovered, most special photographic effects involve a lot of in-

This is the Vistaflex camera designed and built at Apogee to shoot both standard four-perf and eight-perf VistaVision formats in the same camera. Also built at Apogee is the nodal motion-control head in which the camera is mounted. (*Photo by Michael Middleton. Copyright © Apogee, Inc.*)

dividually photographed elements that must be combined through additional processing steps to create the famous shots of X-wings and T.I.E. fighters zooming through the stars. As we have seen, all of these additional processing steps result in a slight degradation of the image. If all of the special effects were shot in the same four-perforation 35mm film as the live action, the scenes would not match each other. The special effects footage would look grainy and fuzzy in comparison with the live action footage.

Special effects artists like to work in a larger format so that after all of the photographic effects have been composited, the larger-format image can be reduced to the size of the live action

photography. Reducing the effects footage to the smaller format means that the grain will be finer and the image quality will match the live action photography more closely. Besides the *Star Wars* films, VistaVision effects have been used in *Poltergeist* (1982), *Dragonslayer* (1981), *Star Trek II* (1982), *Star Trek III* (1984), *Young Sherlock Holmes* (1985), and *Star Trek IV* (1986) among others.

Some effects artists prefer to use 65mm film to shoot effects. This format is larger than the VistaVision frame and can yield an even closer match to original 35mm live action. Films displaying effects shot in 65mm include *Star Trek* (1979), *Close Encounters of the Third Kind* (1977), *Blade Runner* (1982), *Brainstorm* (1983), *Ghostbusters* (1984), *2010* (1984), *Poltergeist II* (1986), and *Big Trouble in Little China* (1986).

from the actors. The film's effects were the result of an international effort, with Los Angeles–based effects artists working in England with British artists and technicians. Academy Award for Best Special Effects.

Altered States

1980 WARNER BROS.

Special Effects: Chuck Gaspar. *Special Visual Effects:* Bran Ferren. *Special Makeup:* Dick Smith. *Special Optical Effects:* Robbie Blalock, Jamie Shourt.

A solid special effects film with enormous impact and power. The full-size physical effects are extremely realistic, but no less interesting is the optical fantasy work. Released in 35mm and 70mm blowup.

Beastmaster

1982 MGM/UNITED ARTISTS

Special Effects: Roger George, Frank DeMarco. *Effects Consultant:* Michael Minor. *Miniature Photography:* Cruse & Co., Inc. *Model Shop Supervisor:* William N. Guest.

Low-budget effort directed by Don Coscarelli. The film uses some excellent in-camera foreground miniature work. The flaming-moat sequence at the end of the film features excellent available-light night photography by John Alcott.

Black Hole, The

1979 WALT DISNEY PRODUCTIONS

Director of Miniature Photography: Art Cruickshank, ASC. *Miniature Effects Created and Supervised by:* Peter Ellenshaw. *Composite Optical Photography:* Eustace Lycett. *Mechanical Effects Supervisor:* Danny Lee. *Matte Artist and Matte Effects:* Harrison Ellenshaw. *Robots Created by:* George F. McGinnis. *Animation Special Effects Directed by:* Joe Hale.

An ambitious but vacuous outer-space remake of *20,000 Leagues Under the Sea.* Effects of whirling black hole and derelict spaceship are superb, though. This was Disney's first use of its ACES computer-controlled camera system. Special effects filmed in VistaVision.

Blade Runner

1982 LADD COMPANY (WARNER BROS. RELEASE)

Photographic Effects Supervisors: Douglas Trumbull, David Dryer, Richard Yuricich, ASC. *Matte Artist:* Matthew Yuricich. *Chief Modelmaker:* Mark Stetson. *Special Floor Effects Supervisor:* Terry Frazee

Some of the most beautiful miniature sequences ever filmed, depicting a heavily polluted Los Angeles of the future. A masterpiece of visual art. Effects filmed in 65mm; released in 35mm and 70mm blowup.

Brainstorm

1983 MGM/UNITED ARTISTS

Director of Effects Photography: Dave Stewart. *Optical Effects Supervisor:* Robert Hall. *Compsy [motion-control camera] Effects Supervisor:* Don Baker. *Visual Effects Supervisor:* Alison Yerxa. *Action Props and Miniatures Supervisor:* Mark Stetson. *Matte Artist:* Matthew Yuricich. *Animation and Graphics:* John C. Wash. *Special Visual Effects Created by Entertainment Effects Group.*

Douglas Trumbull and Richard Yuricich turned away from creating special effects for other films to make their own film. Naturally, their company, Entertainment Effects Group, also created the special effects, which were shot in 65mm. Highlight for effects buffs is the depiction of Louise Fletcher's out-of-body visions after she suffers a fatal heart attack. Effects scenes reflect Trumbull's penchant for evoking a sense of wonder and awe.

Clash of the Titans

1981 TITAN PRODUCTIONS (UNITED ARTISTS RELEASE)

Creator of Special Visual Effects: Ray Harryhausen. *Assistants to Ray Harryhausen:* Jim Danforth, Steven Archer. *Special Opticals:* Frank Van der Veer, ASC, Roy Field. *Special Miniatures:* Cliff Culley. *Blue Screen Technicians:* Dennis Bartlett. *Floor/Physical Effects:* Brian Smithies.

Another in Ray Harryhausen's series of mythological adventures combining stop-motion creatures with live-action photography. This high-budget effort surfaces from a fragmented, episodic story, but Harryhausen's animation is as wonderful as ever.

Close Encounters of the Third Kind

1977 COLUMBIA

Special Photographic Effects: Douglas Trumbull. *Director of Photography, Photographic Effects:* Richard Yuricich. *Mechanical Effects:* Roy Arbogast. *Matte Artist:* Matthew Yuricich. *Chief Modelmaker:* Greg Jein. *Animation Supervisor:* Robert Swarthe. *Mother Ship Photography:* Dennis Muren.

Miniatures, front projection, motion-control model photography in smoked room, use of slitscan technique, and mechanical effects reinforce the sense of cosmic awe that director Steven Spielberg evokes in this film. Effects filmed in 65mm; released in 35mm and 70mm blowup. There are three versions of this film: the original release version, a "special edition" with some scenes deleted and some live-action and effects footage added, and a TV version that is a mixture of the other two.

Cocoon

1985 20TH CENTURY–FOX

Special Effects by: ILM. *ILM Visual Effects Supervisor:* Ken Ralston. *Visual Effects Production Supervisor:* Mitch Suskin. *Cocoons and Dolphin Effects Created by:* Robert Short. *Special Alien Creatures and Effects by:* Greg Cannom. *Special Creature Consultant:* Rick Baker. *Visual Effects Art Director:* Phil Norwood. *Visual Effects Cameraman:* Scott Farrar. *Supervising Modelmaker:* Steve Gawley. *Animation Supervisor:* Charles Mullen. *Matte Painting Supervisor:* Chris Evans. *Stop Motion Supervisor:* David Sosalla. *Visual effects produced at Industrial Light & Magic, Marin County, California.*

Oscar winner for Best Special Effects in 1985, the film required effects that had to blend believably with ordinary earthbound locales. The effects required include everything from artificial dolphins to a flying boat.

Conan the Destroyer

1984 UNIVERSAL

Special Effects Supervisor: John Stirber. *Special Photographic Effects Supervisor:* Barry Nolan. *Animation:* Sam Kirson, Garry Payne. *Optical Graphics:* Michael Lloyd. *Dagoth Created by:* Carlo Rambaldi. *Foreground Miniatures by:* Emilio Ruiz Del Rio.

Special effects buffs will be intrigued by the skillful use of in-camera foreground miniatures in situations that would normally have been given

over to a matte artist. The shots work very well and have an uncanny realism.

Dante's Inferno

1935 FOX

Special Effects: Ralph Hammeras, ASC, Lou Witte, William O'Neal, James Donnelly, Edwin Hammeras, Sol Halprin, ASC, J. O. Taylor. *Matte Artist:* Fred Sersen.

Spencer Tracy stars as the owner of a carnival attraction called The Inferno. Highlight is a nightmare sequence that re-creates Satan's dominion in the style of Doré. Some of this material was recolorized and inserted into *Altered States.*

Darby O'Gill and the Little People

1959 WALT DISNEY PRODUCTIONS

Special Effects: Peter Ellenshaw. *Optical Processes:* Eustace Lycett. *Animation Effects:* Joshua Meador.

Absolutely first-class film fantasy with extraordinary special effects. Some chilling moments of horror effects with the banshee and fabulous in-camera perspective setups.

Dark Crystal, The

1982 UNIVERSAL

Special Visual Effects: Roy Field, BSC, Brian Smithies. *Special Sound Effects:* Ben Burtt. *Mechanical Effects:* Ian Wingrove. *Optical Printing:* Richard Dimbleby. *Matte Paintings:* Mike Pangrazio, Chris Evans.

Jim Henson, Frank Oz, and Brian Froud joined forces to create a fantasy world entirely with live-action puppets. Stunning physical design and well-performed puppetry blend to create this unique fantasy. Released in 35mm and 70mm blowup.

Deluge

1933 RKO

Special Effects: Ned Mann. *Effects Camera:* William N. Williams, ASC.

New York City destroyed by earthquakes and tidal waves. Final scene of the destruction of Manhattan was filmed in one take with eight high-

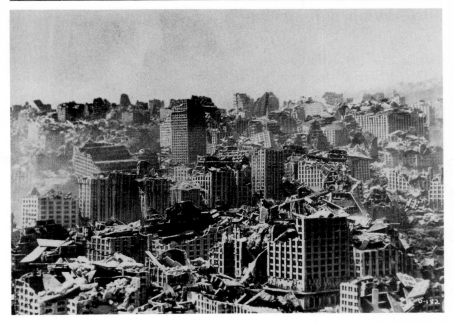

Disaster epics have been around since the earliest days of special effects. *Deluge* (1933) climaxed with the destruction of New York City by earthquake and tidal wave. Created under the supervision of Ned Mann, this sprawling model covered hundreds of square feet and was slowly destroyed while eight cameras filmed at high speed. (*Museum of Modern Art/Film Stills Archive*)

speed cameras turning at up to 240 frames per second. The model covered hundreds of square feet and was built in eight sections.

Destination Moon

1950 UNITED ARTISTS

Special Effects: Lee Zavitz. *Effects Photography:* Lionel Lindon, ASC. *Matte Paintings:* Chesley Bonestell.

This pioneer Technicolor science fiction film strives for accuracy years before anyone knew what the moon really looked like. Though its technology and design are hopelessly dated, it is still a very beautiful production. Won an Academy Award for Best Special Effects.

Dr. Cyclops

1940 PARAMOUNT

Special Effects: Gordon Jennings, ASC. *Effects Cinematography:* Wallace Kelley. *Process Photography:* Farciot Edouart.

This early Technicolor science fiction thriller relies heavily on oversize props for effect of scientist shrinking people down to tiny size, but also includes some excellent process photography. Nominated for an Academy Award for Best Special Effects.

Dr. Jekyll and Mr. Hyde

1931 PARAMOUNT

Special Effects: Gordon Jennings, ASC. *Process Projection:* Farciot Edouart. *Optical Camera:* Paul Lerpae, ASC.

There are a number of film versions of Robert Louis Stevenson's classic, but this one (with Fredric March in the title role) accomplishes the transformation from Jekyll to Hyde with complementary colored filters and special makeup. Director of photography Karl Struss and makeup artist Wally Westmore worked together to achieve this effect. Subsequent transformations in the film were handled with the more traditional series of optical dissolves.

Dragonslayer

1981 PARAMOUNT/WALT DISNEY PRODUCTIONS

Supervisor of Special Mechanical Effects: Brian Johnson. *Supervisor of Special Visual Effects:* Dennis Muren. *Full-Size Dragon Props:* Danny Lee. *Miniature Dragon Animators:* Phil Tippett, Ken Ralston. *Dragon Puppets:* Chris Walas. *Optical Photography Supervisor:* Bruce Nicholson. *Matte Painting Supervisor:* Alan Maley. *Matte Artists:* Chris Evans, Michael Pangrazio. *Pyrotechnics:* Thaine Morris. *Effects Animation Supervisor:* Samuel Comstock. *Additional Animation:* Peter Kuran. *Photographic Effects Produced at Industrial Light & Magic, Marin County, California.*

Interesting tale of sorcerer's apprentice versus dragon. This film marked the first use of the go-motion process developed by Industrial Light & Magic. Many of the sequences using the miniature dragon are much more believable than the shots using full-size props.

Earthquake

1974 UNIVERSAL

Special Effects: Frank Brendell, Glen Robinson, Jack McMasters. *Special Photographic Effects:* Albert Whitlock. *Miniature Consultant:* Clifford Stine, ASC.

Front projection, split screens, matte shots, miniatures, a special camera shaker, and the audience-shaking Sensurround sound system all worked together to create this epic disaster film, which won an Academy Award for Special Achievement in Visual Effects.

Empire Strikes Back, The

1980 LUCASFILM LTD. (20TH CENTURY–FOX RELEASE)

Special Visual Effects: Brian Johnson, Richard Edlund, ASC. *Makeup and Special Creature Design:* Stuart Freeborn. *Mechanical Effects Supervision:* Nick Allder. *Robot Fabrication and Supervision:* Andrew Kelly, Ron Hone. *Effects Director of Photography:* Dennis Muren. *Optical Photography Supervision:* Bruce Nicholson. *Stop-Motion Animation:* Jon Berg, Phil Tippett. *Animation and Rotoscope Supervisor:* Peter Kuran. *Miniature Pyrotechnics:* Joe Viskocil, Dave Pier, Thaine Morris. *Visual Effects Produced at Industrial Light & Magic, Marin County, California.*

The second film in George Lucas' *Star Wars* saga (see entries for *Star Wars* and *Return of the Jedi*). The most interesting effects sequence in the film is the battle in the snow between the Rebel flying craft and the Imperial Walkers, a tour de force of stop-motion and miniature tabletop work. Won Academy Award for Special Achievement in Special Visual Effects. Effects filmed in VistaVision. Released in 35mm and 70mm blowup.

E.T.

1982 LUCASFILM, LTD. (UNIVERSAL RELEASE)

Visual Effects Supervisor: Dennis Muren. *Effects Cameraman:* Mike McAlister. *Optical Photography Supervisor:* Kenneth F. Smith. *Go-Motion Figures:* Tom St. Amand. *Model Shop Supervisor:* Lorne Peterson. *Chief Modelmakers:* Charlie Bailey, Mike Fulmer. *Matte Painting Supervisor:* Michael Pangrazio. *Matte Artists:* Chris Evans, Frank Ordaz. *Animation Supervisor:* Samuel Comstock. *Special Visual Effects Produced at Industrial Light & Magic, Marin County, California.*

This was Steven Spielberg's low-budget quickie, his "little film," as he referred to it. Budgeted at under $10 million, about $1.5 million was set aside for the creation of the film's star and a little less than $1,000,000 for the effects shots. This may sound like a lot of money, but remember most effects pictures are budgeted at $30 million (of which $10 million is for effects). The greatest effects scene in this film comes at the climax, when the children rise into the air on their bicycles, eluding their pursuers. The sequence is difficult because the background plate was shot in broad daylight—no dark of night in which to hide matte lines. Amazingly, the film, including its effects, was shot entirely in standard 35mm four-perf. Won Academy Award for Best Visual Effects. Released in 35mm and 70mm blowup.

Excalibur

1981 ORION PICTURES

Special Effects: Peter Hutchinson, Alan Whibley. *Special Optical Effects:* Wally Veevers.

A magically atmospheric production of Sir Thomas Malory's *La Morte d'Arthur* from producer-director John Boorman. Most of the effects are physical and atmospheric, though there is some "visionary" photographic illusion work.

Fantastic Voyage

1966 20TH CENTURY—FOX

Special Effects: Art Cruickshank, ASC, L. B. Abbott, ASC, Emil Kosa, Danny Lee.

Academy Award winner for Best Visual Effects, this unusual science fiction film depicts a voyage inside the human body with microscopic miniaturized submarine and crew. Enormous sets depicting the inside of the heart and brain were hailed for their anatomical accuracy. The 42-foot submarine, *Proteus,* was built at a cost of $100,000 and weighed more than 8,000 pounds. It was built in sections so that portions could be removed for filming interiors. At the time, this was one of the most expensive ($6.5 million) science fiction films ever made. Filmed in Cinema-Scope.

Forbidden Planet

1956 MGM

Special Effects: A. Arnold Gillespie. *Matte Paintings:* Warren Newcombe, Henri Hillinck, Howard Fisher. *Optical Composites:* Irving G. Reis. *Animation Effects:* Joshua Meador, Joe Alves, Ron Cobb.

Truly ahead of its time, with magnificent furturistic design and miniature effects. The animated "Id" monster is still unrivaled, as is Robby the Robot. The effects and design of this science fiction classic are still being copied by other productions, including *Star Trek.* The look of the film holds up today in spite of its 1950s "Space Cadet" mentality. Filmed in CinemaScope, and with Perspecta Stereophonic Sound.

Ghostbusters

1984 COLUMBIA

Visual Effects Supervisor: Richard Edlund. *Special Effects:* Chuck Gaspar. *Matte Camera:* Neil Krepela. *Chief Matte Artist:* Matthew Yuricich. *Animation Supervisors:* Terry Windell, Garry Waller. *Optical Supervisor:* Mark Vargo. *Mechanical Effects (EEG):* Thaine Morris. *Creature Supervisor:* Stuart Ziff. *Stop Motion:* Randall William Cook.

Truly a phantasmagoria of special effects, this big-budget comedy features superb sequences combining models and location photography. Of particular note is the sequence in which the towering Stay Puft Marshmallow Man strolls up Central Park West. Animation and ghost effects are all state-of-the-art. Effects filmed in 65mm and reduced to 35mm anamorphic to match the live action footage. Release in 35mm anamorphic and 70mm blowup.

Golden Voyage of Sinbad, The

1974 COLUMBIA

Special Visual Effects: Ray Harryhausen.

The master of stop motion, Ray Harryhausen, stepped back into *Arabian Nights* lore for another adventure featuring his Sinbad character. The most exciting sequences include the animation of a ship's figurehead and Sinbad's fight with the six-armed Kali.

Great Train Robbery, The

1903 EDISON

Edwin S. Porter's twelve-minute story uses the *arrêt* technique in a scene in which a dummy is substituted for an actor being hurled off a moving train. Also of great significance is the use of double exposure and in-camera mattes to provide a moving outdoor background that can be seen through the open door of the baggage-car set while the robbery is in progress. The film represents one of the earliest uses of editing to tell a story.

Greatest Show on Earth, The

1952 PARAMOUNT

Special Photographic Effects: Gordon Jennings, ASC, Paul Lerpae, ASC, Devereux Jennings, ASC.

Effects highlight of this DeMille epic is the great train-wreck sequence in the middle of the film. The wreck is a miniature and very effective.

Green Dolphin Street

1947 MGM

Special Effects: A. Arnold Gillespie, Warren Newcombe. *Miniatures:* Donald Jahraus.

This overly long (141 minutes) and very talky adaptation of a novel by Elizabeth Goudge won an Academy Award for Best Special Effects. Filmed in black-and-white, but rich in production values, the big effects sequence is a truly spectacular earthquake, followed by an equally thrill-ing tidal wave. Filmed on a sound stage with sets built on rocker plat-forms, we see buildings collapse and the earth split apart, while actors hold on for dear life. Some sequences are shot in front of rear projection screens with excellent miniature effects footage of the earthquake-roiled forests of New Zealand. The tidal wave is filmed in miniature, too, with a climactic moment played out on board a boat. The camera reveals the point of view of the passengers as the wave (on a rear projection screen) overtakes the boat. Dump tanks unleash hundreds of gallons of water on the live action set. It is very convincing.

Gremlins

1984 AMBLIN ENTERTAINMENT (WARNER BROS. RELEASE)

Gremlins Created by: Chris Walas. *Special Effects Supervisor:* Bob MacDonald, Sr. *Matte Artist:* Rocco Gioffre. *Stop Motion:* Fantasy II Film Effects. *Animation:* Visual Concepts Engineering.

Director Joe Dante creates an utterly wild and fast-paced black comedy done in the style of a Warner Bros. cartoon of the 1940s. Good production values, an interesting story, and top-notch visual effects add up to an enjoyable show. There is only the briefest cut of stop motion, but the puppet work, especially with little Gizmo, would melt even the most cynical heart.

Indiana Jones and the Temple of Doom

1984 LUCASFILM LTD. (PARAMOUNT RELEASE)

Visual Effects Supervisor: Dennis Muren. *Mechanical Effects Supervisor:* George Gibbs. *Chief Visual Effects Cameraman:* Mike McAlister. *Optical Photography Supervisor:* Bruce Nicholson. *Matte Painting Supervisor:* Michael Pangrazio. *Model Shop Supervisor:* Lorne Peterson. *Stop-Motion Animation:* Tom St. Amand. *Head Effects Animator:* Bruce Walters. *Miniature Pyrotechnics:* Ted Moehnke, Peter Stolz, Bob Finley, Jr. *Visual Effects Produced at Industrial Light & Magic, Marin County, California.*

A mind-boggling roller-coaster ride through the world of special effects. Miniature and blue-screen photography vary in quality from sequence to sequence, but the effects sequence at the finale—a runaway mine-car ride—intercuts miniature and live-action photography very skillfully. Won Academy Award for Best Visual Effects.

Invaders from Mars

1953 20TH CENTURY–FOX

Mechanical Effects and Miniatures: Theodore Lydecker. *Opticals Effects:* Jack Rabin. *Matte Artist:* Irving Block.

Designed and directed by William Cameron Menzies, this stylish low-budget "sci-fi fantasy" features effects that are neither spectacular nor

expensive. Most of the effects were produced in the studio rather than in an optical facility. Nevertheless, they are exceedingly well designed and engineered. The film has a cult following and was "rescued" from obscurity by Wade Williams of Kansas City. Williams has restored sequences that were cut out of the film and deleted some repetitious shots and poorly matched stock footage. Recently, Cannon Films and Tobe Hooper attempted a big-budget remake, but without commercial or critical success.

Invasion of the Body Snatchers

1978 UNITED ARTISTS

Special Effects by: Dell Rheaume, Russ Hessey. *Makeup Effects Created by:* Thomas Burman. *Special Sound Effects:* Ben Burtt. *Stereo Sound Effects Recording and Design:* Andrew Wiskes, Susan Crutcher. *Space Sequence:* Ron Dexter, Howard Preston.

This remake of the Don Siegel cult classic (1956) is not necessarily an improvement. Try to see a Dolby stereo print; the stereo sound effects add an unusual sense of aural space.

Invisible Man Returns, The

1939 UNIVERSAL

Photographic Effects: John Fulton, ASC

The first of the film adaptations of this classic H. G. Wells tale was made in 1933. John Fulton created startling effects for about six "invisible" films in all. The 1939 sequel is perhaps the most satisfying visually and dramatically. Despite the 1975 version made in color with modern effects technology, the magic and artistry of Fulton's work will never be dated.

It Came from Outer Space

1953 UNIVERSAL

Special Effects: David S. Horsley, ASC. *Miniature Photography:* Clifford Stine, ASC.

Black-and-white 3-D science fiction with a story by Ray Bradbury. Effects highlight is the opening meteoric crash of the alien spacecraft.

It's a Mad, Mad, Mad, Mad World

1963 MGM

Special Optical Effects: Linwood G. Dunn. *Effects Camera:* James C. Gordon, ASC. *Stop-Motion Animation:* Willis H. O'Brien, Jim Danforth. *Miniature Effects:* Howard Lydecker. *Mechanical Effects:* Danny Lee. *Stop-Motion Models:* Maurice Delgado. *Rear Projection:* Irmin Roberts, Farciot Edouart.

Willis H. O'Brien died at the age of 72 just as the effects for this production were getting underway. Jim Danforth was hired to animate the climax of the movie, which creates the illusion that the film's stars are hanging onto the top of an enormous fire-truck ladder as it swings wildly back and forth. Most of the climax sequence is a jigsaw puzzle of matte paintings and split-screen shots with miniatures and live action—all assembled with the optical wizardry of Linwood Dunn. Filmed in 65mm and originally shown in Cinerama, current prints are 35mm printdowns.

Jack the Giant Killer

1962 UNITED ARTISTS

Special Photographic Effects: Howard A. Anderson. *Creature Design:* Wah Chang. *Creature Construction:* Marcel and Victor Delgado. *Creature Animation:* Jim Danforth, Tom Holland, Dave Pal, Don Sahlin. *Effects Animation:* Lloyd L. Vaughan. *Process Supervision:* Phil Kellison. *Matte Paintings:* Bill Brace.

A procession of fantastic creatures in the tradition of Ray Harryhausen's Sinbad series. Be warned that a revised version of this film exists, with songs dubbed into the original film by another producer. This "musical" version will make your teeth ache, but if you are watching it on TV, just turn the sound down and watch the animation.

Jason and the Argonauts

1963 COLUMBIA

Special Visual Effects: Ray Harryhausen.

Like Harryhausen's Sinbad series, this is another mythological special effects tour de force. Animated creatures include a seven-headed hydra, a "living" bronze statue, and seven animated skeletons that engage three

humans in a climactic battle. Each of the skeletons was a model about eight inches high. The sequence is so complex that Harryhausen often only managed to shoot 13 frames (about a foot of film) a day.

Journey to the Center of the Earth

1959 20TH CENTURY–FOX

Special Effects: L. B. Abbott, ASC, James B. Gordon, Emil Kosa, Jr.

Spectacular CinemaScope adaptation of the classic Jules Verne story. Dimetrodon dinosaurs were created by attaching prosthetic appliances to lizards and filming the creatures as miniatures. The technique is surprisingly effective. Matte paintings and miniatures are used, but the full-size effects, particularly the crystal cave, steal the show. Other highlights include a giant whirlpool at the center of the earth and a volcanic eruption at the film's climax.

Just Imagine

1930 FOX

Special Effects: Ralph Hammeras, ASC.

Very dated musical that created a futuristic vision of New York City in 1980. Many of the miniature shots found their way into *Flash Gordon* and *Buck Rogers* as stock footage.

King Kong

1933 RKO–RADIO PICTURES

Special Effects Supervisor: Willis H. O'Brien. *Technical Staff:* E. B. Gibson, Marcel Delgado, Fred Reefe, Orville Goldner, Carroll Shepphird. *Art Technicians:* Mario Larrinaga, Byron L. Crabbe. *Photography:* Edwin G. Linden, ASC, J. O. Taylor, ASC, Vernon L. Walker, Bill Reinhold, Kenneth Peach, ASC, Harold Wellman, ASC, Clarence Slifer, Bert Willis, William Clothier, ASC, G. Felix Schoedsack. *Optical Photography:* Linwood G. Dunn, William Ulm. *Projection Process:* Sidney Saunders. *Dunning Process Supervision:* Carroll H. Dunning, C. Dodge Dunning. *Williams Matte Supervision:* Frank Williams. *Special Effects:* Harry Redmond, Jr. *Technical Artists:* Juan Larrinaga, Zachary Hoag, Victor Delgado.

One of the most famous special effects films of all time and an inspiration for many of today's filmmakers. The credits read like an honor roll

of special effects artists. Very successful in its day (it rescued RKO from bankruptcy), it still draws lines of eager filmgoers to theaters. Recent prints include scenes that were deleted from the original film because they were considered too violent by the Hays Office.

Last Starfighter, The

1984 UNIVERSAL

Special Effects: Kevin Pike, Michael Lantieri, Darrell D. Pritchett, James Dale Camomile, Joseph C. Sasgen. *Optical Effects:* Apogee, Inc., Van der Veer Photo Effects, Pacific Title and Optical. *Star Car Built by:* Gene Winfield Special Projects. *Digital Scene Simulation:* Digital Productions. *Technical Executive:* Gary Demos. *Senior Drafter/Encoder:* Kevin Rafferty. *Supercomputer:* Cray X-MP.

John W. Whitney, Jr., and Gary Demos' first feature-film project since *TRON.* Traditional motion-control models and blue-screen photography has been replaced by computer-generated graphics. Whitney, associate producer for this film, pursues his goal of creating computer-realized images that are "indistinguishable from the real thing."

Man Who Could Work Miracles, The

1937 UNITED ARTISTS

Special Effects: Ned Mann. *Miniature Photography:* Edward Colman, ASC, Harry Zech. *Miniature Designer:* Ross Jacklin. *Optical Camera:* Jack Thomas. *Matte Paintings:* W. Percy Day.

The famous H. G. Wells story scripted for the screen by Wells himself. This British production requires every special effect in the book to provide the miracles that timid store clerk Roland Young performs. Miniatures, stop-motion animation, and other effects are intriguingly used.

Mary Poppins

1964 WALT DISNEY PRODUCTIONS

Special Effects Supervisor: Peter Ellenshaw. *Special Optical Effects:* Eustace Lycett. *Mechanical Effects Supervisor:* Robert A. Mattey. *Mechanical Effects:* Walter Stone, Danny Lee, Marcel Delgado. *Process Cinematography:* Ub Iwerks. *Opticals:* Art Cruickshank, ASC. *Animation Director:* Hamilton S. Luske. *Effects Animation:* Lee Dyer.

Winner of five Academy Awards, including Best Special Visual Effects. This film is the *ne plus ultra* of live-action/animation composite films. The audio animatronic props and creatures add a unique touch.

Mighty Joe Young

1949 RKO–RADIO PICTURES

Special Effects: Willis H. O'Brien. *Stop Motion:* Ray Harryhausen, Willis H. O'Brien, Pete Peterson. *Creature Fabrication:* Marcel Delgado, George Lofgren. *Armatures:* Harry Cunningham. *Matte Paintings:* Fitch Fulton. *Miniature Cinematography:* Harold Stine, Bert Willis. *Opticals:* Linwood Dunn.

The last in a series of animated ape films inspired by *King Kong* and created under the aegis of Willis O'Brien. Fittingly, O'Brien won an Academy Award for Best Special Effects. Originally, the last reel showing the burning orphanage was tinted, but most existing prints are entirely black-and-white.

Moonraker

1979 UNITED ARTISTS

Visual Effects Supervisor: Derek Meddings. *Special Effects:* John Evans, John Richardson.

The James Bond films are well known for their gadgetry, but this film is interesting because of the laser effects that Derek Meddings used live on the vast 007 sound stage at Pinewood Studios, England. (Normally such laser effects are added in postproduction.) Meddings, one of England's greatest effects artists, smoked the atmosphere on the sound stage to make the laser beams visible to the camera.

Neverending Story, The

1984 WARNER BROS.

Supervisor of Special and Visual Effects: Brian Johnson. *Special Effects Makeup and Sculpture Supervisor:* Colin Arthur. *Chief Animatronics Engineer for Mechanical Special Effects Creatures:* Giuseppe Tortona. *Special Effects Engineering Supervisor:* Ron Hone. *Main Unit Special Effects Super-*

of special effects artists. Very successful in its day (it rescued RKO from bankruptcy), it still draws lines of eager filmgoers to theaters. Recent prints include scenes that were deleted from the original film because they were considered too violent by the Hays Office.

Last Starfighter, The

1984 UNIVERSAL

Special Effects: Kevin Pike, Michael Lantieri, Darrell D. Pritchett, James Dale Camomile, Joseph C. Sasgen. *Optical Effects:* Apogee, Inc., Van der Veer Photo Effects, Pacific Title and Optical. *Star Car Built by:* Gene Winfield Special Projects. *Digital Scene Simulation:* Digital Productions. *Technical Executive:* Gary Demos. *Senior Drafter/Encoder:* Kevin Rafferty. *Supercomputer:* Cray X-MP.

John W. Whitney, Jr., and Gary Demos' first feature-film project since *TRON*. Traditional motion-control models and blue-screen photography has been replaced by computer-generated graphics. Whitney, associate producer for this film, pursues his goal of creating computer-realized images that are "indistinguishable from the real thing."

Man Who Could Work Miracles, The

1937 UNITED ARTISTS

Special Effects: Ned Mann. *Miniature Photography:* Edward Colman, ASC, Harry Zech. *Miniature Designer:* Ross Jacklin. *Optical Camera:* Jack Thomas. *Matte Paintings:* W. Percy Day.

The famous H. G. Wells story scripted for the screen by Wells himself. This British production requires every special effect in the book to provide the miracles that timid store clerk Roland Young performs. Miniatures, stop-motion animation, and other effects are intriguingly used.

Mary Poppins

1964 WALT DISNEY PRODUCTIONS

Special Effects Supervisor: Peter Ellenshaw. *Special Optical Effects:* Eustace Lycett. *Mechanical Effects Supervisor:* Robert A. Mattey. *Mechanical Effects:* Walter Stone, Danny Lee, Marcel Delgado. *Process Cinematography:* Ub Iwerks. *Opticals:* Art Cruickshank, ASC. *Animation Director:* Hamilton S. Luske. *Effects Animation:* Lee Dyer.

Winner of five Academy Awards, including Best Special Visual Effects. This film is the *ne plus ultra* of live-action/animation composite films. The audio animatronic props and creatures add a unique touch.

Mighty Joe Young

1949 RKO–RADIO PICTURES

Special Effects: Willis H. O'Brien. *Stop Motion:* Ray Harryhausen, Willis H. O'Brien, Pete Peterson. *Creature Fabrication:* Marcel Delgado, George Lofgren. *Armatures:* Harry Cunningham. *Matte Paintings:* Fitch Fulton. *Miniature Cinematography:* Harold Stine, Bert Willis. *Opticals:* Linwood Dunn.

The last in a series of animated ape films inspired by *King Kong* and created under the aegis of Willis O'Brien. Fittingly, O'Brien won an Academy Award for Best Special Effects. Originally, the last reel showing the burning orphanage was tinted, but most existing prints are entirely black-and-white.

Moonraker

1979 UNITED ARTISTS

Visual Effects Supervisor: Derek Meddings. *Special Effects:* John Evans, John Richardson.

The James Bond films are well known for their gadgetry, but this film is interesting because of the laser effects that Derek Meddings used live on the vast 007 sound stage at Pinewood Studios, England. (Normally such laser effects are added in postproduction.) Meddings, one of England's greatest effects artists, smoked the atmosphere on the sound stage to make the laser beams visible to the camera.

Neverending Story, The

1984 WARNER BROS.

Supervisor of Special and Visual Effects: Brian Johnson. *Special Effects Makeup and Sculpture Supervisor:* Colin Arthur. *Chief Animatronics Engineer for Mechanical Special Effects Creatures:* Giuseppe Tortona. *Special Effects Engineering Supervisor:* Ron Hone. *Main Unit Special Effects Super-*

visor: Philip Knowles. *Second Unit Special Effects Supervisor:* Barry Whitrod. *Cloud Effects Unit Supervisor:* Mike White. *Motion Control Unit Supervisor:* Dennis Lowe. *Optical Supervisor:* Bruce Nicholson. *Matte Paintings Supervisor:* Michael Pangrazio. *Matte Painters:* Jim Danforth, Chris Evans, Caroleen Green, Frank Ordaz. *Animator:* Steve Archer.

A fantasy-world production every bit as complicated as *The Dark Crystal,* but with a much more interesting story. The film was directed by Wolfgang Petersen and shot at the Bavaria Studios, Munich, but many of the effects artists are well-known Britishers or technicians from George Lucas' Industrial Light & Magic. Of special interest is the sequence involving in-camera perspective shots, which make the gnome characters (played by normal-height adults) appear to be only a couple of feet tall.

1941

1979 UNIVERSAL/COLUMBIA

Special Effects: A. D. Flowers. *Miniatures Supervisor:* Greg Jein. *Matte Artist:* Matthew Yuricich. *Optical Consultant:* L. B. Abbott, ASC. *Optical Process:* Frank Van der Veer, ASC.

A dazzling special effects extravaganza about Los Angeles residents panicked by rumors of a Japanese submarine raid during World War II. Great full-size physical effects sequences include a tank driving through a paint factory and the destruction of an entire house. Superb miniature effects include a model re-creation of Hollywood Boulevard buzzed by a fighter plane and the demolition of an amusement park Ferris wheel, which rolls off the end of a miniature dock.

Noah's Ark

1929 WARNER BROS.

Special Photographic Effects: Fred Jackman. *Effects Camera:* H. F. Koenekamp, ASC.

Multiple in-camera matte effects and miniatures take a back seat to the use of full-scale wind, water, and lighting effects. Director Michael Curtiz insisted on full-scale flooding effects, resulting in the severe injury of several stunt extras.

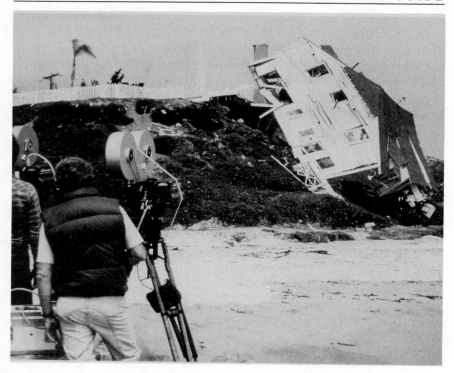

The illusion of destruction carried out on a massive scale was the task facing the special effects artists in Steven Spielberg's *1941* (1979). At the climax of the film an entire house is pushed over a cliff. Effects supervisor A. D. Flowers mounted the house on rollers, rigged sections to break away on cue, planted bombs, and even placed geysers of water to suggest broken plumbing. Obviously, this was a one-take situation. Should something have gone wrong, it would have taken more than $250,000 to set up this shot again. (*Copyright © Universal Pictures, a Division of Universal City Studios, Inc. Courtesy MCA Publishing Rights, a Division of MCA, Inc.*)

Poseidon Adventure, The

1972 20TH CENTURY–FOX

Photographic Effects: L. B. Abbott, ASC. *Mechanical Effects:* A. D. Flowers.

Irwin Allen's classic disaster epic was shot in sequence to maintain continuity as the actors became progressively disheveled while making their way through a capsized ocean liner. Effects highlights include numerous

The climactic flood sequence in this silent epic of 1929 is so spectacular that it was reissued in 1957 with music and narration added. (*Museum of Modern Art/Film Stills Archive*)

upside-down sets filled with smoke, fire, and water, which were all built in the Fox sound stages; a beautifully crafted one-quarter-scale $35,000 miniature ship, which was capsized with two dump tanks on the back lot; and a magnificent sequence depicting the inversion of the first-class dining salon when the tidal wave washes over the ship. Won an Academy Award for Special Achievement in Visual Effects.

Raiders of the Lost Ark

1981 LUCASFILM LTD. (PARAMOUNT RELEASE)

Visual Effects Supervisor: Richard Edlund, ASC. *Mechanical Effects Supervisor:* Kit West. *Matte Painting Supervisor:* Alan Maley. *Opticals:* Bruce Nicholson. *Effects Art Director:* Joe Johnston. *Special visual effects produced at Industrial Light & Magic, Marin County, California.*

Cloud-tank skies, animation effects, miniatures, matte paintings, and blue-screen compositing are used to create a stupendous special effects finale as the power of the Ark is unleashed. Sharp-eyed viewers can spot the top of an actor's head vanishing behind the edge of a matte painting in the final warehouse shot. Academy Award winner for Best Visual Effects. Effects filmed in VistaVision. Released in 35mm and 70mm blowup.

Raise the Titanic!

1980 ASSOCIATED FILM DISTRIBUTION

Special Effects Supervisor: Alex Weldon. *Model and Mechanical Effects Supervisor:* John Richardson. *Model Unit Director:* Ricou Browning. *Matte Effects Supervisor:* Wally Veevers.

Most of the model effects for this ambitious, but only marginally successful, film were shot in Malta, site of the world's largest outdoor tank. Bruce Hill filmed many of the model sequences with his high-speed pin-registered Photosonics camera. For some miniature shots, salt was substituted for water to create the effect of a miniature spray.

Return of the Jedi

1983 LUCASFILM LTD. (20TH CENTURY–FOX RELEASE)

Visual Effects: Richard Edlund, ASC., Dennis Muren, Ken Ralston. *Mechanical Effects Supervision:* Kit West. *Makeup and Creature Design:* Phil Tippett, Stuart Freeborn. *Sound Design:* Ben Burtt. *Optical Photography Supervisor:* Bruce Nicholson. *Stop-Motion Animator:* Tom St. Amand. *Matte Painting Supervisor:* Michael Pangrazio. *Miniature and Optical Effects Produced at Industrial Light & Magic, Marin County, California.*

The third film in George Lucas' *Star Wars* saga (see entries for *Star Wars* and *The Empire Strikes Back*). One of the most interesting effects se-

quences involves a high-speed chase on flying "bikes" through a dense redwood forest. Inventor Garrett Brown modified his Steadicam to produce ultra-steady background plates for the animators. Won an Academy Award in 1983 for Special Achievement in Special Effects. Effects shot in VistaVision. Released in 35mm and 70mm blowup.

Samson and Delilah

1950 PARAMOUNT

Special Effects: Gordon Jennings, ASC. *Motion Control:* Gordon Jennings, ASC, G.L. Stancliffe, Jr., Frank Butler. *Matte Artist:* Jan Domela. *Process Photography:* Farciot Edouart. *Effects Camera:* Paul Lerpae, ASC.

The climactic temple-destruction sequence was filmed with a new motion-repeater system for the effects camera. Small servo motors controlled pans and tilts. The camera move was rehearsed and recorded by the system, and then the live action and miniature portions were filmed, with the camera repeating the moves automatically.

Seven Faces of Dr. Lao

1964 MGM

Special Photographic Effects: Wah Chang, Jim Danforth. *Fantasy Makeup:* William Tuttle.

Interesting screen adaptation of Charles G. Finney's fantasy. The film features very smooth animation by Jim Danforth, and William Tuttle won an Academy Award for his designs for the various characters played by Tony Randall.

Seventh Voyage of Sinbad, The

1958 COLUMBIA

Visual Effects: Ray Harryhausen.

Split screens, traveling mattes, oversize props, miniatures, and the incredible stop-motion effects of Ray Harryhausen make this one of his most successful films. Magical sequences include a horned cyclops, a fire-breathing dragon, and a duel to the death with an animated skeleton.

Spacehunter: Adventures in the Forbidden Zone

1983 COLUMBIA

Special Makeup Effects: Thomas R. Burman. *Special Effects Coordinator:* Dale Martin. *Special Visual Effects Supervisors:* Gene Warren, Jr., Peter Kleinow. *Effects Art Director:* Michael Minor. *Model Shop Supervisor:* Dennis Schultz. *Pyrotechnics:* Joe Viskocil. *Optical Photography:* Phil Huff, Mike Warren. *Effects Animation:* Ernest D. Farino. *Special Visual Effects Produced by Fantasy II Film Effects.*

This 3-D alien-world adventure has some good-looking miniatures and animation effects that work very well, but are nothing special unless the picture is screened in 3-D.

Star Trek: The Motion Picture

1979 PARAMOUNT

Special Photographic Effects Director: Douglas Trumbull. *Special Photographic Effects Supervisor:* John Dykstra. *Special Photographic Effects Producer:* Richard Yuricich. *Special Animation Effects:* Robert Swarthe. *Mechanical Special Effects:* Alex Weldon, Darrell Pritchett, Ray Mattey, Marty Bresin. *Special Photographic Effects Directors of Photography:* Dave Stewart, Richard Yuricich. *Matte Artists:* Matthew Yuricich, Rocco Gioffre. *Miniatures:* Greg Jein, Russ Simpson, Jim Dow. *Special Photographic Effects Sequences by:* Apogee, Inc. *Miniatures Supervisor:* Grant McCune. *Director of Optical Photography:* Roger Dorney.

It's something of a wonder this movie was ever made. For years it was an on-again/off-again project. When the production finally started rolling under director Robert Wise, Paramount's Magicam was building the models and Robert Abel's small effects company was supposed to create the effects. Problems during production necessitated moving the effects over to Douglas Trumbull's company, who then farmed some sequences out to John Dykstra's Apogee. By this time, only a few months remained in the schedule. Miraculously, the film did get finished. There are some interesting "kinetic" lighting effects in the engine room set and the *V'ger* set by Sam Nicholson and Brian Longbotham. Best effects sequences include the opening Klingon sequence, the wormhole effect, and the final cosmic apotheosis. Effects filmed in standard 35mm, VistaVision, and 65mm.

Star Trek II: The Wrath of Khan

1982 PARAMOUNT

Special Effects Supervisor: Bob Dawson. *Special Lighting Effects:* Sam Nicholson. *Special Visual Effects Supervisors:* Jim Veilleux, Ken Ralston. *Optical Photography Supervisor:* Bruce Nicholson. *Matte Artists:* Chris Evans, Frank Ordaz. *Matte Photography:* Neil Krepela. *Supervising Modelmaker:* Steve Gawley. *Model Electronics:* Marty Brenneis. *Animation Supervisor:* Samuel Comstock. *Additional Animation:* V.C.E. *Computer Graphics:* Loren Carpenter, Ed Catmull, Pat Cole, Rob Cook, Tom Duff, Robert D. Poor, Thomas Porter, William Reeves, Alvy Ray Smith. *Starfield Effects by:* Evans & Sutherland Digistar System. *Tactical Displays by:* Evans & Sutherland Picture System (Brent Watson, Steve McAllister, Neil Harrington, Jeri Panek). *Molecular Computer Graphics by:* Computer Graphics Laboratory, University of California, San Francisco (Dr. Robert Langridge). *Pyrotechnics:* Thaine Morris. *Special Visual Effects Produced at Industrial Light & Magic, Marin County, California.*

The most interesting effects in this film are the computer-generated graphics in the "Genesis" sequence. For this second *Star Trek* film, the models from the first film were rebuilt and other new designs created at Industrial Light & Magic. Instrumentation displays aboard the *Enterprise* bridge set were converted to video from rear-projected film loops. Effects filmed in VistaVision. Released in 35mm and 70mm blowup.

Star Trek III: The Search for Spock

1984 PARAMOUNT

Special Effects: Rocky Gehr. *Supervisor of Visual Effects:* Kenneth Ralston. *Optical Photography Supervisor:* Kenneth F. Smith. *Supervising Modelmaker:* Steve Gawley. *Matte Painting Supervisor:* Michael Pangrazio. *Animation Supervisor:* Charles Mullen. *Miniature Pyrotechnics:* Ted Moehnke. *Special Visual Effects Produced at Industrial Light & Magic, Marin County, California.*

Interesting effects sequences include a full-size set that erupts flame and is constantly shaken by earthquakes, a space battle, and the destruction of the *Enterprise*. The "Genesis" computer-graphics sequence is briefly reprised. Effects filmed in VistaVision. Released in 35mm and 70mm blowup.

Star Trek IV: The Voyage Home

1986 PARAMOUNT

Visual Effects Supervisor: Ken Ralston. *Special Effects Supervisor:* Michael Lanteri. *Special Effects:* Clay Pinney, Brian Tipton, Don Elliott, Robert Spurlock, Tim Moran. *Visual Effects Produced at Industrial Light & Magic. Effects Director of Photography:* Don Dow. *Visual Effects Art Director:* Nilo Rodis. *Optical Supervisor:* Ralph Gordon. *Whale Design and Project Supervisor:* Walt Conti. *Visual Effects Editor:* Mike Gleason. *Matte Painting Supervisor:* Chris Evans. *Model Shop Supervisor:* Jeff Mann. *Animation Supervisor:* Ellen Lichtwardt. *Storyboard Artist:* John Bell. *Camera Operators:* Selwyn Eddy III, John V. Fante, Peter Daulton, Toby Heindel, Pat Sweeney. *Optical Camera Operators:* Don Clark, Dave McCue, Jim Hagedorn. *Optical Lineup:* Peg Hunter, Bruce Vecchitto. *Whale Mold Supervisor:* Sean Casey. *Whale Mechanical Designer:* Rick Anderson. *Whale Operators/Puppeteers:* Tony Hudson, Mark Miller. *Underwater Whale Photography:* Pete Romano. *Matte Photography Supervisor:* Craig Barron. *Matte Artists:* Frank Ordaz, Caroleen Green, Sean Joyce. *Matte Photography:* Randy Johnson. *Chief Modelmaker:* Larry Tan. *Modelmakers:* Eric Christensen, Paul Kraus. *Rotoscope Artist:* Ellen Ferguson. *Pyrotechnician:* Bob Finley, Jr. *Time Travel Effects:* ILM Computer Graphics. *Creatures Created by:* Richard Snell Designs (Dale Brady, Craig Caton, Allen Feuerstein, Shannon Shea, Brian Wade, Nancy Nimoy). *Computer Animation and Tactical Displays:* Video Images: (John Wash, Richard Hollander), Novocom, Inc. (Jim Gerken, Mark Peterson, Michael Okuda). *Video Supervisor:* Hal Landaker. *Chief Engineer:* Alan Landaker. *Process Coordinator:* Donald Hansard, Sr.

The crew of the starship *Enterprise* travel back in time to the twentieth century to pick up a pair of humpback whales, which have become extinct in their own time, and return with them as breeding stock. Space sequences are at a minimum this time, with most of the action set in contemporary San Francisco. Except for a few brief shots near the end of the film, the whales are highly detailed and very realistic-looking plastic, radio-controlled models approximately four feet long, crafted by Industrial Light & Magic and capable of swimming under their own power. There are three spectacular matte and miniature shots to watch for: a panning shot across the Vulcan landscape as the *Bird of Prey* wings across the sunset; an establishing shot of the Starfleet Command Center with the Golden Gate Bridge in the background; and, near the end, the *Bird of Prey* swooping out of the storm clouds and crashing into San Francisco Bay under the Golden Gate. There is also an interesting time-

travel effect produced with computer graphics. Filmed in 35mm Panavision and blown-up to 70mm for release.

Star Wars

1977 LUCASFILM LTDS (20TH CENTURY–FOX RELEASE)

Special Photographic Effects Supervisor: John Dykstra. *Special Production and Mechanical Effects Supervisor:* John Stears. *Makeup Supervisor:* Stuart Freeborn. *Composite Optical Photography:* Robert Blalock. *Matte Artist:* Harrison Ellenshaw. *Chief Modelmaker:* Grant McCune. *Animation and Rotoscope Design:* Adam Beckett. *Stop-Motion Animation:* Jon Berg, Phil Tippett. *Miniature Explosions:* Joe Viskocil, Greg Auer. *Computer Animation and Graphic Displays:* Dan O'Bannon, Larry Cuba, John Wash, Jay Teitzell, Image West.

The first film in George Lucas' *Star Wars* series (see entries for *The Empire Strikes Back* and *Return of the Jedi*). It reopened the door to film fantasy and special effects in the late 1970s. It is the showcase film for the first major use of computer-controlled camera systems. Notable sequences include the exciting space battles and explosions, the stop-motion chess sequence, and the computer displays, in particular Larry Cuba's computer rendition of the Death Star plans. Won Academy Award for Best Visual Effects. Effects filmed in VistaVision. Released in 35mm and 70mm blowup.

Superman

1978 WARNER BROS.

Special Effects: Colin Chilvers, John Richardson. *Supervisor of Optical Visual Effects:* Roy Field. *Process Photography Supervisor:* Denys Coop, BSC. *Miniatures Supervisor:* Derek Meddings. *Supervisor of Mattes and Composites:* Les Bowie. *Zoptic Effects:* Zoran Perisic.

Special effects took several jumps forward with this film, principally with the full development of Zoran Perisic's Zoptic front-projection system, which was used for many of the flying sequences. Roy Field had the task of working out blue processes for Superman, who was dressed in blue. Generally excellent miniature work, held-take mattes, and the astounding degree of love and commitment evident in this film raise it above what might have been expected. The opening zoom titles, created on a

computer-controlled Oxberry by R. Greenberg Associates of New York, gave computer-controlled motion graphics a new look. Won Academy Award for Special Achievement in Visual Effects.

Ten Commandments, The

1956 PARAMOUNT

Special Effects: John P. Fulton, ASC. *Rear Projection Process:* Farciot Edouart , ASC. *Optical Supervisor:* Paul Lerpae, ASC. *Matte Camera:* Irmin Roberts, ASC. *Matte Artist:* Jan Domela. *Plate Photography:* Wallace Kelley, ASC. *Modelmaker:* Ivyl Burks.

A Technicolor and VistaVision spectacle of spectacles. Watch the parting of the Red Sea over and over if you can, because you'll never see anything like it again. Top-notch miniature and matte work is also seen in the full-vista shots of the pharaoh's city under construction. Also noteworthy is the burning hail. The film received an Academy Award for Best Special Effects.

Thief of Baghdad, The

1940 UNITED ARTISTS

Special Effects: Lawrence Butler, Tom Howard, Jack Whitney. *Matte Paintings:* W. Percy Day.

Technicolor special effects add much to this fantasy produced by Alexander Korda. Academy Award winner for Best Special Effects.

Thing, The

1982 UNIVERSAL

Special Makeup Effects Created and Designed by: Rob Bottin. *Special Visual Effects by:* Albert Whitlock. *Dimensional Animation Effects Created by:* Randall William Cook.

John Carpenter's remake of the 1951 Howard Hawks classic *The Thing from Another World* (original release title). This version is much closer to the original John W. Campbell story. Visual effects provide truly eye-opening horrors as "the Thing" is depicted in all its guises.

Things to Come

1936 LONDON FILMS

Special Effects: Ned Mann, Lawrence Butler. *Effects Photography:* Edward Colman, ASC, Harry Zech. *Miniature Design:* Ross Jacklin. *Optical Camera:* Jack Thomas. *Matte Paintings:* W. Percy Day.

Alexander Korda's brilliant production of the H. G. Wells story, with a screenplay by Wells. Especially notable in this production is use of precision hanging miniatures to create the illusion of vast, furturistic sets.

This Island Earth

1955 UNIVERSAL

Special Effects: Clifford Stine, ASC, David S. Horsely, ASC. *Mechanical Effects:* Charles Baker.

A 1950s special effects spectacular, this film has it all: flying saucers, alien cities, mutant creatures, weird gadgetry, transformations, fantastic explosions. Of particular interest is the interchanging of the Technicolor dye matrices to achieve interesting color effects. The effects were produced at the Universal studio for a mere $100,000, one-eighth of the film's total budget.

Time Bandits

1981 HANDMADE FILMS (AVCO EMBASSY PICTURES RELEASE)

Special Effects Supervisor: John Bunker.

Well-designed miniatures, optical effects, and physical effects add to the wild delight of this fantasy, directed and co-written (with Michael Palin) by Terry Gilliam of Monty Python. Of particular interest are the effects of time travel and of the live horse breaking through a closet door.

Time Machine, The

1960 MGM

Special Effects: Tim Barr, Wah Chang, Gene Warren.

George Pal's production of the famous H. G. Wells story earned an Academy Award for Best Special Effects. There are many time-lapse

sequences suggesting rapid time travel, as well as a miniature volcanic eruption in London.

tom thumb

1958 MGM

George Pal's first British production won an Oscar for Best Special Effects for supervisor Tom Howard. Optical effects include split-screen shots with the split moving within the frame. Pal's famous Puppetoon animation technique appears in a number of sequences.

Trip to the Moon, A

1902 MÉLIÈS

Georges Méliès' fourteen-minute parody of Wells' and Verne's science fiction novels is still famous today. A magical melange of stage effects and in-camera techniques, this film features perhaps the earliest use of the lap dissolve.

TRON

1982 WALT DISNEY PRODUCTIONS

Supervisors of Visual Effects: Harrison Ellenshaw, Richard W. Taylor. *Computer Animation by:* Digital Effects, Information International, MAGI, Robert Abel & Associates.

A showcase film for computer imagery. Standard animation and graphics effects are combined with computer-generated graphics to create an electronic fantasy world. Filmed in Super Panavision 70. Released in 70mm and 35mm reduction print.

20,000 Leagues Under the Sea

1954 WALT DISNEY PRODUCTIONS

Production Designer: Harper Goff. *Effects Photography:* Ralph Hammeras, ASC. *Special Photographic Processes:* Ub Iwerks. *Special Effects Animation:* John Hench, Josh Meador. *Matte Artist:* Peter Ellenshaw. *Special Mechanical Effects:* Robert A. Mattey. *Squid Sculpture:* Chris Mueller. *Effects Consultants:* Howard and Theodore Lydecker.

Winner of four Academy Awards, including Best Special Effects, this $9 million CinemaScope adaptation of the Jules Verne story has never been

Things to Come

1936 LONDON FILMS

Special Effects: Ned Mann, Lawrence Butler. *Effects Photography:* Edward Colman, ASC, Harry Zech. *Miniature Design:* Ross Jacklin. *Optical Camera:* Jack Thomas. *Matte Paintings:* W. Percy Day.

Alexander Korda's brilliant production of the H. G. Wells story, with a screenplay by Wells. Especially notable in this production is use of precision hanging miniatures to create the illusion of vast, furturistic sets.

This Island Earth

1955 UNIVERSAL

Special Effects: Clifford Stine, ASC, David S. Horsely, ASC. *Mechanical Effects:* Charles Baker.

A 1950s special effects spectacular, this film has it all: flying saucers, alien cities, mutant creatures, weird gadgetry, transformations, fantastic explosions. Of particular interest is the interchanging of the Technicolor dye matrices to achieve interesting color effects. The effects were produced at the Universal studio for a mere $100,000, one-eighth of the film's total budget.

Time Bandits

1981 HANDMADE FILMS (AVCO EMBASSY PICTURES RELEASE)

Special Effects Supervisor: John Bunker.

Well-designed miniatures, optical effects, and physical effects add to the wild delight of this fantasy, directed and co-written (with Michael Palin) by Terry Gilliam of Monty Python. Of particular interest are the effects of time travel and of the live horse breaking through a closet door.

Time Machine, The

1960 MGM

Special Effects: Tim Barr, Wah Chang, Gene Warren.

George Pal's production of the famous H. G. Wells story earned an Academy Award for Best Special Effects. There are many time-lapse

sequences suggesting rapid time travel, as well as a miniature volcanic eruption in London.

tom thumb

1958 MGM

George Pal's first British production won an Oscar for Best Special Effects for supervisor Tom Howard. Optical effects include split-screen shots with the split moving within the frame. Pal's famous Puppetoon animation technique appears in a number of sequences.

Trip to the Moon, A

1902 MÉLIÈS

Georges Méliès' fourteen-minute parody of Wells' and Verne's science fiction novels is still famous today. A magical melange of stage effects and in-camera techniques, this film features perhaps the earliest use of the lap dissolve.

TRON

1982 WALT DISNEY PRODUCTIONS

Supervisors of Visual Effects: Harrison Ellenshaw, Richard W. Taylor. *Computer Animation by:* Digital Effects, Information International, MAGI, Robert Abel & Associates.

A showcase film for computer imagery. Standard animation and graphics effects are combined with computer-generated graphics to create an electronic fantasy world. Filmed in Super Panavision 70. Released in 70mm and 35mm reduction print.

20,000 Leagues Under the Sea

1954 WALT DISNEY PRODUCTIONS

Production Designer: Harper Goff. *Effects Photography:* Ralph Hammeras, ASC. *Special Photographic Processes:* Ub Iwerks. *Special Effects Animation:* John Hench, Josh Meador. *Matte Artist:* Peter Ellenshaw. *Special Mechanical Effects:* Robert A. Mattey. *Squid Sculpture:* Chris Mueller. *Effects Consultants:* Howard and Theodore Lydecker.

Winner of four Academy Awards, including Best Special Effects, this $9 million CinemaScope adaptation of the Jules Verne story has never been

equaled by the Disney studio. Walt Disney and Harper Goff strove for a level of perfection and authenticity that is rarely attained in motion pictures. The climactic battle with the giant squid was shot twice because Walt Disney was not satisfied with the first version, shot against the background of a sunset. At great expense the studio reshot the sequence using a new vacuum- and pressure-controlled squid in a storm simulation. The gloom, howling wind, and crashing waves add immeasurably to the effectiveness of the sequence. With faultless effects, it remains one of the all-time great adventure films.

2001: A Space Odyssey

1968 MGM

Special Effects Supervisors: Wally Veevers, Douglas Trumbull, Con Pederson, Tom Howard.

A legend in special effects filmmaking, it features the earliest use of computer-controlled motion graphics work, large-scale front-projection scenes, and excellent model work. The large-scale physical effects include an enormous centrifuge built for the *Discovery* spacecraft. Filmed

An enormous whirling centrifuge 38 feet in diameter was built for Stanley Kubrick's *2001: A Space Odyssey* (1968) at a cost of $750,000. Kubrick hoped to suggest the creation of artificial gravity in the vacuum of outer space. (*Copyright © 1968 Metro-Goldwyn-Mayer, Inc.*)

A miniature moonscape towers over the astronauts in *2001*. Douglas Trumbull's pioneering work with giant front-projection screens enabled his crew to create vistas that stretched to the horizon within the confines of a studio stage. Some scenes were shot using a giant 40-by-90-foot front-projection screen. (*Copyright © 1968 Metro-Goldwyn-Mayer, Inc.*)

entirely in Super Panavision. Released in single-projector Cinerama, standard 70mm, and 35mm anamorphic.

2010: The Year We Make Contact

1984 MGM/UA

Visual Effects Supervisor: Richard Edlund. *Special Effects Supervisor:* Henry Millar. *Special Effects Assistants:* Dave Blitstein, Andy Evans. *Video Effects Supervisor:* Greg McMurray. *Video Computer Graphics:* Richard E. Hollander. *Computer Graphics Supervisor:* John C. Wash. *Visual Effects Photography:* Dave Stewart. *Matte Department Supervisor:* Neil Krepela. *Mechanical Effects Supervisor (EEG):* Thaine Morris. *Special Projects:* Gary Platek. *Model Shop Supervisor:* Mark Stetson. *Optical Supervisor:* Mark Vargo. *Chief Engineer:* Gene Whiteman. *Animation Supervisors:* Terry Windell, Garry Waller. *Chief Matte Artist:* Matthew Yuricich. *Stop Motion:* Randall William Cook. *Digital Jupiter Simulation:* Digital Productions.

Filmed adaptation of Arthur C. Clarke's novel, *2010,* with Peter Hyams taking on the roles of director, producer, cinematographer, and writer.

Top-notch effects photography simulates the look of space and the Jupiter system by using NASA photographs from the Voyager expeditions. Particularly clever is the effects sequence with actor Roy Scheider as he appears to work with a number of "weightless" ball point pens that are floating in front of his face. Actually, Scheider mimed the action and the pens were added optically in postproduction. Another highlight is the digital simulation of the swirling cloud vortexes on the surface of Jupiter. Special effects were filmed in 65mm and reduced to 35mm anamorphic to match the live-action photography. Released in 35mm anamorphic and 70mm blow-up.

Valley of Gwangi, The

1969 WARNER BROS.

Special Visual Effects: Ray Harryhausen.

Dinosaurs being rounded up and roped by cowboys are the effects highlight of this film. Harryhausen confessed that that sequence alone took him five months of labor in front of the animation camera.

War of the Worlds

1953 PARAMOUNT

Special Effects: Gordon Jennings, ASC. *Effects Photography:* Wallace Kelley, ASC, Irmin Roberts, ASC. *Models:* Ivyl Burks. *Matte Photography:* Paul Lerpae, ASC, Aubrey Law, Jack Caldwell. *Matte Painters:* Chesley Bonestell, Jan Domela, Irmin Roberts.

George Pal's updating of H. G. Well's novel. The Martian invasion is rich in Technicolor animation effects, detailed miniatures, and excellent process photography. Won an Academy Award for Best Special Effects. Gordon Jennings died shortly after the completion of this film.

When Worlds Collide

1951 PARAMOUNT

Special Effects: Gordon Jennings, ASC. *Matte Artist:* Chesley Bonestell.

This George Pal production won an Academy Award for Best Special

Effects. Split-screen model shots add good production value to this screen adaptation of the 1932 novel by Edwin Balmer and Philip Wylie.

Wind, The

1928 MGM

Director of Photography: John Arnold.

No effects credits are listed on this Lillian Gish silent. The film must have required the use of every wind machine in Hollywood to tell the story of a simple Virginia girl adjusting to life on a windswept prairie. Miniatures are used for some shots, including a sequence in which a cyclone tears through a town. The cyclone is an animated effect, not nearly as successful as A. Arnold Gillespie's effort for *The Wizard of Oz* ten years later, but the sequence is brief and it works. There is also a brilliant double-exposure shot of villain Montagu Love, designed to reveal his inner self. Feigning severe injury, he lies on a bed with his face covered. His double-exposed image turns up from the bed and leers into the camera. Throughout the picture, literally tons of sand are hurled through wind machines at windows, walls, and actors. Double-exposed cloud and wind effects add to the atmosphere.

Wonder Man

1945 RKO—RADIO PICTURES

Special Effects: John P. Fulton.

Technicolor split-screen effects with Danny Kaye playing twins. Absolute magic. Won an Academy Award for Best Special Effects.

Wonderful World of the Brothers Grimm, The

1962 MGM

Special Visual Effects: Gene Warren, Wah Chang, Tim Barr, Robert R. Hoag, ASC, Jim Danforth, Don Sahlin, Dave Pal.

Best effects sequences are George Pal's "Cobbler and the Elves" Puppetoon sequence and Jim Danforth's animated dragon in "The Singing Bone" sequence. Originally filmed in three-panel Cinerama, this seldom-seen film is still available in printed-down 35mm anamorphic versions.

Young Sherlock Holmes

1985 PARAMOUNT

Supervisor of Visual Effects: Dennis Muren. *Optical Supervisor:* John Ellis. *Creature Fabrication:* David Sosalla. *Pastry Sequence: Motion Supervisor:* David Allen; *Effects Cameraman:* Scott Farrar. *Glass Man Sequence: Pixar Computer Animation:* Bill Reeves, John Lasseter, David DeFrancesco, Eben Ostby, David Salesin, Robert Cook, Don Conway, Craig Good. *Happy Sequence: Effects Cameraman:* Michael Owens; *Go-Motion Animation:* Harry Walton. *Visual Effects Produced at Industrial Light & Magic, Marin County, California.*

Magnificently seamless blending of live action and special effects. Computer animation, rod puppetry, and go-motion mixed with extraordinary artistry produce highly dramatic and original fantasy effects. Best effect moments are the computer-animated stained-glass knight and the attack of the French pastries.

GLOSSARY

Academy aperture. In modern 35mm film, the full rectangular picture area framing an image approximately 5/8 inch high by 7/8 inch wide. This is slightly smaller than the original Edison aperture, which was approximately 3/4 inch high by 1 inch wide. The smaller Academy aperture preserves the 1.33:1 aspect ratio but allows room for the sound-track area, which runs along the left inside edge of the film perforations.

Anamorphic lens. A special lens that is used to create wide-screen pictures, usually with an aspect ratio of 2.35:1. The anamorphic lens squeezes the image horizontally to take in a wider field of view. All the images on the frame appear to be very tall and skinny—squeezed. Another anamorphic lens is used on the projector in the theater to unsqueeze the image, spreading it out to its full width. This technique was created by Henri Chrétien in the mid-1920s. His lens was adopted by 20th Century–Fox in the early 1950s and became known as CinemaScope. Many different companies produce anamorphic lenses today, using such trade names as Panavision, Technovision, and Technirama.

Animation effects. A special effects technique that uses hand-drawn art or mattes to create various visual effects. The laser beams in the *Star Wars* films are classic examples of this type of effect.

Animation stand. A motion picture camera, equipped for single-frame exposure, mounted on a stand, usually vertically. The camera is most commonly used to shoot cartoon animation. In the United States, an animation stand designed by the late John W. Oxberry continues to be

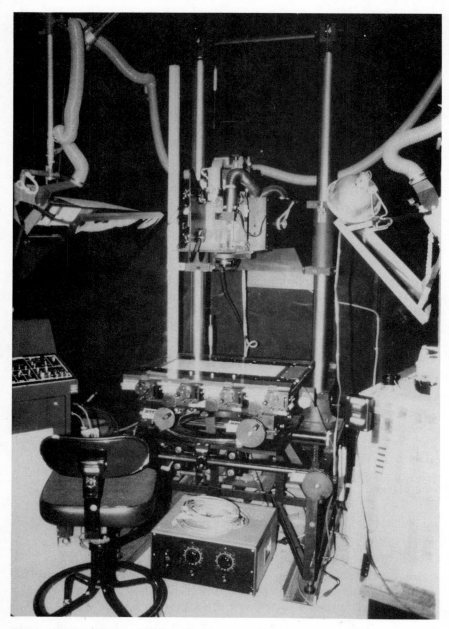

An animation stand is the workhorse of today's special effects artists. These extremely versatile tools were originally designed for shooting flat artwork, but now they are used for everything from rotoscoping to making blue-screen shots.

very popular in special effects studios. In Great Britain an animation stand is also known as a camera rostrum.

Arrêt. French for a halt or stop. This is one of the early techniques that Georges Méliès put to good use in his trick films. A portion of a scene is filmed, the camera is stopped, an object is removed or added to the scene, and then the camera is started again. Seen in projection, objects can be made to appear or vanish mysteriously. William S. Porter used this technique in his landmark production of *The Great Train Robbery* (1903). During a fight in the rear of the locomotive, one of the train crew is beaten senseless by the robbers and thrown off the moving train. Porter used the *arrêt* technique, stopping the camera to replace the actor with a dummy that is thrown off the train. The shot gets a laugh today, since the dummy is obviously a dummy, but in those days audiences were shocked. The technique has been polished a bit and is still in use today.

Aspect ratio. The ratio of the height to the width of the picture frame, both on the film and as projected in the theater. Aspect ratios in common use today are: 2.35:1, 2.2:1, 2:1, 1.85:1, 1.66:1, and 1.33:1. Often only the first number is used to describe the picture format; for example, a filmmaker may say, "I'm shooting 1.66."

Bi-pack matting. An optical-printer effects technique by which two films are threaded in contact with each other in either the camera or projection film gate. This is the basic technique that produces such optical effects as wipes and titles. The technique was also integral to many obsolete traveling-matte systems, such as the Dunning process, but it is still used today in more modern systems. The late Wally Veevers of England was highly skilled in bi-pack camera techniques.

Blowup. An optical process in which the image is physically enlarged. This technique is commonly used to create 70mm release prints from 35mm original films. Films such as *E.T., Altered States,* the *Star Wars* trilogy, and others were shot on 35mm film and blown up to 70mm for release. Usually the reason for making a 70mm blowup release is to take advantage of the superior sound-track capabilities of the six magnetic tracks on 70mm prints. Sometimes the 70mm blowup print suffers slightly in image quality in comparison to the 35mm print. Films both shot and released in 70mm include *Lawrence of Arabia* (1962), *Battle of the Bulge* (1965), *Ben Hur* (1959), *My Fair Lady* (1964), *Oklahoma!* (1955), and *2001: A Space Odyssey* (1968).

Blue-screen shot. A common method of producing a traveling matte. The foreground elements are shot against an illuminated blue screen. Mattes are extracted from this original negative and are used to com-

bine the foreground images with a previously photographed background plate.

CinemaScope. CinemaScope was 20th Century–Fox's answer to Cinerama and 3-D in the early 1950s. It was the first commercially successful wide-screen process. A special anamorphic lens system, developed by Henri Chrétien in 1931, was used to film *The Robe,* the first CinemaScope feature. This lens effectively doubled the width of the projected image to an aspect ratio of 2.66:1; in practice, this enormous width was reduced slightly by the magnetic sound track, which encroached on the image area, reducing the aspect ratio to 2.55:1. Few screens of the day were able to accommodate such a wide image, and projectionists often had to cut off part of the picture. Audiences would be mystified to hear principal characters speaking "offscreen." Over the years, this width has been chopped down to 2.35:1, which is the current wide-screen standard. A related system, CinemaScope 55, used a negative 55.6mm wide. The negative image area was four times that of 35mm Cinema-Scope (twice as high and twice as wide), the camera lens still incorporated a 2:1 squeeze, and each frame was eight perforations high. 20th Century–Fox used the process for only two films, *Carousel* (1956) and *The King and I* (1956), then dropped it in favor of Todd-AO, another large-negative, but nonanamorphic, process. Standard CinemaScope survived at Fox until 1962, when it was abandoned in favor of Panavision.

Cinerama. The first commercially successful multiple-camera/multiple-screen process. *This Is Cinerama* opened at New York City's Broadway Theater on September 30, 1952, and played for a record 2,165 showings before being replaced by a second Cinerama feature, *Cinerama Holiday* (1955). Invented by Fred Waller, the process uses three cameras, one of which faces directly ahead, while the other two record the scene immediately to the left and right of the center camera. Each frame of film is six perforations high running at a speed of 26 frames per second. In the theater the three films are projected simultaneously, side-by-side on a deeply curved screen. The three images blend together to form one enormous panorama covering 146 degrees in the horizontal and 55 degrees in the vertical plane. The six sound tracks are played back on a separate 35mm film in synchronization with the three film projectors. The impact of the process was enormous and box office records were set wherever Cinerama films were shown. Other titles filmed in three-panel Cinerama include *Seven Wonders of the World* (1955), *Search for Paradise* (1957), *South Seas Adventure* (1958), *How the West Was Won* (1962), and *The Wonderful World of the Brothers Grimm* (1962). After these last two films, the Cinerama Company stopped making films in its three-panel process (switching instead to a single-camera,

70mm anamorphic process) and the depth of the screen was reduced. The multi-channel sound was retained, but now the film itself was magnetically stripped, carrying six channels of sound. The new frame rate was changed to the standard 24 frames per second and the frame height was slightly reduced to five perforations. Ancestors of the Cinerama process include Abel Gance's Polyvision, which was used for *Napoleon* (1927). Polyvision involved not only three-panel panorama scenes, but also simultaneously projected three distinct but related images, triptych style. At the 1939 World's Fair in New York, audiences thrilled to inventor Fred Waller's early version of Cinerama. Called Vitarama, it involved eleven projectors throwing an image on an immense curved arc covered by a quarter of a dome. Today, descendants of the Cinerama system can be seen at some theme parks and world's fairs.

Circle-Vision 360. A special exhibition process utilized by Walt Disney Productions for use in their theme parks. The system uses nine 35mm motion picture cameras arrayed in a circle photographing a full 360-degree panorama. Each 35mm Mitchell camera is mounted around a central post; a single motor operates all nine cameras synchronously. The cameras are pointed upward into a carousel of front-surface mirrors, each of which captures a 40-degree slice of the action (one-ninth of 360 degrees). The theater is an immense circular arena with the audience watching from the center. The nine screens completely surround the viewer with a wraparound image that effectively places the audience in the center of the action. The sound track is carried on a separate magnetic film. Some current Disney installations are using digital sound systems for "ultimate" fidelity sound. The principle of the 360-degree motion picture dates from Raoul Grimoin-Sanson's Cineorama, which used 10 projectors to create a wraparound experience at the 1900 Paris Exhibition. An early version of Disney's Circle-Vision was unveiled at the 1958 Brussels World's Fair, where it was known as Circarama.

Clarke process. An Academy Award–winning process developed in the early 1940s by Charles G. Clarke, ASC, of 20th Century–Fox for the addition of dramatic or pleasing cloud formations to a shot. A large glass-plate transparency (approximately 16 by 20 inches) is placed in front of the camera. The top half of the glass plate includes the cloud formations, while the bottom half is clear. If the bottom of the cloud formations is aligned with the horizon, live action in the bottom half of the frame can be recorded normally, while dramatic cloud effects are filmed in the upper half of the frame. Clarke worked as an effects cameraman on dozens of films, but is best remembered for the sandstorm in *Suez* (1938) and the matte effects in *The Red Dance* (1928). His

career in film began after futile attempts to break into the theater as an actor. In 1919 he started as a laboratory assistant for D. W. Griffith productions, quickly advanced to assistant cameraman, and by the early 1920s was director of photography. His films include *Captain from Castile* (1947), *Destination Gobi* (1953), *Prince of Players* (1955), *The Man in the Gray Flannel Suit* (1956), and *Carousel* (1956).

Color-difference process. An improved version of the standard blue-screen traveling-matte process, which allows the use of such normally difficult blue-screen subjects as smoke and water with little or no blue fringing around the matted objects. The original process was developed in the 1950s and patented by Petro Vlahos in 1964. The technique has undergone many refinements over the years.

Complementary colors. Three colors that result when the three additive primaries are subtracted from the color spectrum: minus green (magenta), minus red (cyan), and minus blue (yellow).

Computer-controlled camera. The means by which camera moves are electronically recorded for precision multiple-pass photography. By the use of such systems, complicated moving-camera effects shots can be achieved, thereby creating a sense of fluid camera motion in the same style as traditional live-action photography. Early models of camera-motion recorders were in use in the 1950s, but the big boom in the technique began with *Star Wars* (1977) and what was known as the Dykstraflex camera, named after John Dykstra, that picture's special effects supervisor.

Computer scene simulation. The technique of using computer graphics and imaging programs to simulate the photography of real objects. For example, if a film such as *Star Wars* had used computer scene simulation, models of the X-wing fighter craft, the *Millennium Falcon,* and the Death Star would not have been built. Instead, their images would have been created by computer programs and been colored and moved by computers in whatever fashion called for by the script. Computer-realized objects and scenes can be moved and manipulated with far greater ease than real models, as in the space battle sequences in *The Last Starfighter.* Also, many more dramatic effects and moves are possible in computer scene simulation.

Dailies. Each day's exposed film, rushed to the laboratory, developed, and printed for viewing the next day by the director, cinematographer, and other production personnel. Also called *rushes.*

Depth of field. The range of distances from the camera in which objects are in satisfactory focus. For example, if the camera is focused on an

object about 10 feet away, other objects a short distance in front of and behind that object will also be in satisfactory focus. The depth of field can be either very shallow, mere inches or feet, or very deep, extending to infinity.

Dialogue replacement. The recording of dialogue in an acoustically ideal studio, with the actors timing their delivery to match their previously filmed lip movements. Often used in films shot on location outside of the studio or in noisy environments, which are likely to suffer from poor sound tracks. Also called *dubbing* or *looping.*

Dissolve. A very common optical effect in which one image slowly replaces another image superimposed on the screen. Sometimes called a *lap dissolve.*

Dolby stereo. A high-fidelity stereo sound process for motion pictures. In 35mm release prints there are two optical sound tracks, which are recorded and encoded in such a way that Dolby sound processors in the theater can play them back with high-fidelity quality on as many as four channels: left, center, right, and "surround." In 70mm release prints, Dolby stereo uses six magnetic tracks to produce wide-range, extreme high-fidelity multi-channel sound. The first feature film with Dolby encoded stereo-optical sound track for general release was Ken Russell's *Lisztomania* (1975). Other films noted for their Dolby sound tracks include *Apocalypse Now,* the *Star Wars* films, *Close Encounters of the Third Kind,* and *Superman.*

Dolly. A small, wheeled vehicle for moving the camera very smoothly during a shot. The dolly is often equipped with a boom on which the camera is mounted. The dolly also accommodates a camera operator and assistant.

Double exposure. An in-camera effects technique by which two images are superimposed on the same frame of film. Among the oldest of photographic effects techniques, it is the traditional technique for obtaining ghost effects.

Dunning process. A self-matting background composite process for black-and-white films patented by C. Dodge Dunning in 1927, when he was only seventeen. The process allows the camera to film actors on a sound stage and combine them in-camera with previously photographed background footage. The process can be seen in *King Kong* (1933), *Anna Christie* (1930), *Trader Horn* (1931), and *Tarzan, the Ape Man* (1932). A special bi-back camera was used for Dunning shots; it held a yellow-orange-dyed positive of the background scene in contact with the raw negative stock. The actors and foreground set objects are bathed in

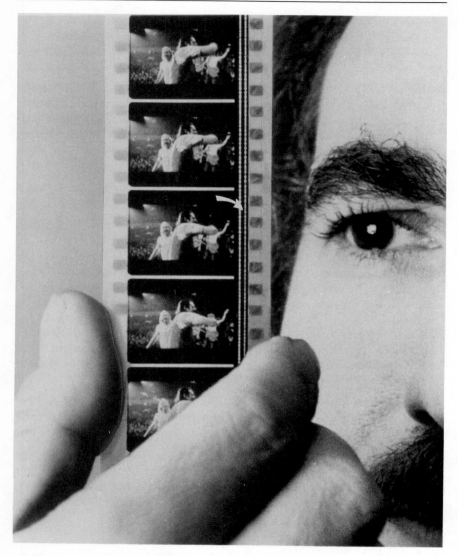

The Dolby Stereo optical sound track is visible to the right of the
image area in this strip of 35mm film. The narrow parallel lines
carry the sound information (arrow). When the film is shown, light
passes through the clear portions of the sound track, causing the
light intensity to vary. The two light signals are then converted into
electrical signals by photo cells. The Dolby Stereo processor analyzes
the signals and directs them to the left, center, and right loudspeak-
ers behind the movie screen and to the surround speakers in the
theater auditorium. (*Courtesy Dolby Laboratories*)

yellow-orange light, but the background is a large blue screen. The blue screen acts as a printing light, transferring the image of the yellow-orange background positive to the raw negative in the camera. The actors and foreground block the blue light and are recorded on the negative, normally. When the film is developed and printed, the actors appear to be working in front of whatever background scene was loaded into the camera. No further optical steps are necessary to complete the composite. Greta Garbo and Charles Bickford can be seen playing out scenes in *Anna Christie* that appear to have been shot in New York Harbor. But the Dunning process allowed the actors to remain in Culver City on the MGM sound stages, the background footage having been previously shot. The technique had its heyday in the early 1930s but was eventually replaced with rear-screen projection and other traveling-matte processes. While the Dunning process usually yielded acceptable results, it can be said that in actuality it worked better in theory than in practice.

Film gate. The device that holds motion picture film flat at the aperture of a camera or projector.

Foot-candle. A measure of illumination, equivalent to the amount of light produced by a source of one candle at a distance of one foot. Candle power refers to the luminous intensity of any light source. Cinematographers often measure the illumination of studio sets with a foot-candle meter.

Front projection. A technique of process projection, developed in the 1950s, that allows actors and foreground objects to be filmed in front of a highly reflective screen onto which a previously filmed background is projected from the front. Front projection has an advantage over rear-screen projection when very large vistas are required. The technique was particularly well used in *2001: A Space Odyssey* (1968) for the shots involving wide vistas of the great African Plains in the Dawn of Man sequence.

Glass shot. An in-camera technique that combines scenic elements painted on a large sheet of glass with live-action studio or location photography. The process was adapted from still photographic techniques in the last century and is still in use today. Early uses included the finishing out of architectural details on back-lot sets or locations. One of the earliest and most famous recorded uses was in Norman Dawn's *Missions of California* (1907), in which the technique was used to "restore" ruined and crumbling missions to their former glory for the camera.

Hanging miniature. An in-camera special effect similar in principle to the glass shot, but instead of the live-action set being finished out with

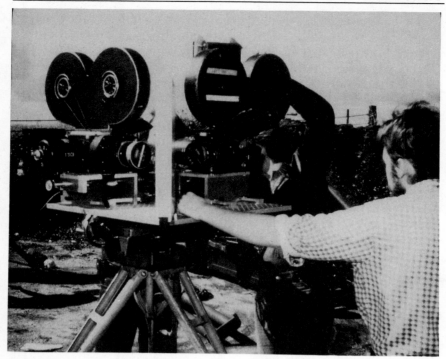

Twin cameras are used to shoot 3-D films, one camera for the image that each eye will see.

a painting on glass placed between the camera and the set, a forced-perspective model is used. For example, only the lower section of a castle wall may be built for a scene, and a miniature model of towers and rooftops is hung a short distance in front of the camera to complete the image of the castle. The model must be perfectly constructed in forced perspective to match the live-action set and must be properly lit to blend imperceptibly with reality. Films that make good use of forced-perspective miniatures include *Things to Come* (1936) and *Beastmaster* (1983).

Held take. A take that is not developed and printed immediately after being shot; instead the film is "held" for a second exposure, usually a matte painting. Matte artist Albert Whitlock is well known for his held-take matte shots. Also called a "latent image shot."

Imax. A large-format special-exhibition process that utilizes 65mm film stock. The film runs through the camera horizontally at the standard speed of 24 frames per second, but each frame is fifteen perforations high (or three times the size of a normal 65mm frame) and ten times larger than the standard 35mm frame. The image is projected on a gargantuan screen (50 by 75 feet at the Smithsonian Institution in Washington, D.C.), engulfing the audience in the image. The rearmost seat is only 75 feet away from the screen. The six sound tracks are not printed with the image on the film, but on 35mm sprocketed fullcoat magnetic film, which is run in interlocked synchronization with the film. The system debuted in 1970 at the Osaka Exposition and has expanded into more than a dozen special-exhibition installations around the world. An adaptation of the Imax format permits projection on a dome screen and is called Omnimax. Most films are less than 30 minutes long and include such titles as *Catch the Sun* (1973), *Volcano* (1973), *To Fly* (1976), *Living Planet* (1979), *Hail Columbia* (1982), *Behold Hawaii* (1982), and *The Dream Is Alive* (1985), which includes footage actually shot in space. Other Imax installations can be found in Los Angeles, New York, and Denver.

In-camera effects. A special effect that is produced without any postproduction optical work. In-camera effects include held takes, split-screen shots, double exposures, colored-filter effects, perspective shots, Clarke process, and rear-screen and front-projection process shots. Many of these techniques date from the earliest days of still photography.

Interpositive. An intermediate color positive print made from the original camera negative. The interpositive is used to produce a series of duplicate negatives from which the release prints will be made. Frequently, postproduction special effects are composited while the interpositive is being made.

Latent image shot. See *held take.*

Magicam. A camera system patented by Douglas Trumbull, Dan Slater, Joseph L. Matza, and John C. Gale for compositing live action and miniatures. The system interlocks electronically two cameras, one for the live action and one for the miniature background. All movements made by the live-action camera are duplicated in scale by the camera on the background miniature. Extremely realistic live-action and miniature special effects sequences can be created with this system. An example is the PBS *Cosmos* series, in which Carl Sagan appears to be strolling through the vast spaces of the ancient Library of Alexandria. In actuality, Sagan strolled around a large blue-screen stage with a few

props and benches; the Magicam composite-camera system placed him into a table-top miniature of the library and tracked his movements in perfect scale throughout the miniature.

Matte. A device used to obstruct light and prevent it from exposing a portion of the frame. The matte can be something as simple as a piece of black cardboard placed in front of the lens to block out part of a scene that will be "matted-in" later. A female matte, or cover matte is used to create a black or opaque background and a clear "window" for the foreground elements. A male matte, or counter matte, is used to create a clear background and black or opaque silhouettes of the foreground elements.

Matte box. A device mounted in front of the camera lens that can hold a variety of filters and mattes for in-camera effects. The matte box often doubles as a sunshade for the camera lens.

Matte painting. A painting produced by a special effects artist that is designed to replace or fill out some part of the image. Sometimes the entire image can be a painting depicting a scene that either does not exist or can not be filmed without great expense or inconvenience. Such "full paintings" are often used for establishing shots.

Nodal pan. A pan that is made with the camera mounted on a specially designed head so that the axis of the pan is coincident with the nodal point, or optical center, of the lens. Such pans result in a view in which there is no change in the perspective and in the relative placement of foreground and background elements in a shot. A nodal pan must be used when the camera is panning during a shot that involves a hanging miniature.

Optical effects. Any special photographic effect that is produced during postproduction and is composited on an optical printer or with a bi-pack printer. Optical effects are distinguished from *physical effects*.

Overcranking. Running film through a camera faster than the normal speed of 24 frames per second, such as 48, 96, or 120 frames per second. When an overcranked scene is projected in a theater at normal frame rate, the action appears to slow down. This technique is often used to photograph miniatures. The term "cranking" harkens back to the early days of cinematography, when cameras were turned or cranked by hand. Not long after the turn of the century, during the silent era, an approximate speed of 1 foot of film (16 frames) per second was the general standard. Cinematographers had to rely on experience to crank film at the proper speed.

Pan. To pivot the camera in a horizontal plane. The word is derived from "panorama." The term is sometimes used to refer to camera pivots in other than the horizontal plane.

Panavision. A company founded by Robert E. Gottschalk in 1953 that became noted for its extremely sharp and distortion-free anamorphic lenses, which eventually won out over the CinemaScope lens. The company has also become famous for its high-quality motion picture cameras, which it rents but does not sell, a practice by which it seeks to maintain the quality of the equipment. Today the company produces high-quality lenses and cameras for 35mm and 65mm film with both anamorphic and spherical lenses. "Filmed in Panavision" in the credits means that the movie was shot with Panavision 35mm equipment. See also *Super Panavision* and *Ultra Panavision*.

Perspecta Sound. A pseudo-stereo sound system invented in the mid-1950s that uses a single optical track with three sub-audible control tones, which shifted specific sounds to left, center, or right speakers in the theater.

Physical effects. Any of a broad category of special effects that are produced "live" for the cameras. These include atmospheric effects such as rain or snow, explosions, breakaways, and special mechanical rigs. In England physical effects are sometimes called *floor effects,* meaning that they are created on the floor, or stage. Physical effects are distinguished from *optical effects.*

Pilot-pin registration. A technique, required for most special effects, in which a camera is equipped with special pins positioned near the aperture that engage the perforations of each frame of film, holding it steady and in a precise position during exposure.

Pixilation. An animation technique in which live-action scenes are filmed one frame at a time or in short bursts of a few frames. Alternatively, the technique can be created in editing or on an optical printer by removing frames of film from a sequence. The technique has numerous uses, but the most commonly seen effect involves shooting a frame or two of film every time an actor jumps in the air. When this process is repeated many times, the actor appears to be floating in the air when the film is projected.

Plate. A motion picture positive print that is used for process backgrounds. A plate is usually shot with a special camera that uses pilot pins to produce extremely steady images.

Playback. A technique, most often used for filming musical sequences, in which the music or vocals, or both, are prerecorded and played back during the filming of the action. This technique allows the director to concentrate on getting a good take of the action without having to worry about the quality of the music and vocal tracks, since they have been previously recorded under ideal conditions. The playback is used to maintain action and lip sync during the shooting of the live action. The sound track and image are conformed in postproduction.

Process projection. See *front projection* and *rear-screen projection*.

Pulldown. The action of an intermittent sprocket or claw in the film gate that brings each frame of film into position for exposure or projection.

Rear-screen projection. A technique by which a previously filmed scene is projected onto a translucent screen which has been built into part of a studio set. The most common use of this technique is the shipboard scene, in which two actors may be talking at the rail, while in the background we see a moonlit sky and waves. The sky and waves are a rear-screen, or process, projection.

Release print. The final composite (sound and picture) print produced for general theatrical distribution and exhibition.

Rotoscope. A technique patented by Max Fleischer in which live-action film is projected a frame at a time onto a drawing table so that an artist can trace the image. The technique is often used in special effects for creating mattes in previously filmed scenes, thus solving difficult animation problems involving human characters or difficult perspective changes.

Saunders screen. An improvement on the rear-projection process developed by Sidney Saunders of RKO (with Fred Jackman of Warners and George J. Teague of Fox). Heavy, cumbersome, grainy ground-glass screens were replaced with large, lightweight rear-projection screens made from cellulose. The screen was known as the Saunders screen. Rear-screen projection has largely been replaced by front projection and traveling-matte techniques.

Schufftan shot. An in-camera special effects technique named for cameraman Eugen Schufftan and first used successfully in Fritz Lang's *Metropolis* (1927). A Schufftan shot combines miniature scenery and live action with a mirror placed at a 45-degree angle in front of the camera. The mirror reflects the image of the miniature set into the lens of the camera, and the live action is seen through a gap in the mirror made by scraping a small amount of silver off the back. The classic example involves a shot of live action seen through a castle gate. The castle is

MAX FLEISCHER

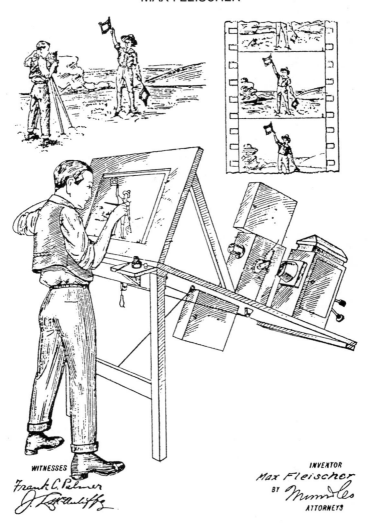

WITNESSES

Frank C. Palmer

J. R. Rawcliffe

INVENTOR

Max Fleischer

BY *Munn & Co.*

ATTORNEYS

reflected in the mirror, and the live action takes place in the gap where the silver has been scraped off, precisely where the opening of the castle gate should be. The advantage of the technique is that the silver edge in the mirror is out of focus, thereby making it possible to achieve a soft blend between the miniature set and the live action. This technique was brilliantly used by Peter Ellenshaw in Disney's *Darby O'Gill and the Little People* (1959).

Separation negatives. A set of three black-and-white negatives, usually prepared from the master positive, each of which represents a record of one of the three primary colors—red, green, and blue. In the early days of Technicolor these negatives were created in the camera and were used to produce the dye matrices for the Technicolor imbibition process. Today separation negatives are used in some special effects processes and serve as an archival storage medium for the completed film.

Shooting script. The final, working version of the script, used by the director and the cinematographer during the shooting of the film. The script details each shot by number and describes the scene, dialogue, sound effects, and visual effects.

Showscan. A film production process, developed by Douglas Trumbull, that boasts extremely high image quality and brightness. The camera utilizes 65mm film running at 60 frames per second; in the theater, the film is projected at this same high speed on a very large screen. An average 500-seat Showscan theater would require a screen approximately 34 feet high and 75 feet wide (a normal theater screen for an audience of this size would be 19 feet by 35 feet). Showscan has been developed primarily for special applications including theme parks and World Fairs that regularly make use of spectacular large-screen processes.

Slitscan. A technique developed by Douglas Trumbull for *2001: A Space Odyssey* and based upon the experimental film work of John Whitney and others. Artwork or colored light is photographed as a streak with a lengthy exposure. Successive frames are taken with slight changes in the position of the streak (by moving either the camera or the artwork). When projected, the film appears to have recorded animated planes of light. It was first used to create the corridors of light in the star-gate sequence at the end of *2001*. Trumbull and others have made use of the technique in subsequent films, and it has become a basic tool of computer motion graphics.

Sodium vapor process. A self-matting process currently licensed to Walt Disney Productions and best known for its use in *Mary Poppins* (1964).

The foreground action is photographed in front of a bright yellow screen illuminated by sodium vapor lamps. A camera, adapted from the old Technicolor camera, is loaded with two film magazines—one roll of color negative and one roll of black-and-white negative. A special prism and filter direct the bright yellow light to the black-and-white negative to create a traveling matte and direct the light from the foreground image to the color negative in order to record the color foreground image. The matte produced is of exceedingly high quality. The system's major disadvantage is that the camera will not take an anamorphic lens.

Split screen. The technique of creating an invisible split in the image for the purpose of "marrying" two different images. The technique is commonly used when an actor has to appear in the same scene with a dangerous animal. Animal and actor are filmed separately, for example with the actor in the left half of the frame and the animal in the right. In postproduction an optical printer combines the left and right halves into a seamless whole so that animal and actor appear to be in the same shot simultaneously. The technique has been used in such films as *Bringing Up Baby* (1938), *Forbidden Planet* (1956), and *Krull* (1983).

Stereoscopic projection. See *3-D*.

Stock footage. Library footage of scenes and locales that is available to filmmakers, who use it instead of going to the trouble and expense of shooting it anew. Generally, stock footage consists of generic scenes, such as New York City street traffic or Iowa cornfields. Effects sequences, particularly destruction sequences, sometimes become stock footage. An unusual example is the futuristic cityscape footage created for Fox's musical *Just Imagine* (1930), which later appeared as stock footage in Buck Rogers and Flash Gordon serials.

Stop-motion animation. An animation technique that involves shooting one frame at a time, usually of tabletop miniature setups. The classic use of this technique is in model animation, the creation of apparent motion by using miniatures sculpted out of clay or cast in foam latex, photographing tiny changes in their positions frame by frame.

Storyboard. A series of sketches illustrating key moments in the action of a film. Storyboards are most often used for animated films, but it is not uncommon for live-action films to be storyboarded, too.

Super Panavision. A 65mm non-anamorphic-camera process, which is printed on slightly wider 70mm film to allow more room for the magnetic sound tracks. The frame height is five perforations and the aspect ratio is 2.2:1. Super Panavision was created in the mid-1950s, but 65mm

giant-screen systems date from the 1920s. The Fox Grandeur cameras used 65mm film to shoot *Fox Movietone Follies of 1929*, *Happy Days* (1929), and *The Big Trail* (1930). Other 65mm films of the era include *The Bat Whispers* (1930), *Kismet* (1930), and *The Lash* (1931). The big-film format did not really achieve success until the advent of Todd-AO in 1955.

SuperScope. An obsolete wide-screen anamorphic projection system designed by Joseph and Irving Tushinsky and adopted by RKO in the mid-1950s. The projection system involved a variable aspect-ratio projection lens and was used in such films as *Underwater!* (1955), *Son of Sinbad* (1955), *Vera Cruz* (1954), and *Slightly Scarlet* (1956). The camera used a normal spherical lens, exposing the image from sprocket hole to sprocket hole. Anamorphosis was introduced at the printing stage either as "standard" SuperScope (which could be shown at any aspect ratio from 1.75:1 to 2:1) or SuperScope-235 (which could be shown at any aspect ratio from 2:1 to 2.35:1). The advantage of the system lay in its combination of standard spherical lenses and camera technique during shooting with wide-screen projection for release. In the mid-1950s both *Fantasia* (1940) and *Henry V* (1945) were optically reprinted for release in SuperScope. The process was eventually dropped in favor of Panavision equipment and lenses.

Super Techniscope. A very recent adaptation of the old SuperScope process. First used by cinematographer John Alcott on *Greystoke* (1984) and then again for Disney's *Baby* (1985). The 35mm film is exposed across the full width from sprocket hole to sprocket hole. The camera's viewfinder is marked for 2.35:1, but the camera aperture is masked to approximately 1.66:1. Normal 35mm anamorphic release prints are prepared by blowing up the image slightly and adding the anamorphic squeeze; 70mm release prints can be made by enlarging the image and printing without anamorphosis. The advantages of the process are twofold: first, the process enables the cameraman to use high-speed spherical lenses, which are necessary in low-light situations, such as were encountered in the jungles in both *Greystoke* and *Baby;* second, the extra headroom on the negative with the 1.66 masking means that the film can easily be shown on television without a lot of optical panning and scanning, which is usually necessary with wide-screen films.

Swish pan. A very rapid panning motion that blurs the action into a streak. Most often used to blend two scenes together, suggesting rapid movement from one locale to another.

Take. A single, continuous piece of action recorded on camera. Many takes of each scene in the script may be made until the director is satisfied.

Technicolor. The most famous of all color film processes. The inventors, Herbert T. Kalmus and Daniel F. Comstock, produced their first primitive color picture in 1917, but it was not until 1932 that the full three-color process was available and used by Walt Disney in his cartoon short *Flowers and Trees* (1932). The Technicolor camera used three black-and-white negatives to capture the three primary colors of a scene (red, green and blue). From these black-and-white negatives were created dye matrices, which were used like printing plates to transfer colored dyes to sprocketed movie film. The process has never been equaled for either the brilliance of the color or the permanence of the dyes in the print. In the mid-1950s, Kodak's Eastman color negative began to be the preferred camera stock when CinemaScope became popular. Eastman color was cheaper and worked better in low light situations than Technicolor. As a result, Technicolor began to phase out their camera department and concentrated on making dye imbibition prints for release. By the mid-1970s, though, Technicolor shut down the process completely in favor of the cheaper Eastman Color process. Today, the only laboratory left in the world that produces true Technicolor-style dye imbibition prints is located in China.

Technirama. A wide-screen camera format unveiled by Technicolor in 1957. The film travels through the camera horizontally in a manner similar to Paramount's VistaVision process. The camera uses an anamorphic lens with a 50 percent compression. Release prints are created with a 90-degree rotation of the image in the optical printer and an additional 33 percent squeeze to obtain standard 35mm anamorphic (2:1 compression) prints. The process is particularly useful for making blowup prints to conventional 70mm unsqueezed. In this format the process is referred to as Technirama 70. Pioneer Technirama films include *Sayonara* (1957), *Legend of the Lost* (1957), *The Monte Carlo Story* (1957), and *Night Passage* (1957). Technirama 70 productions include *Spartacus* (1960), *Sleeping Beauty* (1959), *Solomon and Sheba* (1959), *Barabbas* (1962) and *The Black Cauldron* (1985).

Techniscope. A budget-conscious 35mm system developed by Technicolor (Italy) that uses ordinary 35mm color negative film (not three-strip Technicolor) in a specially modified camera with spherical lenses. The film gate and pulldown are modified to a height of two perforations from the standard height of four perforations. Release prints created by Technicolor involve a blowup and compression to create standard 35mm four-perf anamorphic projection prints. The advantage of the Techniscope camera is an immediate saving of 50 percent on film stock, a smaller and quieter camera, the use of standard high-quality spherical and zoom lenses, and the relative ease

of creating release prints in a variety of formats covering TV and
16mm release. It was the favorite system used by Italian producers of
"spaghetti Westerns." The process has been available since 1964 and is
still in use today.

3-D. The popular name for *stereoscopic projection*. The earliest 3-D films
were exhibited by the Lumière brothers in 1903. Since that time, 3-D
has reappeared in cycles about every fifteen to twenty years. Basically,
twin cameras or twin lenses record separate images for the right and
left eyes. In the theater twin projectors or twin-lensed projectors su-
perimpose the two images on a silver screen. Audience members don
special Polaroid glasses to view the 3-D effect. Most producers have
used the medium to produce cheap, exploitation horror and porno-
graphic films. Russian filmmakers have held the process in greater
regard, using it, for example, in *Robinson Crusoe* (1946), *Aleko, Lalim,*
and *Night in May* (all 1948). British filmmakers created the first 3-D
animated cartoon. In the United States notable 3-D films include

Apogee's front-projection camera rig with a standard Panavision
camera mounted on top. The background plate is wound on the
cores visible in the lower half of the rig. This system uses the eight-
perf VistaVision format for its background plates.

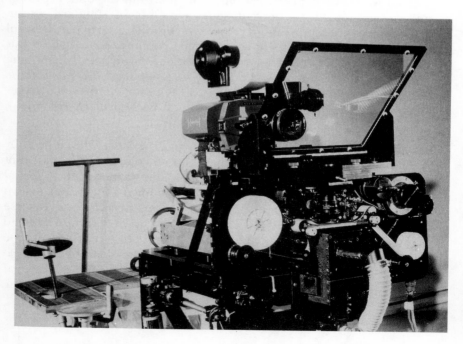

Hitchcock's *Dial M for Murder* (1954), MGM's *Kiss Me Kate* (1954), Universal's *Creature from the Black Lagoon* (1954), Warner's *Hondo* (1953), and *House of Wax* (1953). Among the best 3-D films are those made for special exhibitions and amusement parks. EPCOT Center's *Magic Journeys* combines complicated optical effects, live action, and computer animation in a brilliant twin 70mm 3-D film. Disneyland boasts *Captain Eo,* a special effects–laden, 3-D musical short.

Todd-AO. A large-screen, wide-angle format that uses 65mm film and five perforations per frame and (originally) runs at 30 frames per second. The name of the process is an amalgam of producer Michael Todd and the American Optical Company. The process premiered in 1955 with *Oklahoma!* Other features using Todd-AO include *Around the World in 80 Days* (1956), *South Pacific* (1958), *Porgy and Bess* (1959), *Cleopatra* (1963), and *The Sound of Music* (1965). The large-screen format and use of extreme wide-angle lenses helped to create a greater sense of audience involvement without the need to move up to a system as complicated as Cinerama. Projection prints in Todd-AO are 70mm wide; six magnetic tracks give superior sound fidelity. Interestingly, *Oklahoma!* was shot in both 65mm Todd-AO and 35mm CinemaScope. Since Todd-AO operated at 30 frames per second, it was not possible to print down directly to 24 frames per second for standard 35mm release. Eventually, the Todd-AO cameras were modified to conform to the 24 frames per second standard.

Traveling matte. A matte that changes shape from frame to frame.

Ultra Panavision 70. A 65mm wide-screen camera process that uses anamorphic lenses. The system could achieve an aspect ratio of 2.75:1 and was the single-camera system that eventually replaced three-camera Cinerama. Films released in this super-screen process include *Mutiny on the Bounty* (1962), *The Fall of the Roman Empire* (1964), *Battle of the Bulge* (1965), and *Hallelujah Trail* (1965).

Undercrank. To turn the camera over at a speed slower than the normal frame rate. When undercranked footage is projected at the normal speed, the action appears to be speeded up. This technique is often used for comic effect.

VistaVision. A 35mm wide-screen process in which the film runs through the camera horizontally, each frame taking up an image width of eight perforations. The process was devised in the second decade of this century and adopted by Paramount, which premiered it with *White Christmas* in 1954. In a few situations, special projectors were built that could handle VistaVision-format prints by running the film horizontally. *Strategic Air Command* (1955) was the first film to be exhibited with

a VistaVision projector. Most release prints were printed down to the standard 35mm four-perf format. The process is used today for special effects sequences because of the larger negative area.

Williams process. A composite traveling-matte system patented by Frank D. Williams in 1918. Actors or foreground elements were photographed in front of either a white or a black screen. From that film, complementary mattes were created. Early uses of the Williams process include *Beyond the Rocks* (1922), *The Thief of Baghdad* (1924), *The Lost World* (1925), and *Ben Hur* (1925). By the early 1930s Williams had improved the process, using colored backings and optical printing in both *King Kong* and *Son of Kong* (both 1933).

Zoom lens. A lens of continuously variable focal length, which has the property of changing the magnification of the image during a shot. The development of the zoom lens is credited to Joseph Walker, ASC, who created several prototypes in the 1920s and 1930s. He received a patent for a zoom lens in 1933.

Zoptic process. A special effects process invented by Zoran Perisic and used to create many of the flying effects in *Superman I* and *II* (1978, 1980) and Disney's *Return to Oz* (1985). The device interlocks zoom lenses, one on the camera and the other on the background projector. The system creates the illusion of movement in depth.

INDEX

A

B

C

N